AUTHOR RIDING IN POINT TO POINT
(DAVID JACKSON IN FRONT AND IAN LOFTUS BEHIND)
Author's collection

HEART IN ART

Dedicated to my grandfather, Percy Johnson, and my father, Oscar Johnson
— two illustrious art dealers —
and, particularly, to my wife, Gay

HEART IN ART
A Life in Paintings

Peter Johnson

BENE FACTUM PUBLISHING

The following pictures are reproduced by kind permission of:
p xvi *Grey Arabian (with Creswell Crags in the background)* by George Stubbs, ARA – Private Collection; p 4 & 5 *Mares and Foals* by George Stubbs, ARA – Tate Britain, London; p 8 *Haymakers* by George Stubbs, ARA – Tate Britain, London; p 9 *Reapers* by George Stubbs, ARA – Tate Britain, London; p 14 *Tygers at Play* by George Stubbs, ARA – Private Collection; p 36 *Four Generations of the Pitcairn Family out Hunting at Stonehenge* by Samuel Spode – British Sporting Art Trust; p 39 *Adoration of the Shepherds* by Louis Le Nain – National Gallery, London; p 41 *Indian Palace* by William Daniel, RA – Yale Centre for British Art, New Haven, Connecticut, USA; p 51 *Leopards* by William Huggins – Private Collection; p 65 *The Ackermann Vase* – Fitzwilliam Museum, Cambridge; p 75 *Boy with Red Flower* by Thomas Gainsborough – Gainsborough's House, Sudbury; p 83 *Boy in Red Cape* by Sir John Everett Millais, PRA – Private Collection; p 85 *Lady Erskine and her Children* by George Jamesone – Scottish National Portrait Gallery; p 87 *Portrait of a Boy* by Sir Henry Raeburn – Aberdeen Art Gallery; p 97 & 98 *Field of Poppies at Hastings* by Albert Goodwin, RWS – Private Collection; p 101 *Lion* by William Huggins – Richard Hoare, OBE; p 103 *Horse Fair at Woolpit* by E.R. Smythe – Private Collection; p 110 *Dochfour House, Loch Ness* by Alexander Nasmyth – Earl Cadogan; p 117 *Salisbury Cathedral* by John Constable, RA – Sir Edward Manton; p 121 *Portrait of Princess Diana* by Douglas Anderson, RP – Royal Marsden Hospital, London; *Sir Winston and Lady Churchill* by Oscar Nemon – Chartwell, Kent (National Trust); p 135 *Winston Churchill, Aged Four* by P. Ayron Ward – Bulldog Trust (on loan to the Cabinet War Rooms); p 137 *Rudolph Ackermann* by François-Nicolas Mouchet – National Portrait Gallery, London; p 139 *Lord Balfour (Arthur) PM* by John Singer Sargent – National Portrait Gallery, London; p 147 *Queen Elizabeth I* by unknown artist – Private Collection; p 153 *View of Norwood, Looking towards St Paul's and Westminster Abbey* by Charlotte Nasmyth – Johnson Fine Art; p 154 & 155 *Wooded Landscape, Sussex* by Patrick Nasmyth – Johnson Fine Art; p 157 *Malmesbury Abbey* by J.M.W. Turner, RA – Private Collection; p 159 *Flower Piece* by Balthasar Van Der Ast – Temple Newsam, West Yorkshire; p 165 *Mrs Beal Bonnell* by George Romney – Fitzwilliam Museum, Cambridge.

The remaining pictures and illustrations are in the author's own collection.

Heart in Art
A Life in Paintings

First published in 2010 by Bene Factum Publishing Ltd
PO Box 58122, London SW8 5WZ

Email: inquiries@bene-factum.co.uk
www.bene-factum.co.uk

ISBN: 978-1-903071-31-1

Text © Peter Johnson

A CIP catalogue record of this is available from the British Library

Cover and book design by Mousemat Design Ltd

Printed and bound in Slovenia on behalf of Latitude Press

Contents

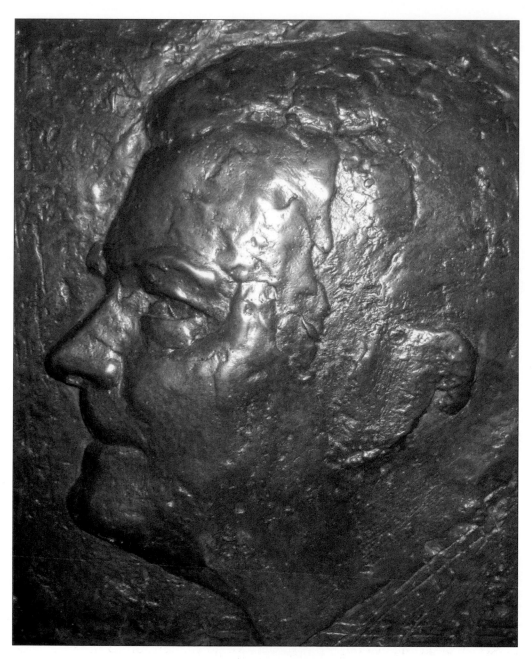

PETER JOHNSON
Oscar Nemon
Author's Collection

Nemon called this relief his 'Donatello'

Author's Acknowledgements

IT HAS BEEN A FASCINATING, EYE-OPENING and rewarding project to try to get some of my experiences of half a century of dealing down on paper, and I owe many people a debt of thanks.

First of all, I would like to thank my friends, especially Paul Robertshaw, for their support, and I am very grateful to all my clients and friends who provided me with such an enjoyable life that provided the source material for a book.

For me, there could not have been a more perfect start to such a book than Dr Christopher Brown's kind words in the Foreword and Charles Saumarez Smith's excellent Introduction.

I am extremely grateful to all the owners of the pictures illustrated for having generously given permission to reproduce their works, and to Roy Fox for his excellent photography.

Rose Proby was an superb picture researcher, doing much of the initial detective work. Margaret Slade and then Claire Rastogi assiduously prepared the manuscript — it would have taken me years to type, had I been doing it by myself. Tom Cobbe edited the book, so you now know whom to praise or blame; I greatly enjoyed our many conversations about art and music that the book sparked. I would like to flag up Anthony Weldon's attention to the finer details of book production and his ceaseless diligence. He was helped no end by Ian Hughes, who designed the book so beautifully.

Finally, I would like to thank my family, who, along with my wife, have been a unending source of inspiration and joy.

Foreword

Peter Johnson has been a friend for many years. While I was Curator of Dutch and Flemish Paintings at the National Gallery and subsequently Chief Curator, I often used to visit Ackermann & Johnson to look at Dutch and British paintings. Over those years, I saw many outstanding works. An evident gap at that time in the National Gallery's superb Dutch 17th-century collection was still-life, and so I was particularly pleased when Peter brought to my attention a fine still-life by Balthasar van der Ast which he hoped would become available to the Gallery under the In Lieu arrangements. The story of this negotiation is told in these pages. It was acquired for the nation but now hangs at Temple Newsam rather than in Trafalgar Square. I am pleased to say that, although this negotiation was not successful (at least as far as the National Gallery was concerned), Peter has sold many paintings over the years to public collections, notably Tate and the National Portrait Gallery.

Peter and his wife, Gay, are great supporters of the museums and galleries of this country. Since my move to the Ashmolean Museum in Oxford, Peter has introduced me to one of his clients, Mrs Jilly Scott, a great-niece of the great art dealer Joseph Duveen. With Peter's crucial encouragement, she has undertaken to present part of her splendid collection of paintings and porcelain to the museum. He has also introduced us to his friend Timothy Sanderson, who has become a benefactor of the museum. In these ways, Peter has supported the work

of the Ashmolean with his characteristic infectious enthusiasm. I am immensely grateful to him, not just for his support for the two institutions in which I have worked but for his friendship and good company.

Dr Christopher Brown
Director
The Ashmolean Museum, University of Oxford

Introduction

I FIRST BECAME AWARE OF PETER JOHNSON as a well-known and important art dealer not long after I was appointed Director of the National Portrait Gallery in 1994. We were offered a portrait of the early 19th-century dealer and publisher Rudolph Ackermann, who, in 1783, came to London from Saxony and, in 1797, set up an art shop at 101, The Strand. Here he sold a wide variety of prints, drawings and paints as well as publishing *The Repository of Arts* on a site which had previously been William Shipley's drawing school. Over time, Rudolph Ackermann's firm evolved into Arthur Ackermann Ltd, which Peter acquired in 1992 to form Ackermann & Johnson, and it was Peter who arranged for the portrait of the founder of the firm to be sold to the National Portrait Gallery. It now hangs very appropriately in the Regency Galleries on the top floor.

I don't think I actually met Peter himself until a year or so later, when I received a message from Henry Keswick, my chairman of Trustees, that Peter wanted to introduce one of his customers to the National Portrait Gallery, since the customer was deeply interested in portraiture and wanted to foster closer relations between the National Portrait Gallery and the Royal Society of Portrait Painters. Peter and I met for lunch in the gardens of the Chelsea Arts Club on a hot summer's day, and he told me about his customer, whose name was Christopher Ondaatje. From that point onwards, I saw a lot of Peter and his wife, Gay, who were great supporters of the National Portrait Gallery. I owe him

a great debt of gratitude, since it was owing to him and his introduction to Christopher Ondaatje that the Ondaatje Wing was built – to the eternal benefit of the National Portrait Gallery and the culture of London as a whole.

I should add that Peter was also responsible for the sale of two important portraits, one to Christopher Ondaatje and another to the National Portrait Gallery. The first was a portrait of Emma Hamilton by the French artist, Elisabeth-Louise Vigée Le Brun. I don't know where and how Peter found it, but it admirably exemplifies the painter's description of Emma Hamilton: 'Nothing was more curious than the faculty that Lady Hamilton had acquired of suddenly imparting to all her features the expression of sorrow or joy, and of posing in a wonderful manner in order to represent different characters. Her eyes alight with animation, her hair strewn about her, she displayed to you a delicious bacchanale, then all at once her face expressed sadness, and you saw an admirable repentant Magdalene.' The picture now hangs in a place of honour at Christopher's country house, Glenthorne.

Peter's other *coup* was encouraging the Carlton Club to sell Sargent's wonderful, stately portrait of the politician, Arthur Balfour, direct to the National Portrait Gallery, rather than putting it on the open market. But I will leave Peter himself to tell the story of its sale and of his other adventures in the art world.

<div style="text-align: right">

Charles Saumarez Smith
Secretary and Chief Executive
Royal Academy

</div>

Timeline

26 July 1936 Born, Stanstead Mount Fitchet

1943 Birkdale School, Sheffield

1945 Nevill Holt School

1950 Uppingham School

1958 Joined Leggatt Brothers

1962 Won Cambridge point-to-point on Spanish Dew

1963 Opened gallery as Oscar & Peter Johnson

1965 Married Gay Lindsay

1966 Juliet born

1967 Learned to fly a Tiger Moth and went solo

1968 My father, Oscar, died

1969 Guide to the Chelsea Physic Garden

1969 Chairman of Hans Town ward, Conservatives

1969 Art Adviser to the Cromwell Museum, Huntingdon

1970 Annabel born

1970 Council Member of British Antique Dealers Association

1970 Chairman of the Cleaner Royal Borough

1970 Sold *Haymakers* and *Reapers* by George Stubbs to the
 Tate Gallery

1970 Involved with developing fibre-optic lights for pictures

1972 Governor of Holland Park School

1977 The British Sporting Art Trust becomes a charity

1977 Wrote book on with Ernle Money on the Nasmyth family

1986 British delegate for the Conseil International de la Chasse

1987	Queen Mother unveiled statue of Sir Winston and Lady Churchill at Chartwell
1991	Marjorie Johnson, my mother, died
1993	Governor of Kimbolton School
1993	Bought Ackermann's
1994	Patented weed-gathering hoe with John Barwell
1999	Executive Council of the Historic Houses Association
1999	Millwright Project
2000	Started the Colvin Fire Prevention Trust with Jamie Cayzer-Colvin
2002	Sold portrait of Arthur Balfour to National Portrait Gallery
2008	Sold gallery
8 October 2009	Started new business: Johnson Fine Art

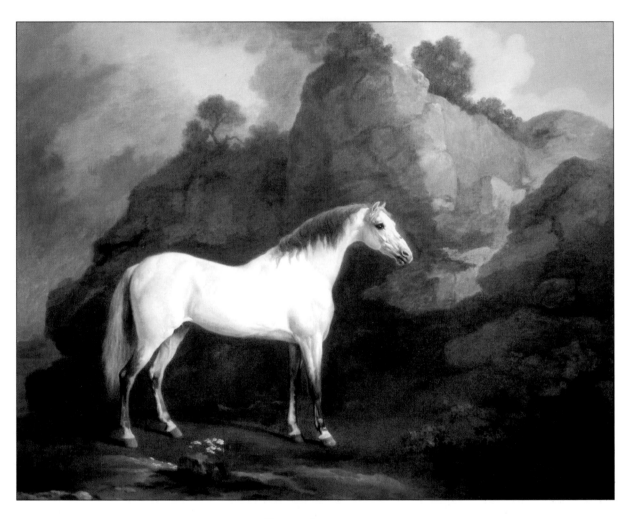

GREY ARABIAN
(WITH CRESWELL CRAGS IN THE BACKGROUND)
George Stubbs, ARA
Private Collection

Stubbs – and the British Sporting Art Trust

The wind of heaven is that which blows between a horse's ears
(Arabian proverb)

AT A COUNCIL MEETING OF THE Historic Houses Association, Gaby Robertshaw introduced me to William Parente as 'Mr Stubbs'. This caused me much amusement, as I have probably dealt in more pictures by George Stubbs than any other dealer. From the very first exhibition at the Whitechapel Art Gallery in 1957 to the splendid exhibition at Tate Britain in 2006–7, this brilliant painter has been one of my favourites and a special interest. I have had wonderful spaniels, sensational leopards, and simple but beautiful horses. Perhaps the pair of Arab horses that we bought 50 years ago were the epitome of his work. I was also pleased with the saving of *Whistlejacket*, Lord Fitzwilliam's picture on loan to Kenwood House. This picture had hung in the Orangery and was getting damaged by the excessive heat. I wrote to him warning him about this danger, and it was moved; it was later bought by the National Gallery, where it hangs now. To celebrate the purchase, it was printed out in a massive laser print on the facade – a wonderful validation of its importance.

George Stubbs was the son of a tanner, which is possibly the reason he did not notice the smell when he dissected a horse in his studio. He was quite an amazing man who, until he was in his 80s, walked 10 miles every morning. He taught himself to engrave so that he could produce his *Anatomy of the Horse*, which was still being used by vets until the beginning of the 20th century. By dissecting a horse, he was able to understand the horse's anatomy and paint them so

successfully. He studied another animals too: there were some drawings by Stubbs found in the Royal Academy Library which specially related to his book *A Comparative Anatomical Structure of the Human Body with that of a Tiger and a Common Fowl*. I particularly loved his cockerel, which still looks alive despite being featherless. The drawings were found by Constance-Anne Parker, the librarian, who wrote a book called *Mr Stubbs the Horse Painter* which was published a month before Basil Taylor's book, *Stubbs*. Taylor had previously called Stubbs the greatest painter scientist since Leonardo, perhaps slightly excessive praise, as the science element was always in support of his painting. The magical effect of his paintings has made Stubbs an artist of international importance. He didn't just paint horses, but also pictures of rural scenes like the beautiful *Haymakers* and *Reapers*, which I sold to the Tate Gallery in 1977.

In a place called Ceuta on the Moroccan coast, George Stubbs saw a horse being attacked by a lion. This was to be a subject that affected him for the next 30 years. It was originally thought that he took this subject from a sculpture he saw in Rome, however there is now no doubt that all the vivid paintings that he did of this scene were inspired by seeing the actual event. Not only did he paint the very large picture (96 x 131 inches) which is in the Yale Center for British Art, but he also produced the subject in enamel and even Bas-relief in clay. This series of paintings started with a Barbary horse being frightened by the lion, but then developed into the scene of the lion on the back of the horse with its teeth in the unfortunate animal's flank. Although he painted different forms of this theme 17 times, it is amusing to see that in some of the pictures, he has used Creswell Crags as the background. This probably led to the idea that he was copying from an ancient source rather than from having witnessed it at first hand.

Why are his pictures so important? Firstly they are beautifully painted. Secondly, if the picture is a horse, you feel you can ride it. Thirdly, the composition of his pictures is exceptional. This is particularly true of the *Mares and Foals*, which is made up of triangles. Not only that, but Stubbs kept to what is called the Golden Section in his balance of subject, landscape and sky. (The Golden Section is the proportion that forms the basis of many shapes in nature and is what the ancient Greeks deemed perfect). People who own pictures by Stubbs are particularly lucky, because they are wonderful to live with — mainly, I think, because Stubbs loved his animals, whether a spaniel or a rhino. The Royal

Veterinary College were given by Paul Mellon George Stubbs's *Eclipse*, still meant to be the fastest horse that ever lived. Appropriately they also have a copy of the *Anatomy of the Horse*. This book shows every detail of muscles, sinews and skin, and on every page you see a different view of the horse. It was interesting for me to find that a copy of the *Anatomy* is for sale in London for £19,000, and it seems to be in similar condition to my copy.

How do you compare George Stubbs with other sporting artists? Certainly his pictures stand out, but what about John Wootton and Ben Marshall? John Wootton was earlier, but some of his pictures are very impressive, like the set of paintings in the hall at Longleat in Wiltshire. They are dramatic and show excellent skill. They depict the fighting of two stallions in which the stable boy was killed trying to separate them. Ben Marshall is altogether a different style of painter: his pictures combine a much more contemporary look, even though they were painted at about the same time as Stubbs. In fact, there is an excellent 1929 book entitled *George Stubbs and Ben Marshall* by Walter Shaw Sparrow. It is a joy to me to find, as a sporting man, that these pictures ring all the right bells, not only from the point of view that they are works of art, but also because they are very dear to my heart which must be one of the reasons for the title of this book. The other being taken from a lovely television programme called *Hart to Hart*, with Robert Wagner – a client of ours – with the beautiful Stephanie Powers.

I remember going in my 20s to the first George Stubbs exhibition at the Whitechapel Art Gallery and thinking how wonderful his pictures were. It is very pleasing that Stubbs is now considered a major master, thanks to the exhibition at the Tate Gallery (to which I contributed) and the advent of Paul Mellon – the major collector of Stubbs, under the guidance of the art historian Basil Taylor.

Perhaps the most beautiful picture we handled was the magical *Mares and Foals* by George Stubbs. This belonged to Lord Midleton, who decided when he was moving to Jersey with the actress René Ray that he wanted to sell it. It was, to my mind, the finest of the series of *Mares and Foals*: although the Fitzwilliam one as a frieze without a background is very beautiful, this one had the most idyllic landscape. The perfect home for this picture was the Tate Gallery, but there was still the question of money. The figure that was suggested in 1961 was £14,000. Lord Crawford, who was then Chairman of the National Art Collection Fund, said it was too much. Nowadays, you would have to put a few

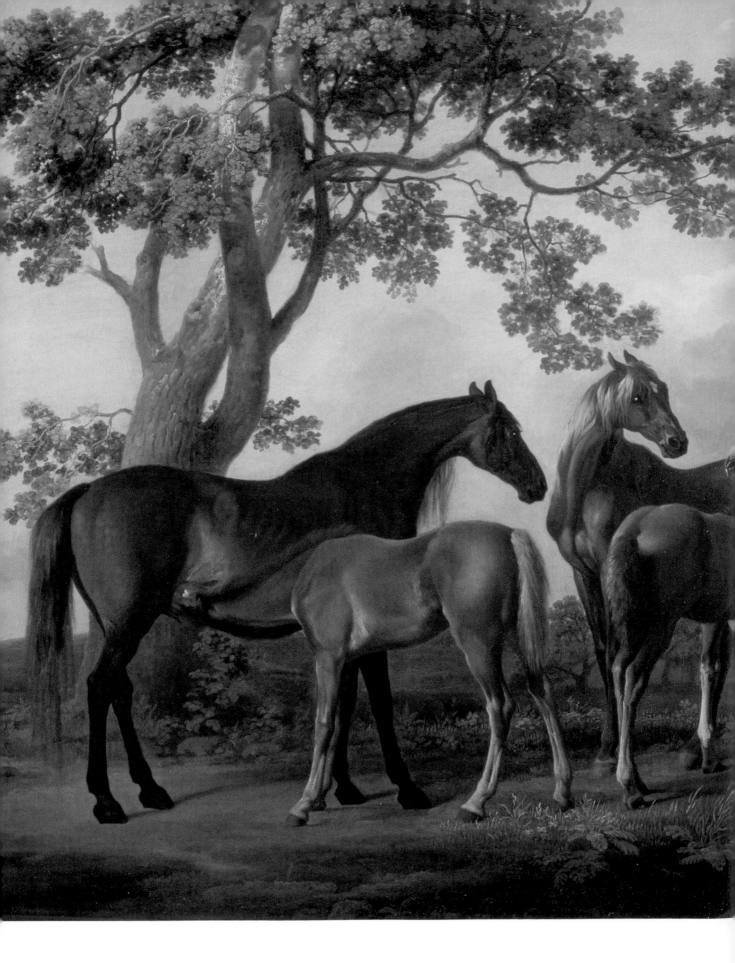

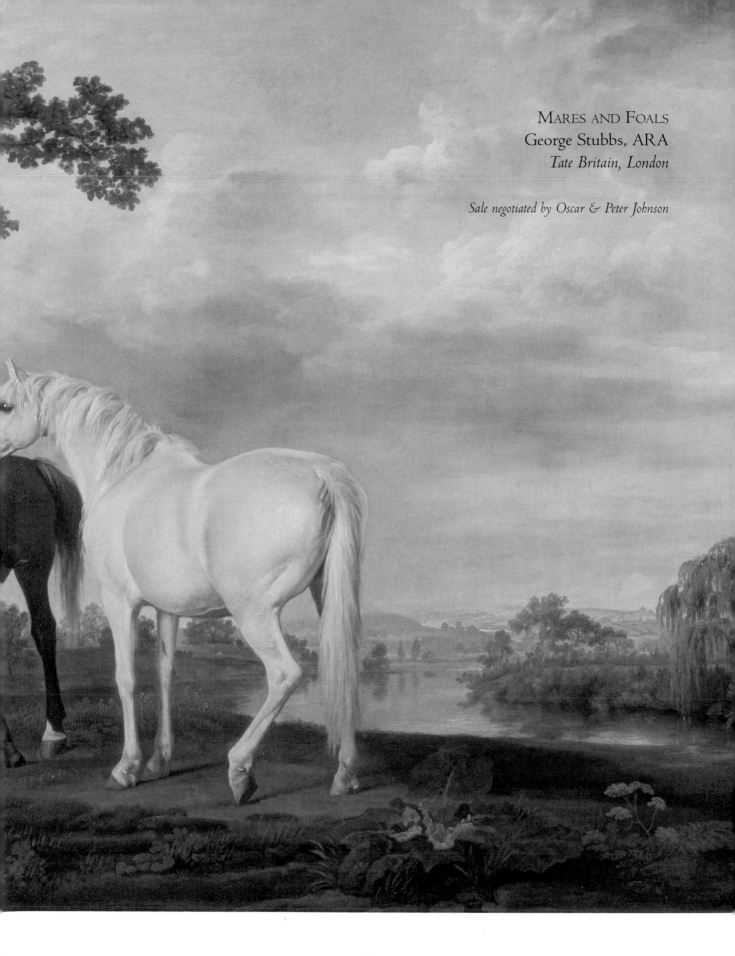

noughts after that figure. After much discussion, the purchase was agreed with the Tate. It was, of course, before Paul Mellon had particularly focussed on purchasing pictures by George Stubbs. Although I knew the picture well, it wasn't until I went to a lecture at the Tate in front of the picture for three quarters of an hour that I realised the great beauty of this exceptional work of art. The lecturer pointed out that the composition was made up of triangles in which all the mares and foals fit and the balance of the tree to the left and the landscape behind. What a picture!

Another impressive work is the picture of Dungannon with a sheep, in the collection of the Earl of Halifax. Apparently, the horse wouldn't go anywhere without its ovine friend. This is where Stubbs shows his outstanding ability to paint animals; not only is the horse beautifully painted, but the feeling of even the texture of the wool on the sheep is superbly rendered. The picture although traditional in presence, has a timeless quality about it. Professor Michael Jaffe, then the director of the Fitzwilliam Museum, contacted me as the chairman of the British Sporting Art Trust to ask if we would contribute to the purchase of a most important painting of *Gimcrack with John Pratt up, at Newmarket* painted in 1765 and considered one of the artist's major works, as reported by the *Daily Telegraph*. The director was convinced that if the Trust made a donation, he would be able to raise the £601,000 that was required for the Fitzwilliam to acquire the picture. Although the Trust only contributed £3,000, it did the trick, and I was happy to be looking at this lovely picture last week in the museum.

One of the families I most enjoyed was the Willses. They all had that wonderful relaxed sense of fun. I remember my first meeting with old Mrs Wills, Andrew Wills's grandmother. It was an old-fashioned tea party at Longparish, Hampshire. In the middle of it, Mrs Wills said to Andrew, 'What have you done to your front tooth?' Andrew explained how his son had pulled his pipe out of his mouth and with it his front tooth, and how he had stuck back his tooth with Bostik. Nothing eccentric in that! Mrs Wills was the widow of Captain Arnold Wills, the collector who, when asked by my grandfather, Percy Johnson, whether he was pleased with the painting by George Stubbs that he had bought, said that he couldn't find anywhere to hang it so he had put it in the cupboard under the stairs!

Andrew was great fun, and lunch with him was highly entertaining. He was a Walter Mitty type of character. On one occasion, we sat down at the Rib Room

in the Carlton Towers to celebrate the sale of a picture. He said, 'What do you want to eat? I feel like some large jumbo Mediterranean prawns.' When a huge pile of ice arrived with a mountain of prawns on it, he said, 'I can eat my side if you can eat yours!' His method of crossing Sloane Street had to be seen to be believed. All he did was stick his umbrella out and walk. Cars were seen standing on their noses, but nobody hooted at him or ran into him. He must have been quite something as a young Guards Officer. In fact, he told me how many girls he had had in one day. His carpentry was eccentric, and I am still the proud owner of the table I bought from Liz after Andrew had died. It is made up from bits of left-over wood; Liz gave the money to charity. Major John Wills, Andrew's father, was a very smart and delightful person who always made you feel welcome. He carried on the family tradition of buying pictures from us, acquiring a picture of Carnarvon Castle, which he gave to Prince Charles when he was invested as Prince of Wales there in 1969.

The exciting time over Stubbs was when John Wills came to see me and said he wanted to sell his wonderful pair of pictured *Haymakers* and *Reapers*. I knew they belonged at the Tate and immediately offered them there. A complication was that Hugh Leggatt, my ex-partner, had offered them to the National Gallery. After a number of difficulties, the Tate bought them, and John Wills was able to buy his farm in the West Country. From my point of view, it was the first £1m deal I had done, and it was also with thanks to the diligence and help from my friend, the solicitor David Eldridge of Lee & Pemberton that the whole deal went through. The problem was the tax and value of the paintings. As I knew that Paul Mellon would give about £1m for them, it then became a matter of working out the tax, and I was able to sort out the best arrangement between the gallery and owner as to receiving the best figure after capital gains tax, this endeavour being helped considerably by the addition of a *douceur* from the government, an incentive by way of a tax return to encourage owners to sell to British public galleries rather than the works going abroad. It is marvellous to think I am a third-generation art dealer and to have dealt with three generations of Willses.

To achieve the sale of this pair of exceptional pictures was not without difficulties. It was the first of many occasions on which I had to wear two hats. In this case, it was that there was another pair of paintings of the same subjects by George Stubbs, and Martin Butlin of the Tate Gallery asked me to give my

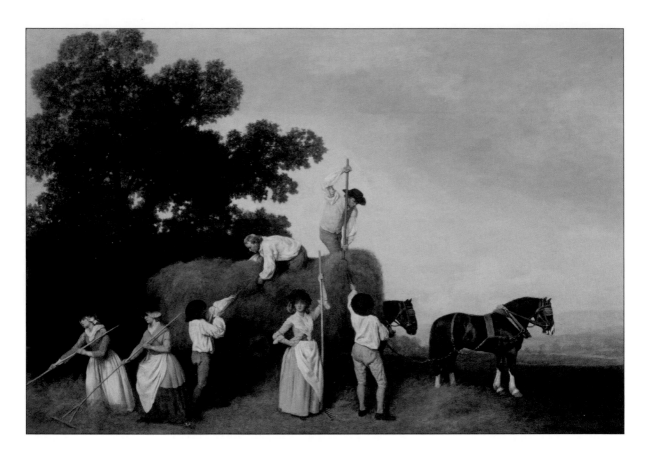

HAYMAKERS
George Stubbs, ARA
Tate Britain, London

Acquired by the Tate through the author

REAPERS
George Stubbs, ARA
Tate Britain, London

Acquired by the Tate through the author

opinion as to whether the pair I was offering the Tate was better than the pair belonging to Lord Bearsted of Upton House. It was a tricky problem, but in a jolly frame of mind, I travelled down to see the pair in Warwickshire. Luckily, I was able to report that the pictures belonging to John Wills, the owner of the pair that I was selling, were more colourful and in better condition than those at Upton House. Martin Butlin accepted my opinion, and the sale went ahead.

It is an interesting debate as to which pair was painted first. It is possible that the Bearsted pictures were older, as Stubbs subsequently explored the use of more colour in his later works, and, as usual with this exciting artist, he continued to experiment with paint and preparation. When you consider that he taught himself to engrave, it is not surprising that he also tested different ways of painting. His association with Josiah Wedgewood produced the plaques which were painted on porcelain and were then fired, in order to produce most effective and colourful works of art. Although not usually considered a member of the Enlightenment, he was definitely an outstanding man of this incredible period of British history. As far as these lovely pictures are concerned, it is difficult to believe that they wore such extravagantly beautiful and colourful costumes in order to work in the fields. Whatever their story, I must say that a special trip to the Tate and half an hour spent solely admiring the detail, composition and colour of these paintings would still not do them justice.

Brigadier Sir James Gault was liaison officer between Eisenhower and Churchill and a great friend of my father's. He lived in Eaton Square and was a regular visitor to the gallery. Unfortunately he rarely bought pictures, mainly because my father offered him a Stubbs just after the war for £500, which he declined. He therefore spent a lot of time bemoaning the fact that he missed such a wonderful opportunity. He was an extremely charming client, and I did not mind that he prefaced every visit with 'I wish I had bought that Stubbs.' If I regretted every picture I've sold that has subsequently tripled in value, I would be permanently unhappy.

<p style="text-align:center">✳ ✳ ✳</p>

In 1970, I thought it was high time to do something about my grandfather's comment in his reminiscences that, although he wasn't a sporting man, the finest

art that this country has produced was sporting art. There is no doubt that Constable can paint beautiful landscapes and Turner exciting pictures, but to paint a picture with movement, landscapes and animals is a greater achievement. On 15th June 1973, I wrote a letter to the editor of *Horse and Hound* headed 'British Gallery of Sporting Art needed'. In the letter, I stated that the UK is the only country to have a national heritage of sporting art covering 300 years. I also pointed out that many important pictures of the genre had already left this country and that it would be tragic and shameful if our descendants would have to cross the Atlantic to see fine examples of British sporting art. I mentioned the original object of the Hutchinson Collection was to form the basis of what was being proposed here. (Unfortunately, this collection was dispersed on the death of its founder, many pictures going to Lord Woolavington, a very big collector of sporting art.) Even then, I mentioned the problems of 1) financing the purchase of sporting paintings 2) finding an appropriate gallery 3) forming a committee to advise and support the scheme. Finally, the letter said that if we didn't act now, the enjoyment of sporting art by ourselves and our children will be lost to this country. To my surprise and disappointment, the art historian Basil Taylor wrote against the idea, saying that it would lead to a fragmentation of art, even though I had been careful to point out that there was already the National Maritime Museum and the National Portrait Gallery.

My letter was followed up by one from Stella Walker suggesting Somerset House as a venue. This was then followed by a letter written by Dr Robert B. Fountain suggesting the formation of 'Friends of Sporting Art'. These letters started a rush of reports in *Horse and Hound*, and an article by Dr Fountain in the *British Racehorse*, as a trustee and member of the executive committee of the newly formed British Sporting Art Trust. In this article, he illustrated the painting in the Jockey Club of *Gimcrack* by George Stubbs (a different composition from the Fitzwilliam picture). It was with great pleasure that I formed a committee, and we held our first meeting in my office at the gallery — people came up with all sorts of ideas but were sceptical about obtaining any funding for the project. The members of the original committee were:

Mrs Stella Walker

Anthony Barbour

Martin Butlin

The Marquess of Dufferin and Ava
Mrs Judy Egerton
Dr Robert Fountain
Alfred Gates
Bobby Selway
Lt. Colonel John Wood
and myself as chairman

We produced a brochure with our aims with an illustration of Mr Russell on his bay hunter by James Seymour – lent to the trust by Mr and Mrs Paul Mellon. The Queen Mother agreed to be our patron. Martin Butlin, at a meeting I had with him, said that if we formed an honorary council, he would put it forward to the trustees of the Tate that they would provide a gallery for displaying sporting art. We were amazingly successful in forming the most distinguished council:
The Duke of Beaufort
Earl Fitzwilliam
Major Sir Reginald Macdonald-Buchanan
Lady Macdonald-Buchanan
Paul Mellon, KBE
Lavinia, Duchess of Norfolk
Sir Norman Reid, Director of the Tate Gallery
Earl Spencer
The Marchioness of Tavistock
The Marquess Townshend
Dorian Williams, MFH

With this powerful honorary council, the Tate agreed for the trust to have a gallery to display sporting art. The brochure set out our plans and asked for members. Our first member was Sir Henry Tate, a member of the sugar family whose name is on the gallery on the Embankment. Our first secretary was Joan Tate, and our first AGM was held at the Tate Gallery. As chairman, I was happy to say it was a *Tate-à-Tate*. The Tate thought that only ten people would turn up. In fact over 50 came and more chairs had to be found. I produced a map of

England on which we put flags where we had members. I thought Sir Reginald Macdonald-Buchanan had gone to sleep, but he said, 'I am not asleep – and the answer to your question is...'!

I travelled around telling people about the importance of sporting art. I went to Devon and, of course, Leicestershire, the centre of hunting country, where Jeannie Abel Smith hosted a dinner, and I gave a lecture with slides. Sir Thomas Lethbridge sent out a rather grand invitation inviting people in Somerset to meet me. Gradually, our membership increased, and articles began appearing in *Country Life*, the *Daily Telegraph* and *The Field*. A particularly nice piece in the *Daily Telegraph* entitled 'Sporting paintings for Tate' written by Terence Mullaly (10th August 1977). Our first press release was prepared on 25th July 1977, a day before my birthday.

We received enormous press coverage. I was particularly pleased with *Horse and Hound* on 16th December 1977, when *Mr Russell* by James Seymour was illustrated on the cover. Another very good article – in the same month – by David Coombes entitled 'The Englishman's art' appeared in *The Connoisseur*. This was followed by a piece in the *Shooting Times* by Douglas Leslie entitled 'Sporting treasures'.

Another press release was prepared on 5th June 1980 announcing 'New sporting art galleries at the Tate'. Even the *Philatelic Bulletin* had a piece saying 'Save British sporting art for the nation'. This article referred to the Post Office's use of equestrian inspiration for its stamps, particularly the lovely picture in the Tate of *Mares and Foals* by George Stubbs. Then came that wonderful gift of 30 pictures to the Tate through the British Sporting Art Trust, prompting headlines such as '£6m gift of sporting art for Tate' (Frances Gibb) and a piece in Peterborough diary in *the Daily Telegraph* stating, 'A nucleus of a British Gallery of Sporting Art has been established' with an illustration of the Stubbs of *Otho with John Larken up*, a handsome racehorse beside the famous rubbing-down house, with a church in the distance. For an artist who takes great care with his composition, it is extraordinary that the spire of the church seems to be sticking up the horse's muzzle. This doesn't alter the fact that this picture was a wonderful gift to the Tate through the British Sporting Art Trust. One article in *Horse and Hound* said 'Paul Mellor [*sic*] to donate 30 paintings to Tate Gallery'. Luckily, the article managed to spell the donor's name correctly. Another headline was 'Thank

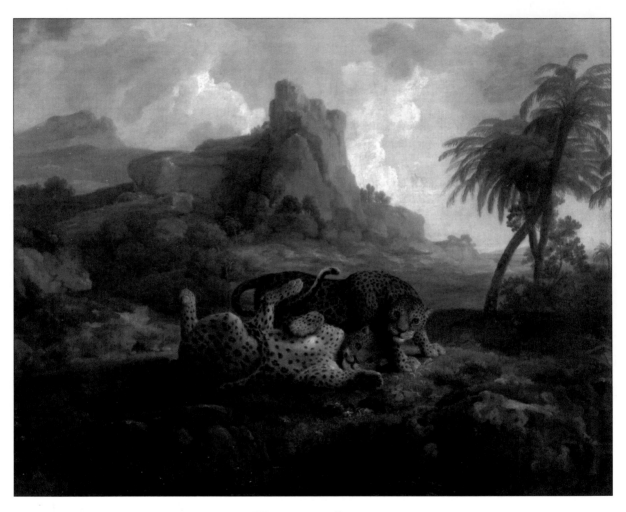

TYGERS AT PLAY
George Stubbs, ARA
Private Collection

Bought by a Yorkshire collector; still owned by the family

you Mr Paul Mellon!' (*Horse and Hound*, December 1979) also illustrating Stubbs's *Otho*. In *Country Life* (30th August 1979) was 'Gift from a galloping Anglophile' (Christopher Neve). On 10th June 1980, the *Daily Telegraph* announced that the Tate was to open two rooms 'devoted to a permanent exhibition of British sporting art'. Thanks to Paul Mellon's generosity, Mrs Ambrose Clark was encouraged to give some of her collection, including the wonderful James Pollard of *Coursing at Hatfield Park*. Lord Salisbury invited us to a meeting at his park, and I was able to stand where James Pollard had sat and painted this picture of ladies riding side-saddle and gentlemen in top hats with any number of greyhounds and children on ponies.

By 1977, the trust had become a registered charity and it bought its first picture, a large painting of the four generations of the Pitcairn family out hunting at Stonehenge — a particularly interesting scene by Samuel Spode from *c.* 1850. The descendents of the family now live in Australia. Jane Agace (now Wates) generously allowed the trust to buy the painting for the same figure that she had originally paid for it, and Jeremy Cotton has bequeathed a lovely big hunting picture by Edwin Cooper to the trust.

In 1991, thanks to Edmund Vestey's generosity, the Vestey Gallery was opened at Newmarket, in association with the National Horseracing Museum. Opened by the Queen Mother, not only did it appear in the Court Circular, but there was a piece in the *Daily Telegraph*: 'Queen Mother opens sporting art display'. It was a real pleasure to think that the small committee that started the British Sporting Art Trust in my office in 1977 had achieved, 14 years later, a royal opening by the lovely Queen Mother. We were also supported by another member of the Royal family on 26 October 1981. Princess Anne, now Princess Royal, opened an exhibition of Charles Johnson Payne, better known as Snaffles, at the Alpine Gallery in South Audley Street, London.

We have been very lucky with our various benefactors. John Wood, who died this year, persuaded the owner of a Harry Hall, and the owner of a John Ferneley, Snr, to give us their paintings. Not only that, but John gave *Partridges* by Francis Sartorius from his own collection. John Wood and Bobby Selway were stalwart supporters of the trust ever since it started. John has always given his opinion and helped the trust when possible. He retired as a trustee at the age of 93. One person I greatly admire is Geoffrey Bond, who was a marvellous

honorary solicitor and gave us his advice and help over the development of the trust. It is these dedicated people who have made the trust move forward. The latest project being organised by our energetic new chairman, Peter Jensen, is to convert Palace House in Newmarket, once the home of Charles II and his mistress Nell Gwyn, into a permanent home for the British Sporting Art Trust.

The trust not only developed in this country, but a very good friend of mine started a Stateside one too. It was a great gesture to have help from across the Atlantic, and David Diebold organised the friends very well. There were many successful events, but the one I remembered most was a fundraising event organised by my wife, Gay, with the excellent help of Diana and Anthony Barbour, who was then chairman of the trust. The evening auction was held at Christie's in May 2008. Everyone was most generous in both giving objects and bidding for those items. The evening raised over £30,000 and thanks must be given to everyone concerned for their help in making it such a success.

One of the side effects of the trust was some wonderful trips organised by Dr Robert Fountain to see sporting art in other countries. We went to France, Austria, Ireland and the USA. They were most enjoyable tours, and they greatly helped the trust in the early days, because more and more people wanted to be involved. I particularly remember the one to Vienna that Dr Fountain organised. We had a wonderful visit to see the Spanish Riding School and saw the Lipizzaners doing their *haute école* dressage, but the real joy was a visit to Piber, where these massive horses were bred. To start with, the landscape is glorious, and seeing the mares and foals set in that undulating countryside was a real picture. I met one of the stallions with very large intelligent heads. We also travelled south where we were entertained by Prince Reuss. He was a lovely Austrian with a great sense of humour. Around his house he had a wildlife park. When we arrived, we were greeted by a lot of monkeys. Henry Reuss took us on a tour of the animals. The American Bison looked large and impressive, and I was trying to take a photo of them when Henry said, 'If you go through that gate, you can take a better photograph.' I said to him, 'Is it safe?' And he said, 'No.' I decided not to win Wildlife Photographer of the Year Award this time.

Veni, Vidi, Vinci

———— ⊒ ————

Guessing what is the other side of the hill
(General Arthur Wellesley, later 1st Duke of Wellington)

WHEN MY GRANDFATHER WAS ASKED WHERE he bought the pictures for his business, his answer was, 'Ubique.' It is also true today that I have in my 50 years of art dealing bought pictures everywhere. Travel is part of an art dealer's life – my grandfather also said that the greatest asset of an art dealer is mobility. On average, I have been to New York twice a year for the last 40 years. The trips have always consisted of seeing clients, viewing sales and exhibitions and especially a visit to my favourite museum in this world, the Frick Collection. It has everything: wonderful pictures, marvellous atmosphere and it is not too crowded. And it was all thanks to the art dealer Joseph Duveen: he chose the site and the architect and advised Henry Clay Frick on the contents. It is an incredible tribute to the man who is generally criticised but later became Lord Duveen of Millbank. The criticism, no doubt, stems from his most famous/notorious sale of Thomas Gainsborough's *Blue Boy* out of the UK to the Huntington Library, San Marino, California.

Sir Edwin 'Jim' Manton made sure that we had a good time in New York by inviting Gay and me to wonderful restaurants, like the Algonquin, and afterwards to the theatre. One occasion, he took me to see Rex Harrison in a play where he forgot all his lines; even more unfortunately, I had seen the same play in London just a few weeks before. I bought an exceptional pair of sporting pictures from Jay Rousuck, a redoubtable dealer in New York. There was a pair of pictures by

AUTHOR WITH LIPIZZANER

Photographed at Piber, Austria, where Lipizzaners are bred

J.N. Sartorius of shooting in the early 19th century, with ponies to carry the game. On that trip, my wife and I went on to San Francisco and Australia. When I got back to London, I expected to see the Sartoriuses. I rang the dealer, who told me that I couldn't buy them for the price we had shaken hands on but I would have to pay more. If I hadn't wanted the pictures so much, I wouldn't have agreed to the increase in price.

On my first ever trip to the USA, my father and I set sail on the *SS United States*, which held the Blue Riband because it was the fastest to New York – five days. It was enormous fun, and I met some delightful Americans. The tricky part was to remember that American English is not the same as British English – two countries divided by a common language, etc. On one occasion, I asked a very pretty American girl if she would like a knock-up. This was entirely innocent, as I was referring to table tennis, which was a very competitive sport on board. My father seemed to enjoy himself, and the sun and the Atlantic air seemed to do him good. It was lovely standing on deck after endless parties and meals. My father was standing on deck when he found a set of gallery keys in his pocket and, saying that he might lose them in New York, he promptly threw them overboard. It is funny to think that somewhere in the mid-Atlantic is a set of keys to the gallery in Knightsbridge.

On the last night, we had a really good party. A group of us at about midnight, in our dinner jackets/tuxedos decided to go to the other part of the ship, and eventually we found ourselves in with a noisy crowd of Irishmen. I got back to my cabin at 4am, and at 6am, there was a knock on the door. It was the steward, who said, 'Your father insists that you go on deck.' I will never forget the sight of the Statue of Liberty appearing out of the mist and the amazing sky-line of New York and its skyscrapers behind. A real work of art in vision. My father introduced me to the American art trade and then flew back to London, while I caught a train to Montreal.

It was a most enjoyable visit, where I met all the Reford family. Joris decided I should help him cut down trees in my suit. Sonya drove me round the city in her car without shock-absorbers. As there was a liquor strike, we had to go out into the harbour to drink on board a Swedish boat. It was great fun. But the purpose of the trip was to collect a very beautiful picture entitled *Quillebeuf* by the great English artist, R.P. Bonington, who died so young, at the age of 25.

This inspirational work belonged to the Reford Trust (as did a wonderful Hoppner of a beautiful lady and a Gainsborough of Mrs Lowndes) and had already been committed to a possible sale to Paul Mellon. All would have been well, except that Mrs Reford considered the picture to be her own personal property. When I spoke to the butler, he said that it was going to be very difficult for me to collect the picture. Eventually, it was arranged that he would have it ready for me half an hour before my plane took off for London.

So when I arrived at the Reford mansion in Mount Royal (now part of the McGill University), there at the back door, much to my relief, was the butler with the painting. I had to dash, as she was due back any moment. When I boarded the aircraft, which had beds that came down from the ceiling, the stewardess told me to put the picture in the loo. I explained that it was very valuable and, after much discussion, managed to arrange that it go under my seat. She later managed to spill some marmalade onto the picture – luckily, it didn't seem to damage it too much! The flight was not without incident, in that when we landed to refuel at Goose Bay, Newfoundland, the man next to me was given oxygen in the middle of the night. Later on, I looked at him, and he seemed to be a very odd colour. I called the steward, and they put a blanket over him. When we arrived at Heathrow, a hearse was the first vehicle to come out the plane, much to the horror of my parents, who were waiting for me at the corrugated building at Heathrow.

Both the Hoppner and the Gainsborough found good homes. The Hoppner was bought by Angus Lloyd's mother and given to him, and I was proud to see the latter in the home of my Royston neighbour Sir Gerard Newman. Lady Newman was a great supporter of the gallery, and it was great fun when we bought a Hubert Robert painting without the knowledge of her husband. Another time, he instructed me to go up to £50,000 for a lovely picture by James Seymour of the Craven Hunt. I did not know that I was bidding against the Tate, where the picture hangs today.

In 1965, just after I was married, I took my new wife on a business trip to New York, where we found a wonderful portrait of Charlemagne by John Ferneley, Snr. The day I returned, I sold this lovely picture and paid for the trip. Gay said to me that I had sold it too cheaply, and she was proved right, because I sold the picture again to Jack R. Dick of Blackwatch Farms who was a very keen collector of sporting art. Within a couple of years, he found he owed a lot of

money to the Internal Revenue – he was an unreliable payer to many picture dealers too but luckily not me. Sotheby's held a four-day sale of his collection, some of which he had never paid for. *Charlemagne* went off to California for a substantial figure, but a couple of years later, it returned, sadly with damage to the picture.

On my first trip to America with the Museums Association, the starting-point was Boston, where we stayed in a hotel on a railway track, which had a notice in the elevator saying: 'This hotel is due for demolition in...'. The date had been removed, but the reason for the notice definitely still held true. My watch had broken, so I went across the railway line and bought, for $10, a watch from a drugstore. By the time I'd returned to the hotel, it had stopped. I went back and exchanged it for another. This lasted until New York, and I actually sent it back, and to my amazement, received yet another watch. This was my first experience of a 'throw-away society'.

As a group of Englishmen, we were invited to a tea party – a Boston tea party – at the fabulous Isabella Stewart Gardner Museum. The building is an Italianate villa set in the middle of Boston. This very rich lady provided the funds for Bernard Berenson to be educated, and subsequently, to organise this charming museum. The Boston ladies all decked out in their finery, with impressive amounts of jewellery, gave us tea served from a large samovar. Having survived the Boston tea party, we went on to the Museum of Fine Art, Boston, which was one of the most important museums at the time. My father was involved in the sale to it of a wonderful, big Francesco Guardi view of Venice, painted from the lagoon.

We made two wonderful trips to Australia after a busy time in New York, the first in 1966 and the second in 1972. In 1966, we went via San Francisco, where we stayed at the Mark Hopkins Hotel and had the biggest breakfast of my life. I rang down to room service and at the same time asked my wife what she would like for breakfast, failing to realise that the man was writing down everything I read out from the menu, so a trolley came to our room with the entire menu on it. This kept us going until we arrived at Sydney at 8 o'clock in the morning, to be greeted by about 50 people from the press. It was the first time an art dealer had visited this continent. The effect of all this press coverage was that the telephone switchboard in the hotel was completely blocked, and the operator was offered a box of chocolates to be put through. I was offered

champagne and caviar as an inducement to view a large eight-foot painting of the Household Cavalry by Henry J. Cobbold. Aside from rolling the picture up, there was no way of getting it back to London, so in the end I could not buy it. It would be no problem nowadays, but then the cost and the logistical difficulties (three stop-overs) were too great. Another one that got away was a very important miniature, a self-portrait by John Smart. The owner wouldn't come down from 10,000 Australian dollars, and I decided that was too much.

Thanks, again, to the publicity, I bought 14 pictures in 14 days. Particularly interesting were four pictures by George Vincent, who disappeared in 1831, and if any of the pictures had been dated after that, it would have solved an art mystery. It is possible that Vincent went out to Australia, like John Glover, who became an important Australian artist. One of the calls to the hotel was from a lady who said she had some pictures by Conrad Martens. I hadn't heard the name, and it wasn't until we went to the Mitchell Library in Sydney and saw all his beautiful water-colour views of Australia that I realised what we were missing. I made up for this later by buying pictures by this lovely artist whenever I came across them.

We had a wonderful time in Sydney, and I was lucky to survive my swim there after a very good lunch. The first I knew that I was on my way to New Zealand was the speed that I was leaving the shore. I shouted at Gay to swim for the beach, and Juliet was asked by our hostess, 'Have you said goodbye to your father?' Luckily, our host was a life-saver, and he knew that there was a sand bank out in the bay and that if he could get to it, he could catch me on my way out to sea. It was a rip tide called 'The Escalator'. Travelling at about seven knots, I was completely oblivious of the fact that there were sharks out there and 3,000 miles of sea before I would reach New Zealand. Luckily, John Molyneux caught me on my way past, and we gave a party for him to thank him for saving my life.

On our wonderful trip to South Africa, I was not so successful as I had been in Australia. Peter and Pam Barlow had bought from me a very striking picture by Arthur Devis. When a friend said he wanted to buy a Devis, I showed him the transparency, and he offered £80,000 for the picture. I thought, 'I can't just ring up Pam and ask her on the telephone if she would be prepared to sell it', so I decided to go to South Africa, and a trip was arranged. Very kindly, Pam Barlow asked us to stay at their home in Stellenbosch for our first week, and we booked

into the delightful hotel The Vineyard for the second week. When I asked Pam Barlow if she would accept this substantial profit (they had paid £2,500 twenty years earlier), she was inclined to accept it. The offer was even more attractive at the time, since the Rand had devalued significantly – from around nine to the pound to fourteen. Unfortunately, her son said no, which put a kybosh on the deal. As well as aiming to arrange the Devis sale, I had been asked by Count Paul Raben to do him a service. His ancestor Sir Abe Bailey, the diamond magnate, had bequeathed a wonderful collection to the South African National Gallery in Cape Town; many of the sporting pictures were languishing in the basement racks (obviously, sporting and hunting pictures were not in favour in South Africa). I was to find out the chances of getting them on loan or getting them back. I managed to see them after much difficulty, but couldn't prise them away. It was a wonderful trip and most enjoyable, even if both missions were unsuccessful.

Apart from Australia, I suppose the most exotic place I've visited is Iran. I was asked by Almid Sadagliani, an elegant Iranian bon viveur, to go out to Tehran to advise him on the opening of a gallery there. The trip was an interesting one, in that I was asked by an artist, Andrew Vicari, to go to Beirut to the opening of his exhibition at one of the lovely hotels. We set out from Heathrow and had a most successful and enjoyable three days in Beirut. We met Mr Araktingi, who lived in great style in a house on top of the hill overlooking the city and the sea. The troubles were about to start, and while we were there, a young boy, aged 11, picked up a hand grenade and threw it into a ditch, saving his life and his mother's. With great difficulty, I found a room in Tehran, as everybody was there to meet the Shah, or trying to. I met one of his ministers, who was absolutely charming. I had difficulty over a cup of tea, as I did not realise that you have to wiggle your cup to show that you had had enough. I went down Pahlavi Street (the main street in Tehran, now called Vali Asr Street), where there was a man selling eggs from his cap; around him were chickens, which presumably laid the eggs. The visit was fascinating, but the traffic jams were horrendous. On one occasion, I was going to a party given by a princess. I was within walking distance, but the taxi driver would not let me get out! I then returned to Beirut, where armed soldiers came on the plane. I picked up Andrew Vicari and some caviar and returned to London.

Gay and I have been to a number of weddings, but none have compared to

the wedding of Tim Coffin, son of John and Anne (Anne has a gallery in New York and has kindly offered me a book launch there). The actual service was over in about seven minutes, but the reception was in a palace in Istanbul on the shores of the Bosphorus. Having danced the night away, we flew down the coast to Bodrum where we proceeded to sail in two gullets, one for the young and the other for the wrinklies. It was absolutely marvellous, and a magic Turkish carpet that we spotted on the trip and was subsequently bought by John Coffin (with my encouragement) is now installed in his home in the States. The weather was hot, so we had to sleep on deck, but everybody was in such a good mood. The only thing in the holiday that wasn't so successful was buying a pair of Church's shoes. We went into a cobbler's in Istanbul and saw some very nice-looking shoes. I explained that I didn't have any socks, at which the cobbler took off his socks. The shoes seemed to fit perfectly until we returned to England. No matter how much I tried, the shoes never fitted again. They must have been magical Turkish socks.

<p style="text-align:center">* * *</p>

At 4.30am, I was collected from the Little Boltons by Andrew Wills in his Jensen 541, to drive to Scotland in search of paintings by the Nasmyth family. I asked Andrew why we had to leave at 4.30, and his typical reply was in order to have breakfast at Scotch Corner. We had a very good breakfast there, and Andrew asked if I would mind if we went into Scotland by the Carter Bar. I replied that he was driving so he should be the one picking the route. I was just catching up on some sleep, when Andrew said very quietly, 'Peter, Peter.' I knew something was amiss from how slowly and calmly he was talking. I opened my eyes to find we were on ice, going straight into a van. We hit it with a smack, and it ruptured the whole of the front of the fibre-glass Jensen. Undaunted by this, Andrew got out and proceeded to remove chunks off the car.

In Perth, Andrew called on a car dealer he knew there. 'Peter, what do you think of this car?' he said, looking at a very large and staid Rolls-Royce. 'Very grand,' I replied. We then did a test drive round the city, with Andrew driving it in his usual sporting fashion, much to the dealer's horror – a horror which was considerably lessened when Andrew decided to buy it. We arrived at Andrew's uncle, Lord Elphinstone, who kept asking why Lord Burton's car was outside.

Andrew didn't admit that he had just bought it until his uncle was so persistent with his enquiries that he had to confess all.

We then proceeded to Edinburgh, gathering pictures all the way. There, we saw a lady with a lovely Patrick Nasmyth with a very broken and awful frame. The arrangement with Andrew was that if we liked the picture, we were to say, 'What a lovely frame.' Much to the amazement of the lady, we both burst out laughing. We still managed to buy it, however.

On the way south, at midnight, we were at the roundabout near Stamford when Andrew said that we were going ahead at 4mph while the gear lever was in reverse. We drove into the local air base, and Andrew asked the person on guard if we could leave the Rolls-Royce there. We were collected by a pick-up truck and put all the paintings into that vehicle and proceeded to my parents' home, where we spent the night. In the morning, I borrowed my mother's Morris Minor and finally arrived back at the gallery after a successful trip in which we had travelled in four cars. Happily, out of it came an exhibition and a book on the Nasmyth family.

I was invited by a very nice friend and client to stay at his place near Dollar in Clackmannanshire, Scotland, and I was looking forward to the trip. The train was an open carriage, where you could see the other travellers, but nobody spoke to each other. We reached the charming town of Berwick-on-Tweed, and I was admiring the Northumbrian coastline, when a German said to me, 'How do I stop the train?' My reply was: 'You pull the communication cord, but it'll cost you £50.' He straightaway pulled it, and, much to my surprise, the train stopped, and the German got off with his two sons and started walking back toward Berwick. This had the immediate effect of everyone in the carriage actually talking to each other. Eventually, a policeman appeared and asked me who had pulled the cord, and I told him that a German had pulled it and got off the train, and eventually we continued our rather slow journey to Scotland. I arrived late for the dinner party, but I explained to Bobby Stewart and his guests why I was held up. They were fascinated – nobody had been on a train where that had happened, so briefly I was the centre of attention. The estate was where the famous Battle of Sheriffmuir was fought in 1715. I later found a contemporary picture of the battle which showed every detail of the soldiers and mounted officers, sawboneses and baggage train. To me, it was very exciting that a picture painted of a scene 250 years ago was now hanging in the house where it all happened.

My trips up north, particularly to Northumberland, were very beneficial, both in enjoyment and profit. On one occasion, I went to see John Stephenson, a delightful solicitor and member of the Northern Counties Club in Newcastle. John took me to lunch in the club, and as we were collecting our lunch from the buffet, he pointed to the picture over the cabbage and said that the club wanted to sell it. It was a very fine painting of the match between Matilda and Marmaduke by J.F. Herring Senior. Happily, I found a new home for the picture: the New York apartment of Sir Gordon White. And it's nowhere near the cabbage anymore.

John rang me up and asked me to go to a house the other side of the Pennines where a Surgeon Captain Thwaites had lived. The house contained 55 pictures which had been valued at £5,000, and the family wanted to get the pictures exempted from Estate Duty (now called Capital Transfer Tax), then at a top rate of 80 percent. As there was no money and only land in the estate, I told John Stephenson it wasn't necessary for me to see the collection (I knew that any half-decent collection of 55 paintings was going to be worth more than £5,000), and I would recommend that they borrowed the money to pay the estate duty. This would mean that any future sales wouldn't be burdened by a 80 percent rate. They insisted I visit the house to see the collection, so John and I drove across the Pennines in snowy conditions. In the dining room were some lovely seascapes, any one being worth a lot more than the valuation. I advised them to sell a large religious painting which was duly put into Christie's and fetched £8,000, which meant that the family retained the collection.

On a visit was to the village of Wylam, which was owned by a member of the Blackett family, John took me to meet the elderly eccentric Mr Blackett. There he sat by a one-bar electric heater, while being surrounded by wonderful books, paintings, silver and other objets d'art, sitting in his gumboots in this council-type house. He asked me if I would like a drink, and the choice was between a whisky and a beer, but looking at the state of the glasses I chose a whisky in the hope that the germs would be sterilised. Most of the things went into a sale in Newcastle, but I was lucky to buy a beautiful picture by John Downman of a member of the Percy family. It was a portrait of a young man in a glorious uniform. The picture was bought subsequently by the Duke of Northumberland, so going back to the family.

Keith Shellenberg was another unusual client, who owned the island of Eigg in Scotland. We went up north to see him, and he lived in a tower-type castle. His first question to me was, 'Have you got a car?' He lent me his racing Ford with a racing clutch, and I literally shot around Scotland. I was in my element. I am not sure whether my wife appreciated this exciting car. Keith certainly moved in eccentric style. My favourite story is when he called at the gallery to buy a picture. He left in his Ferrari for Switzerland with his wife and baggage in an Alfa Romeo behind. Although I am not sure how many pictures he bought, it was always a pleasure to see him, and he always made me smile. I am afraid he did not make the islanders on Eigg smile, as he wanted to develop the island. In the end, they succeeded in buying the island from him and are happily living in peace for every after.

Donald Davis was a successful man. He had a ladies clothing business which was based in a shop in Sloane Street, but the clothes were made in the Republic of Ireland. He bought a superb house called Charleville, next to Powerscourt in the Blue Mountains. For this lovely house, he bought some fine pictures, including an elegant portrait of Edward V, which came from the Watney family. At the time, thanks to Sir Richard Powell, we lent pictures to the Institute of Directors (then in Belgrave Square, in walking distance from the gallery). This was a great arrangement, as the Institute filled its walls, and we gained extra hanging space for free. I asked Donald Davis to lunch, and over a glass of port he said to me: 'Which picture are you expecting me to buy?' I pointed to the one in front of us. He agreed, after a certain amount of haggling, to buy this full-length portrait by Joseph Wright of Derby of two toxophilites, the Munday children, for £7,500.

The picture was collected by our shippers, and Donald rang me up from Ireland and said, 'Where's my picture?' I rang up my insurers and said that this large picture had been lost between London and Ireland. They succeeded in finding the picture, but it had been put on a train in Dublin. As there was no train station near Charleville, I had a very trying dream of this picture going round the map of Ireland with the painting sticking out of the top of a carriage. Next morning, I received a call to say that the picture was indeed on the train, but had not left Dublin station. I instructed that it be taken off the train and put in a van and delivered immediately.

As I felt I had to put in some extra effort, I flew over to Ireland to supervise the hanging. This was not without difficulty, as two Irishmen up ladders and trying to organise the lighting was very much like a French farce. Donald had a sale at Charleville, and the Wright of Derby fetched £75,000. This was reported in the *Daily Telegraph*, but it said that the picture had been bought at Christie's. Donald took the reporter out to lunch and insisted that she correct this detail to say that the picture had been bought from me. Another picture he bought was a very large Dutch painting of a family group. When he bought it, he said: 'Peter, do you know how many times I have been into the gallery to look at the picture?' When I replied that I didn't, he said, 'Fourteen times.' I am glad not every client does that, as I certainly wouldn't achieve my picture a day target if they did.

Donald bought a lovely early house in Suffolk when he decided to move back to England. I went and stayed with him. He had two magnificent horses, both over 17 hands. We went for a ride, and at the health farm Shrublands, his horse shied at some snow, and Donald fell off. With great difficulty, I got him back on board, and we rode back to his home. When we arrived, he said, 'I need a port and brandy,' and I asked him how to make that. He said, 'Half port and half brandy.' He drank it and passed out on the stone floor in the hall. I called Donald's wife, Mary, and we telephoned the doctor, who asked if he had had anything to drink. I said, 'Yes, a port and brandy,' and the doctor said, 'Well, he's drunk.' Happily, Donald lived a long time after this incident, but it is extraordinary how an Englishman goes to Ireland and becomes more Irish than the Irish.

One particular trip to Ireland stands out. It was always a pleasure to see the developer Ossie King, and on this trip to Dublin, he took me round the old Bishop's Palace on St Stephen's Green. To my delight, it had been decorated with paintings by the Swiss-Austrian artist Angelica Kauffmann. Although she was married to a Swedish adventurer who called himself the Count de Horn and then to an artist called Antonio Zucchi, she had a famous affair with Sir Joshua Reynolds. The ceilings and walls of the palace were painted with musical instruments and romantic scenes of *putti*. One of the problems was that the decorations on the ceilings were 18 foot up. Two Irish volunteers held the ladder while I inspected the ceilings. As the ladder swayed so much, I was able (rather reluctantly) to see the condition of the lovely ceiling decorations all over.

It was then my job to find an appropriate restorer to do the work in the palace. I found an ideal man, who gave an estimate which was accepted by Ossic King. Unfortunately, this restorer stayed in a pub and had an argument with the locals and had to be recalled. I then found another restorer who went over to Ireland and started to work on the decorated door panels, but suffered from vertigo and therefore couldn't restore the ceiling paintings. The third restorer went to Dublin and successfully completed the restoration, even painting the seriously damaged parts that had been ruined by water. The overall effect was spectacular, and everybody was delighted, especially the restorer, whom I then sent off to the Maharajah of Patiala to work on his paintings. It looked as if Irish Linen Bank was going to rent the building, but amazingly the government wanted the building for offices. Not only did they pay a higher rent, but they also put in some steel filing cabinets which totally spoilt the lovely rooms in this beautiful building.

One of the earliest trips to see art was to Holland in 1956, to see the exhibition of Rembrandt van Rijn. Paul Robertshaw (a tall army friend) and I went to Amsterdam to see the exhibition, only to find it had been moved to Rotterdam. We bought a very cheap bottle of champagne, which I held out of the train window to cool. This didn't work very well as the bottle exploded when I opened it, and the look on the lady's face when she saw the wet seat was quite something. The exhibition of Rembrandt's work was a major one and was an eye-opener to this master. On the way to Rotterdam, we visited The Hague. It is certainly one of the cleanest cities in the world. We also visited the place my father called 'Shove an Engine' (Scheveningen), which was the word the Germans used to check whether you were English, as we cannot pronounce this correctly.

When we arrived at Rotterdam to see the exhibition, I spent three hours looking, as it was what I would describe as 'exceedingly interesting'. Paul spent the time enjoying the garden in the sunshine. We finished the trip with a cruise round the canals of Rotterdam. The next time I was in the city was to see the Erasmus exhibition.

I had a memorable trip to Amsterdam to see the tercentenary Rembrandt exhibition in 1969. On a Saturday morning, we set off to Heathrow where I bought a ticket for Gay, Juliet, aged four, and myself. It was a very great and important exhibition, where I met a curator from the Statens Museum for Kunst

who had come to collect his Rembrandt drawing to take back to Copenhagen. Over lunch, we got involved in a rather heated discussion: 'Who was the world's greatest draughtsman?' Although we started with about 10 names, it was gradually reduced to four: Rembrandt, Dürer, Holbein and Leonardo. I favoured Leonardo, but the curator insisted that Rembrandt was the finest. The argument had got to a stalemate until my four-year-old daughter said, 'Leonardo da Vinci.' The curator was amazed as we had never said the full name of the Renaissance artist, and I won the battle, even though I had to admit it was the name of our dog.

Another lovely trip was to see the Vermeer exhibition in The Hague in 1996. We went with two very good friends, Anthony and Diana Barbour, and it was perfect from every point of view. We stayed in a hotel in Amsterdam and enjoyed even the train journey between these two cities, especially when Anthony said to me that he wanted to buy for Diana's birthday a lion by William Huggins, as Diana was a Leo. When we were back in London, I found the most lovely drawing by Huggins of a pride of lions. The picture then returned to Cheshire, very close to where Huggins lived (at Chiselton, near Chester).

I always loved visiting Stockholm. My first visit there was for the Equestrian Olympics in 1956, when I had a press pass and was able to go anywhere, even stand next to Prince Philip. The Swedish girls were so pretty, and it was the early days of Viyella, which meant that when it rained, their clothing became transparent! On the trip to Stockholm many years later, I was the English delegate of the Conseil International de la Chasse (CIC). I spoke to the bank in London before I left, to make arrangements in case I wanted to buy a picture; it assured me that I had only to go to a bank in Stockholm, and it would provide the money for purchasing a picture. I went into a modern gallery thinking that they might have an English picture, and to my delight they had a charming Victorian picture of an orchard. I decided to see whether Gay liked it as much as I did. However, when she saw it, she did not seem to admire it. When we went out of the gallery, I asked her why she didn't like the picture, and she said I'd taught her not to show what she thought of a picture, in order that the gallery didn't put up the price. I went back and bought the painting, but when I went to the bank, they wouldn't provide the money to pay for it.

That evening we went to a reception given by Sir John Ure, who was the British Ambassador. Sir John not only went to Uppingham, but lived opposite me

in the Albany. I explained my problem about not being able to pay for the picture. He immediately offered to lend the money from the Embassy's fund. Luckily, the next morning, the bank agreed to pay for the picture. When it arrived back in the gallery in London, the Barclay brothers came in and bought it.

When I met a lovely Italian girl, Maria Nobile, I promised her I would visit her when I went to Italy. I organised a trip to Italy for my parents. We flew to the airport just outside the beautiful city of Venice. The hotel we stayed in was the famous Danieli, which was originally the 14th-century palace of Doge Dandolo's family. It overlooks the lagoon and is very grand. It was a great introduction to the city of canals, which reminded me of the picture of the view of the Turkish Embassy by Canaletto, which I bought for Mrs Prince Littler, and the picture of the Redentore Church on the Grand Canal which we sold to Mr Omar, or the pair of oval *Capriccios* by Francesco Guardi which my father sold to Lord Strathcona. We spent the week looking at churches and works of art. My favourite place was the Ca' d'Oro, which is full of the most beautiful Italian Renaissance art. After a week of eating mostly steak tartare, we went on to the car park to collect the Alfa Romeo I had ordered. Unfortunately, as soon as I started the car, it caught fire, but amazingly a brand new Alfa Romeo arrived, and off we set to magical places like Verona and then to Milan, where we saw the famous Leonardo of *The Last Supper* before it had had yet another restoration.

In the Hotel Principe in Milan, I rang Maria, who agreed to come to the hotel. Unfortunately, there was a misunderstanding, as she was waiting at the Hotel Principe in Turin, while we were waiting in Milan. I bundled my family into the Alfa, and we drove furiously to Turin. When we got to Turin, I got into her Fiat Cinquecento and had to hold a box of chocolates out of the window so my mother could follow in the Alfa. Maria drove at great speed down one-way streets the wrong way. We were whistled at by the police, but it didn't seem to matter. I was asked by Maria to meet her family for lunch, but it was not a success. Only Maria spoke English, and the chair I was given was riddled with woodworm and collapsed under my weight, leaving me trying to apologise to a family of Italians who didn't speak English. Having left the old part of Turin, we headed south, after a glorious visit to Florence. The excitement was my mother's driving, when she managed to change down from fifth gear to first. I have never heard a noise quite like it, except on the Grand Prix circuit. She also managed to

go so close to a man repairing the road that the knife he had on his belt went into his bottom. Her best effort was when she drove across the busy *autostrada* at full speed without having an accident. When we finally arrived in Rome, after seeing lovely cities like Sienna, the new Alfa had 2,000 miles on the clock and was well run-in. The doors wouldn't close, the boot wouldn't open, and the engine sounded like a tractor, but it was a magnificent trip.

When I was in my 20s, I was invited to sail with Dick Howarth in his beautiful yacht *Zillaine*, which was designed by him. We all arrived at the Hamble, but when the RAF gave us the forecast, one of the crew went sick. Unfortunately, the forecast of Force 8 gusting 9 was correct, and after one or two set-backs, we found ourselves in the middle of the Channel, hove to. This was even more worrying when Dick sent me up the sharp end, as my father called it, to learn what colour was port and what colour was starboard so we could tell if ships were approaching or going away. Thanks to my brother-in-law, I was armed with some sailing books. Having survived a very bumpy night when I thought the boat was going to break up, we sailed on into the Bay of Biscay. We had a lovely time at a nightclub, when my old friend Knut Robson was amazed when the same number came up three times at roulette. We entertained the very lovely lion-tamer, who next day came on board. When she wasn't at Saint-Jean-de-Luz, she was at the nightclub Elle et Lui in Paris.

The weather was beautiful, and we sailed on to Santander, where we moored at the yacht club. I insisted that in the heat of the day we visited the caves at Altamira, famous for its prehistoric drawings. When we got there, the caves were all locked up. I found the man with a key, and we had a feast on the most marvellous drawings of bison and hunters. The caves were found by a dog going down a hole after a fox. Sadly, no one is now able to see them, because the damage caused by the condensation of human breath on the drawings. It was something I shall never forget, as certainly Picasso was influenced by them.

After a lunch on whitebait, which was caught by children from the decking of the yacht club, we set sail for England. To our surprise, we were becalmed in the middle of the Bay of Biscay. I was about to dive in for a swim when I saw hundreds of Portuguese Men-o-War. Although their sting is only lethal if you're allergic, it's still best avoided. Instead of swimming, we had an argument as to who was the world's greatest artist. I was supporting Rembrandt (as the greatest

artist, even though Leonardo is still in my mind the greatest draughtsman), but Dick Howarth's daughter, Penny, insisted it was Picasso. The BBC came to my rescue, saying, 'Rembrandt, the world's greatest artist...'.

Much to everybody's amusement, my pyjamas went overboard when I was shaking out my bedding. I held a boat-hook, and Knut tried to steer the boat so I could pick them up. Only when the skipper pointed out that there was a huge tanker bearing down on us did I stop. It was a memorable trip, and got me acquainted with the sea, which was a help on the many sailing trips with friends such as Dick McDougal and Michael Stewart Smith, and particularly with Anthony and Caroline Evans. We visited many European harbours, and although I am a land-loving East Anglian, the experiences were most enjoyable, especially as my wife loves sailing and was able to cook in the toughest of weather, whereas I was only happy on the helm.

One of the most enjoyable things to do is to learn how to fly in a Tiger Moth. It is such fun to be playing Biggles in goggles and a helmet. On a glorious sunny day in 1967, I set out from Marshall's Aerodrome to fly on my first solo cross-country flight in an open-cockpit biplane known as a Tiger Moth. The instructions were to fly to Ely Cathedral, turn right for Newmarket and follow the railway line back to Cambridge. I climbed to 3,000 feet and was enjoying the blissful sunshine, but when I looked down below, all I could see was sea. A view just like an etching by C.R.W. Nevinson (who also went to Uppingham, and according to his diary hated every minute of his five years there). I looked at the map which was held down by my forearm onto my leg in order to stop it being blown away. I then realised that I had missed Ely Cathedral and was out over The Wash. Undaunted by this, I looked to see how much fuel was left. The fuel gauge was a tube like a thermometer up on the top wing. It certainly did not register a lot. As I knew I could land on any decent field, I set course for Newmarket, and was I very glad when the famous heath turned up. Again, I checked the fuel gauge, which did not register anything. As I had no means of contacting Marshall's, I decided to follow the railway line back to Cambridge. When I arrived, they had already sent out a search party for me. On arrival at Rippington Manor, rather late for lunch, my mother said, 'How could you possibly miss Ely Cathedral?', while my wife said, 'Next time, take your passport.'

I went to fill up with fuel at Marshall's Aerodrome, and I said to the

attendant that the engine sounded like a tractor. He said he was sure it was alright. Off I went and did some gentle aerobatics. When I was coming in to land, I realised I was going into a lake at the end of the airfield. Luckily, there wasn't anybody water-skiing at the time, but I didn't think I would be very popular if I sunk the Tiger Moth. I opened the throttle, but nothing happened. I tried again, and just as I thought, 'I will need my swimsuit,' the engine gave a cough and the propeller turned a couple of times, which gave the plane enough lift to get over the hedge into the airfield.

It seems funny to think that 10 years ago you could get to New York quicker than you can nowadays. After looking at some sporting pictures in Herefordshire on behalf of the British Sporting Art Trust, I was thinking on my 3½-hour return journey to London how nice it would be to get to New York in the same time. When I arrived at the gallery, I was amazed to find that Sara had accepted an invitation to lunch from Dyer Jones, a yacht-builder, at the New York Yacht Club on Monday. As there was no other way I could have made it, this gave me an admirable excuse for flying on Concorde. Dyer was married to the grand-daughter of P.A.B. Widener, the 19th-century businessman and prolific collector of Old Masters. The picture they wanted to buy was a lovely James Pollard that had belonged to P.A.B.

The difficulty of catching Concorde at that time was that it was still sufficiently new and exciting for people to be want to be involved in catching (or perhaps missing) the plane with me. A girl decided that she must drive me to Heathrow in her Alfa Romeo. I then had to give her breakfast there (my second) before disappearing into the Concorde lounge at the first opportunity, where I had champagne. I was then escorted onto the beautiful plane that flew faster than sound. Although it was small inside, it was comfortable, especially after caviar, smoked salmon and steak, washed down with Dom Pérignon champagne. It was extraordinary to watch the Mach metre as we travelled and to see the sun rise twice. When I arrived at 10.30, New York time, I had time to call in at the Leash Club at 41, E 63rd Street to leave my bags, as well as view a sale at Sotheby's, before getting to the famous Yacht Club. Dyer Jones was absolutely charming: he showed me round the club, including where the famous trophy for the America Cup usually stood – but having been won by the Australians was down under with Alan Bond.

It was difficult to have a second lunch, but I achieved the object, and the coaching painting was bought by a descendant of P.A.B. Widener. I was then invited to drinks with a client who lived in an apartment in Park Avenue that contained some pictures sold by my grandfather. He insisted I stay for dinner, which was served by an English butler wearing white gloves. My last appointment that day was to meet an artist at the King Cole Bar at the St Regis Hotel at 10pm, New York time. As soon as she sat down, she said she was starving and ordered chump chops. By then I had had two breakfasts, one at home and one in Heathrow, two lunches and nearly had two dinners. Amazingly, thanks to the pressurisation of Concorde at 5,000ft rather than at 9,000 on a normal flight, I was still feeling fine, even though it was 4.30 in the morning, by London time.

The week proceeded most successfully: I sold several pictures, bought some too, and on Friday, I found myself on a cheap TWA flight back to London. We were sitting on the runway at Kennedy Airport because they couldn't close the baggage door. I was sitting next to an art dealer, and we were relaxed until the captain said, 'Gee, folks. I am sorry for the delay, but you are not on the same type of plane that fell out of the sky in South Africa.' My companion had had a friend killed on that flight. After a long eight-hour flight back, guess what! They couldn't open the baggage door, so Gay, who was waiting for me to take me to a shoot at Diddington with Peter Thornhill, was quite cross when I had to cancel. I am not at all sure it would have been safe, and I might have peppered a beater. What a wonderful week, thanks to the start on Concorde. I rang up Richard Green, who owned the Pollard, and told him I had sold the picture, and he said he would give me 5%, but when I explained that I took Concorde specially to sell it, he agreed to pay me 10%.

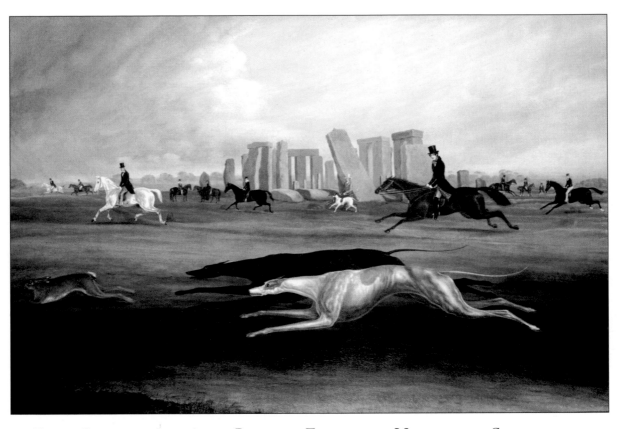

FOUR GENERATIONS OF THE PITCAIRN FAMILY OUT HUNTING AT STONEHENGE
Samuel Spode
British Sporting Art Trust

The Famous and the Infamous

It is the lives we encounter that make life worth living
(Guy de Maupassant)

W E HAVE ALWAYS BEEN LUCKY WITH our high-profile clients. I particularly remember the first visit of Jackie Kennedy, who arrived in a vast Cadillac, asking where she could get away from all the press. I took her down to my office and gave her a cup of tea. She brought a William Huggins drawing of a lion for £120 which was sold in her estate sale in New York for $32,000. I asked the girl at Sotheby's in New York to put a bid on it of £3,000 but might want to go further. I had a call at midnight to say that she could not get hold of me; I was sorry not to get the picture back again, but it was an impressive outcome.

When Jackie Kennedy came in, I said to my secretary, 'Is it who I think it is, or is it her sister?' The sister, Princess Radziwiłł, had on a previous occasion come into my office and seen a picture of leopards which she said she wanted. I had to tell her that it was reserved. Just after she left, the telephone rang, and she said, 'Peter, if I can't have that picture, I am not coming into the gallery again.' One occasion, she came into the gallery wearing a mink hat, mink coat and mink boots. The picture was reserved for Bernard, Duke of Norfolk, who was our best client. We sold pictures for him, he bought pictures from us, and he introduced people to Oscar & Peter Johnson. One of the pictures we sold for him was *The Adoration of the Shepherds*, which was bought by the National Gallery after I had been sent by my father to the Louvre in Paris to identify the picture. Even though I was only 21 at the time, I was confident that the picture was by Louis Le Nain.

My father rang the Director of the National Gallery, Sir Philip Hendy, and asked him if he would be interested in a picture by Louis Le Nain.

On several occasions, we have sold pictures to members of the royal family, and originally Leggatt Brothers held the Royal Warrant. It was a sad occasion when the Royal Warrant Holders Association decided, incorrectly, that we were commission agents. The warrant itself was given to Great Gransden Church by my mother, in memory of my father. But it was a very happy day when Lt. Col. Lord Plunket, the Queen's equerry, asked me to take two pictures round to Buckingham Palace. One was *The Great Shoot at Grimston*; the other, *The Great Shoot at Sandringham*. Her Majesty bought the picture at Sandringham, which included an amazing picnic with all the heads of the European royal families – I particularly remember the Prince of Teck standing in the foreground. I bought this pair of pictures in New York. On a programme on the BBC called *The Royal Heritage*, which was presented by its former Controller Sir Huw Wheldon, it was stated that the picture of Sandringham by Barker had hung in Sandringham since Edward VII's time. I intended to contact the BBC and point out that the Queen had bought the picture, but I failed to do so, and when the programme was shown again, there was this same error. I later went round Sandringham and was disappointed to see the picture was hung in not a very good place, with a large bronze in front of it. Another picture that the Queen bought from me was a painting of the *Royal Yacht Britannia* by Eduardo de Martino. It was said that a giraffe was brought back to London on this yacht – I have a lovely idea it must have had its neck sticking out of the funnel.

Prince Philip has bought pictures too. We had an exhibition of John Gould's bird prints. He came into the gallery with Sir Brian McGrath (his Private Secretary) and bought four of them. He said that I could tell people that he had bought them to encourage other people to buy these lovely prints. The following day, a Mr Crane said he came from Spain to buy the Hoopoe (probably the finest print in the whole series), as he had them on his lawn there. I told him that Prince Philip had bought it. The next day, Sir Brian McGrath called to say that he had received a letter from Mr Crane saying he wanted to buy the Hoopoe. I said how embarrassing it was – I had never dreamt that he would have contacted the Palace. Sir Brian said that Prince Philip had done a deal with Mr Crane whereby he could poach his beloved Hoopoe if he made a donation to the World

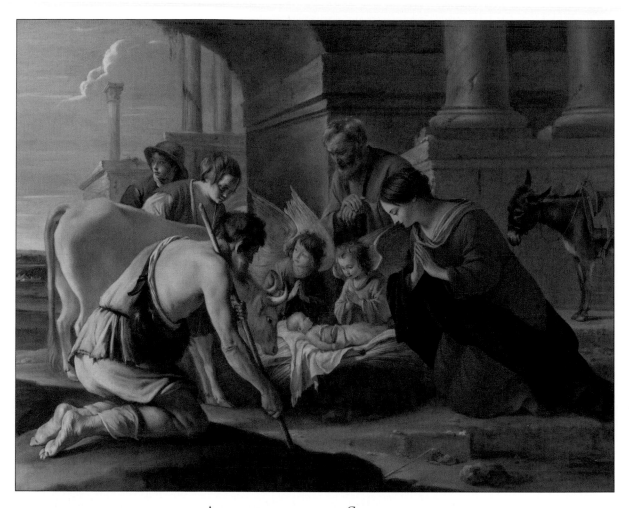

ADORATION OF THE SHEPHERDS
Louis Le Nain
National Gallery, London

Sale to the National Gallery negotiated through Oscar & Peter Johnson

Wildlife Fund. Prince Philip wanted to come in that afternoon to choose another picture by Gould. When he was viewing them all, he said, 'Oh, I do like that Hoopoe', to which Sir Brian said 'Well, it *is* yours!' But Prince Philip said that he had done a deal. It was very pleasing that at the end of all this kerfuffle, everyone ended up happy – Prince Philip got four lovely prints, Mr Crane got his trouble-making Hoopoe, and I managed to sell an extra print.

The Duchess of Alba contacted me as she was interested in the painting by Francis Sartorius entitled *The Earl of Aldborough at Stratford Lodge*. I was excited at the prospect of selling a picture to the famous Alba family. The picture would have joined a collection which includes the Goya of the Duchess of Alba in the nude, entitled *The Nude Maja*. The present duchess was famous for her horses and riding, and there had been a lovely article about her in *Country Life*, with photographs of her on horseback. Unfortunately, her financial advisor advised her against purchasing the picture, and I sold it to America. As soon as I had done so, I had a call from the duchess to say that she would like to buy the painting. Rather like the Boudin which the Queen wanted to buy, this was a major disappointment to me.

The purchase by Tony Blair was just after he took office. I was told that Downing Street was on the telephone, and I was about to say 'Hello, John,' when I remembered that we'd had an election, and 'John' was now 'Tony'. He wanted a map of Denver to take to the G8 conference being held there. After a bit of searching, I found a map of Denver in 1870. I didn't realise that this was the very early days of the city. Anyhow, it was bought by Tony Blair to take to the States.

One of the most charming and suave clients was Paul Mellon, KBE. He would walk from The Berkeley to the gallery in Lowndes Street. I was proud of the fact that whenever he called round, either my father or I was there to greet him, even though there had been no warning that this very important person was visiting. One of my favourite pictures that he bought was a large and very beautiful view of an Indian palace by William Daniell. This was the picture I chose for our Christmas card; what connection it had with the festival I do not know, but it did make a very handsome card. Imagine my pleasure on 4 January, when I returned to work to find a letter from Paul Mellon saying that if the picture by Daniell was for sale, he would like to buy it. It was a very good start to the New Year, and I thought it would pay for all the Christmas cards for many years to come. Unfortunately, my colleagues decided that the expense was too

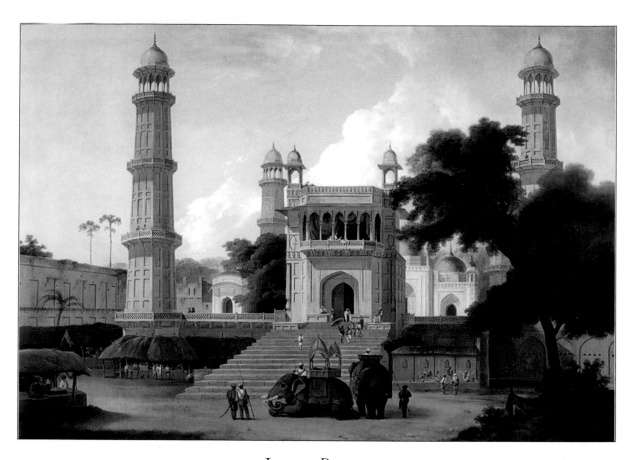

INDIAN PALACE
William Daniell, RA
Yale Center for British Art, New Haven, CT

Sold thanks to a Christmas card to Paul Mellon from the author

great, and we stopped sending them out. Paul Mellon bought many pictures, such as the lovely R.P. Bonington which I collected from the Reford family in Montreal. On the many times we heard and saw this marvellous American gentleman, I can only remember him being cross on one occasion, and that was when we sent him photos of paintings we thought he would like and didn't include the price. I made sure that this didn't happen again. It was always a great pleasure to see him, and whenever he bought a picture, a cheque was on its way soon afterwards.

I read the charming book *Born with a Silver Spoon*, which was about Paul Mellon and written by my friend John Baskett. At the end, I told my wife that I was going to make a Paul Mellon Martini. This consisted of Plymouth gin, vodka and a whisk of Martini. It certainly made a difference to that particular Sunday, as it laid out my mother-in-law, and my wife had difficulty cooking the lunch. There is no question Paul Mellon was one of the most generous sporting gentlemen around (he rode 100 miles across Virginia when he was 80 and won). When he died, his generosity was boundless towards his old college (Clare College, Cambridge), Fitzwilliam Museum and the Royal Veterinary College at Mill Hill, but his real legacy was to point out the beauty of English art. His devotion to George Stubbs and John Constable made the world look at these artists as great *international* painters, and the opening of a special gallery at Yale entitled the Yale Center for British Art was a turning-point for the wonderful paintings which were loved by my grandfather, my father and me.

Robert Wagner, the Hollywood star, who recently wrote his autobiography, and is well-known for the television series *Hart to Hart*, came into the gallery and bought a lovely landscape by F.W. Watts, who is sometimes called the poor man's Constable. When I had another picture by the same artist, I wrote to Robert Wagner. When he came into the gallery in Cadogan Place, he wasn't interested in any of the paintings, but wanted to buy Bandit, our beloved lurcher. Until I read his book, I had no idea he was such a dog-lover.

One of the most exciting occasions was when Lady Hamilton arrived at the gallery, painted by Vigée Le Brun. It took up the whole wall in the special viewing room downstairs for major pictures. It was really beautifully painted, and it proved that the two women obviously got on well together. I have always said that a portrait only works if there is a synergy between sitter and artist, as there was

between Tony Murray Smith and Douglas Anderson (as opposed to Mrs Taubman, whom Douglas painted in New York). At the request of Christopher Ondaatje, I searched for a picture of Lady Hamilton, finding one with Edgar Both. Christopher called into the gallery, and I could see he liked it, but it wasn't until I was at the Countryside Meeting in Hyde Park on a lovely hot June day that I received a call from Christopher who said he wanted to make an offer for it. He asked where I was, and I said I was in the middle of Hyde Park. He asked me what I was doing there, and I explained that it was a rally in support of hunting. He made an offer of £300,000, and I said I was going to buy an ice-cream and then return to the gallery. He said he knew me and that I wouldn't do anything about it. By the end of the day, he had bought the picture from me for slightly more than his initial offer. It is apparently his favourite picture. I have always carried out Christopher's instructions or requests, right from his first one of being introduced to the Charles Saumarez Smith, Director of the National Portrait Gallery. I introduced him to Henry Keswick, who was then Chairman of the Trustees, who in turn had been introduced to me by my old friend Derek Strauss. Christopher gave about £2.75m for Charles Saumarez Smith to make a very successful new entrance to the National Portrait Gallery. Christopher's name is clearly written in stone at the entrance.

Many people have been in the gallery wearing strange and different things. When Henry Wyndham came to see me, it was definitely a first! I said that it was the only time I had seen somebody wearing a fox's brush attached to the back of a jacket. Henry said he would kill his son, who had pinned it there. He said he could not understand why everybody had been staring at him while he walked down Sloane Street. When I went to Sotheby's for one of their excellent parties or to view a sale, I would look behind Henry just to check that he did not have a brush attached this time. This certainly made the tall, elegant auctioneer more approachable.

One of the most colourful people I met was Rex Harrison. I went to a cocktail party given by the artist Andrew Vicari, and there met this successful actor, famous for the part of Professor 'Enery 'Iggins in *My Fair Lady*. He said to me, 'I need some pictures for my new house in Wilton Crescent.' I replied that I had got just the right pictures of the island of Dominica by Augustin Brunais, and he told me he would come round at ten the next morning. I had an exceptionally

pretty secretary at this time, and I told her that Rex Harrison was coming in at 10am, but I bet her £10 he wouldn't turn up. The door opened at 10am, and I started the day a tenner down. We arranged to take these large, beautiful pictures (*View of the Tower of Roseau* and *View of the River of Roseau, on the Island of Dominica*) round to his house. Rex Harrison led the way, followed by me and then our manager, Dennis Mander, holding the front of the pictures and the porter, Fred, on the end. The traffic gave way for us on Motcomb Street, echoing the scene from *My Fair Lady*. Once we got to his house, we held up the pictures against the wall so he could see what they looked like there, and he said he would buy the pair. The next morning, he arrived with a cheque and handed it to the pretty secretary, who was busy swooning. I appeared up the stairs, and he took the cheque off the girl and gave it to me. When I looked at the cheque, I realised that there was a nought missing! When I told him so, he said, 'Never mind. I will send my butler round with another cheque.' Shortly after his visit, the telephone rang, and he asked for the amount in Bermudian dollars. The butler arrived and saw Field Marshal Sir Gerald Templar in the gallery. He marched up to him but received a cold shoulder, even though he had stood for three years on Templar's doorstep as a policeman. A couple of years later I read in the *Evening Standard* that Rex was selling his house. I rang him up and suggested that I would sell the pictures for him. Mrs Heinz who originally wanted the pictures didn't want them, nor did the exotic fashion photographer Norman Parkinson, but happily a book dealer in Jamaica bought them. This pair of lovely pictures came from South Africa; I sold them to a dealer in New York; they came back to London for Mrs Heinz, but Rex Harrison bought them instead; and finally they went to Jamaica.

I had a very charming cousin called John Johnson, a literary agent, who contacted me and said that his client Dick Francis was writing a book and wanted some help over how a painting was made. Dick Francis and his wife, Mary, came round to No. 1, The Little Boltons, where we discussed the novel which he had decided to call *In the Frame*. I told Dick Francis that I would lend him a book called *The Technique of the Great Painters* by Professor A.P. Laurie. The novel was based on a gallery in New South Wales which Dick called Yarra River Fine Arts. I did point out there was a gallery in Australia already called that, but he went ahead anyway. His description of the gallery was based on our one in Lowndes Street, and he gave me an acknowledgement in the front. This was

noticed by my cousins in South Africa, who rang my sister, who was cross that I hadn't told her. I had a number of happy meetings with this wonderful jockey turned successful writer. We had a lovely dinner in Fort Lauderdale, where he surprised me by asking if I thought Coopers & Lybrand's charge of £100,000 for his accounts was a lot! I couldn't believe it, but the discussion was mainly about another planned book about smuggling paintings. I really liked this charming man who always had a twinkle in his eye and wrote delightful letters, such as the one he wrote to me when he had his leg cut off.

The biggest client we had in the 1950s was Sir Harry Ferguson of the famous Ferguson tractor and the first four-wheel drive car. He lived in Stow-on-the-Wold in a Lutyens house with a Gertrude Jekyll garden called Abbotswood. The first picture I remember him buying was a full-length Lawrence, but it was *The Opening of Waterloo Bridge* by John Constable that was the big purchase for £120,000 (subsequently sold to the Tate for millions). The delivery of this picture nearly cost us this valuable client. Sir Harry rang up my father in a fury. He said our van had run into his gate-post, and he was not pleased. My father called me into his office and asked me what had happened. I told him I knew nothing of the incident but would look into it. I asked Taylor, our picture hanger, if he knew anything about Sir Harry's gate-post. He asked the driver (who used to drive our van around Hyde Park Corner at full speed), who denied all knowledge. As this delivery was an area of my responsibility, I looked into the matter further and found out that the milk float had run into the important gate-post as there had been a frost early that morning. My father reported this fact to Sir Harry, all was forgiven, and we carried on selling him pictures.

One particularly interesting client was a Christian Scientist called Captain Prentice. He was a very regular visitor to the gallery, and he loved seascapes. Every time he bought a picture, he always said to me that I must become a member of the Hurlingham Club. I always said 'Next time,' but I eventually decided that I would become a member and have blessed him ever since. On one occasion, Captain Prentice walked into the window and damaged his nose. I said to him 'Did you want me to call a doctor?', forgetting that he was a Christian Scientist. All he asked for was a plaster. On one visit, he fell for a lovely, lively seascape by Charles Brooking. It was priced at £8,500, and I sent him an account. Next morning, I decided to check the account, and to my horror it was made out

for £850. I rang Captain Prentice immediately, and he said he was just writing out the cheque. My heart sank, but he said, 'I saw your mistake, and I am sending you £8,500.' What a nice man.

The door of the gallery opened, and in walked a gentleman who immediately fell for a rather dark picture by a lesser-known member of the Crome family, W.H. Crome. The picture was mostly painted in dark brown, but – like all the Norwich School – there were bits of light. The man decided to buy the picture, which I told him was £850, and he sat down at the desk upstairs and was busy writing out a cheque, when the solid oak door opened again and a man walked straight to the W.H. Crome and said, 'What a marvellous picture, how much is it?' I told him it was £850, and he said, 'Eight and a half thousand? Cheap at the price.' To which I replied that there was a gentleman already writing out a cheque for the painting. He turned on his heels and went out the door, and I said to the man writing out the cheque that he must think I employ people like that, and we both laughed.

A very good client was Sir Gordon White (later Lord White), who was known by everyone as the White Knight. He spent thousands of pounds at sales each week. He would telephone from New York, where he was based, and go through all the catalogue; this involved me then in a lot of bidding and travel. On one occasion, he rang me from his office in London and asked if I would go to Grosvenor House Antiques Fair with him. He collected me in his chauffeur-driven Bentley Mulsanne, but when we got to Park Lane, he saw there was a queue. He said, 'I am not going to queue. Let's have a bottle of champagne.' After we finished the bottle, we went on a buying spree; Gordon bought objects from most stands, while I had to pick up the tab! It was most enjoyable. Another occasion, he came into the gallery with one of Charlie's Angels, Cheryl Ladd. He introduced me as the most eligible bachelor in London. He was a very charismatic person whom it was such a pleasure to call my friend and client. On one occasion, he said: 'You have done it this time. I have 140 pictures, and there is no more space.' I immediately rushed round to his house in Tite Street (originally the studio of John Singer Sargent) and rehung the paintings to make more space.

Whereas our normal profit on pictures was variable, depending on the purchase price and the importance of the work, when I purchased a picture for

him, we charged him a flat 10% commission. This only made sense because he was buying so many pictures, and if we reinvested the money into purchasing stock to be sold to other clients. On a particular day, Gordon came into the gallery and asked me to reduce my commission; I told him I could only manage my efforts on 10%. I had just been to Brussels on his behalf and bid for a picture. I missed the last plane back to London and had a bad dinner and spent an uncomfortable night near Boulevard de Waterloo. He asked if I wouldn't reduce my commission by just a bit, as another dealer had offered to do what I was doing for nothing. I spent the night thinking I should have reduced my charge, but next morning, he rang and just said, 'Carry on.' Although he was a member of the SBS and always seemed very fit, he was taken to India by his new wife and contracted a lung infection. I will never forget his last words to me the night before he took the fatal flight to California. He just said, 'Peter, take care.' Usually, he took Concorde to New York – he was a director of British Airways; if he had this time, he might be still with us. Instead of three and a half hours to New York, it was nine hours to California, and halfway into the flight, he succumbed to the illness. He had a lot going for him: tall, attractive and amusing. He certainly enlivened the gallery greatly.

Guinness is good for you, but not if you are Gerald Ronson or Jack Lyons. Not being well versed in city matters, it wasn't clear to me what they had done wrong. Jack Lyons is the one I knew well, and he lived in great style, with a large double-fronted house and garden in Kensington. He bought a number of pictures from me, including the best view of Venice by William James that I have ever seen. William James is one of those art mysteries: we apparently know when he painted but not when he was born or died. Sir Jack was his name when I knew him, and he was well in with a considerable number of people, including the Queen Mother. He offered me a wonderful set of views of Windsor Castle by William Daniell, and I included them in an exhibition. They were truly beautiful water-colours, and I was very proud to have had them in the gallery. It was sad that a rich man should decide to put his life in jeopardy by being involved in some insider dealing in the Guinness shares. Gerald Ronson had less to lose as he didn't have a title and wasn't known except for his involvement in oil and petrol pumps. I went to visit him in his house near the Spaniards Inn on Hampstead Heath. Everything was a bit clean and smart for me, but I can't

complain, given that he bought the picture I had taken to show him.

I went to visit Ambrose Congreve with Kenneth Webb, head of our insurance brokers Byas Mosley. I met Kenneth at the sentry post outside St James's, and we continued to Warwick House, which previously belonged to Lord Rothermere. Ambrose Congreve had entirely refurbished the interior in the most lavish fashion, with the addition of paintings by Patinir, Romney and Reynolds. As soon as he saw the picture of his ancestor that we'd brought for him to view, he took an immediate dislike, saying that the figures were disproportionately large to the size of the panel. He continued by saying that he was an eccentric millionaire who, having bought pictures for 50 years, was not going to buy one he did not like. He asked me to excuse his eccentricity and then gave Kenneth and me a glass of wine and a cup of coffee, completely ignoring 50 other guests sitting round the dining table. After a delightful conversation, he asked if I would like to the see the drawing room upstairs, which proved to be even more lavish than downstairs. He said that he was involved in a contract for £300 million at the time which he was hoping to sign, and then asked his manager to show his guests out for him! Bravo for Anglo-Irish millionaires!

Lord Adam Gordon was the equerry of the Queen Mother at the time when we had a charming view of St James's Palace in the gallery. It was painted by Hendrick Danckerts in about 1660. When I received a call from him to say that the Queen Mother would like to see the picture at St James's Palace, I was delighted to visit her there – even though I had met her before, it was very special to be able to talk to her at length. We walked around the garden until we found the spot where Danckerts had set up his easel to paint the picture. The Queen Mother said, 'Not much has changed since the picture was painted,' and then she said, in her charming manner, 'Oh yes there has; they have moved the drainpipes.' It is now Christmas 2009, and I was interested to see that the picture is back on the market, although it might well be another version of the same subject. I will have to check that it has one of our small rectangular stickers on the stretcher. It is amusing to think that when the gallery was started, we used the first of these little labels. We discussed what letter should be used in front of the number. At the time, we did not want everyone, including the art trade, to know it was one of our pictures. That ruled out the letters 'O', 'P' or 'J', so we used 'M', which was my mother's name of Marjorie. When I left the gallery on 8th October

2009, we had reached 9,500, but then, of course, there were the pictures handled by us on behalf of clients. That was a similar figure. On that basis, we had been selling 380 pictures a year, well exceeding my sale plan of a picture a day. Let's hope it continues that way. I do not mind if it is the sale of a picture for £10, £100, or £10,000. It means that things were happening and that things were actively active and hopefully making a profit.

One of the nicest clients lived in New York and loved the paintings of John Glover, the English artist who went to Australia and became one of the first Australian artists. He asked me to find some pictures by this wonderful landscape painter. It was an exciting but sad story. James Wilkerson bought four pictures by John Glover from me. Unfortunately, his daughter got mixed up with the notorious radical underground group called the Weathermen. It was tragic when she blew up her father's house in New York in 1970, when trying to make bombs. It was a major news item, and nobody knew at the time what had happened to this client's daughter, Cathlyn — it was thought that she had been blown up in the house with some of the others. Happily, she survived, going on the run for 10 years, but the pictures by John Glover were destroyed.

Of all the people I wish were still with us, the Honourable Cecil Law was definitely one of them. He had enormous charm, and when he asked me if I would be godfather to his son, I was very honoured but pointed out that I already had seven godchildren. I was not allowed to say 'No.' Not only did Cecil buy some really lovely pictures by, especially, James Stark, the lovely Norwich landscape artist, but also by Dominic Serres, who was captured by the English Navy and became one of our best marine artists. As the Law family had a naval tradition, he was interested in Serres, who was made painter to George II. Not only did we have a lovely invitation every year to Royal Ascot, but when one year I had forgotten to apply in time, this was made up for by an invitation to polo at Windsor. On that occasion, Prince Charles came up to me and thanked me for sponsoring the event, which was embarrassing, as standing behind me was Cecil, whose company, Towry Law, had footed the bill. It was even more embarrassing when it appeared in the paper, and I had to explain to the extremely impressed girl at Christie's that it was all a mistake.

Cecil Law loved his racing, and I remember on one occasion we were sitting having a lovely picnic and drinking champagne in the pouring rain. Cecil provided

umbrellas, but unfortunately I was at the confluence of two of them, and my morning suit was soaked. Nevertheless, we all enjoyed it and were entertained by German television, calling the film 'Mad English enjoying themselves in the rain'. I am very pleased to say that Cecil's son Edward and his wife, Lucy, are continuing the tradition, and his widow, Jean, bought some miniatures of the Law ancestors that appeared at Cheffins Auction Room in Cambridge.

One of the wildest clients was John Aspinall. Apart from the nightclubs, he also owned a zoo which was always in the news. There were impressive photos of him hugging a lion but, on a more serious note, his keepers at the zoo were occasionally attacked. He loved buying the pictures by William Huggins, mostly of lions, and it was always a pleasure to sell him these lovely pictures, as he really appreciated them. On one occasion, he rang up and said that if I went round with the Huggins pictures he had bought, he would open a bottle of champagne. Rather like Rex Harrison and the Heseltines, he lived in Wilton Crescent, so I tucked the pictures under my arm and walked via Motcomb Street to his house. Much to my delight, out of the fridge he produced a bottle of vintage Krug, the best champagne of all. You can imagine my pleasure, sitting in John Aspinall's house with a glass of that glorious nectar. We finished the bottle, and he gave me a cheque. What a lovely finish to the day.

One of the most extraordinary clients was an Iranian who claimed to be related to the Shah. His name was Almid Sadagliani, and he lived in great style in Grosvenor Square. He always owed us money, but when he thought I was getting cross, he would produce a tin of caviar or, on one occasion, two. He asked my wife and me to go to dinner with him at Annabel's. When we arrived, he asked the doorman how much he owed. 'Eight thousand pounds' was the reply. Nevertheless we had an excellent dinner and drank vintage pink champagne. I was hoping for a cheque, but at 2am, I decided it was time to go home. A couple of days later, he rang me and said if I went round to Grosvenor Square, we would open a bottle of champagne and he would give me the money. When I arrived, I found there was another man there. Almid said, 'I expect you are wondering why you two are the first people to be paid'. He pointed out that we had not written letters or asked for money and therefore were to be paid first. The other person was his cigar merchant, and he handed out a large amount of cash to him and, after a delay whilst we had a glass of champagne, he paid me.

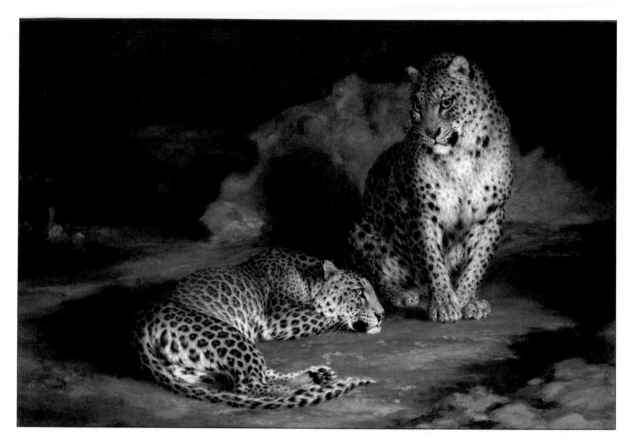

Leopards
William Huggins
Private Collection

Although he was a strange man, I couldn't help liking him, especially when he threw a party. He asked us to dinner at his flat and said to bring a couple of friends. There in the middle of the table was the biggest bowl of caviar I have ever seen. But it was his cavalier attitude you couldn't help admiring. He once drove down Park Lane after a bout of heavy drinking and was running out of petrol. In the petrol station was a police car. He ran straight into the back of it. When the policeman said he would have to go round to Savile Row police station, Almid took the policeman round to the boot of the car and showed the policeman some gold bars. I don't know what happened then!

The Fairer Sex

To make a speech was like trying to climb a wall that was leaning towards you,
or trying to kiss a girl who was leaning away from you
(Sir Winston Churchill)

I WAS INTRODUCED TO A CHARMING South American girl by the Crombies (Ted and Elsie). She came from Bogota and was the daughter of a banker. Estella Carrera was rich, beautiful and great fun, except she never kept to a time. When I went to the Ritz to collect her for the first night of a musical called *The Boyfriend*, the porters would laugh, and we would arrive at the interval. I invited her down to Rippington Manor for Christmas, which would have been fine except that it snowed heavily, and the television announced that you shouldn't venture out. My father said that he, for one, wasn't going to go to this very special party given by Mrs Duberly of 150 people including Prince Galitzine. Estella said she was game, and Mother was her usual determined self. Estella put on her stunning Balenciaga dress, and we got into the Land Rover that usually pulled the horse box. We only just made it out of the village, as the snow was several feet deep, but arrived at Great Staughton to find the 50 people who had made it – dressed in ski clothes and boots. Estella was a star, and the prince took a shine to her. The next day, Estella said she would like to go riding. She appeared in a beautiful Balenciaga riding outfit, totally inappropriate for this weather. At the time, we had two horses in the stable: Highly Inflammable, and my point-to-pointer, Spanish Dew. I decided she would be better on my grey Spaniard, and she certainly looked a picture. The fact she nearly froze to the horse was another matter.

My mother was very concerned about her jewel box containing emeralds

which she had left open in her room. After three days of cold, Estella announced she would have to return to the Ritz. My mother was very upset that she didn't receive a thank you letter from her for staying the weekend, until a small box arrived with a ring of a small white and black pearls and a thank-you card.

I decided that she was too expensive for me, and introduced her to Christopher Bibby who, apart from being an art dealer, was part of the Bibby cattle food family. He said to me he would like to buy Estella a Stubbs painting. I was busy looking for an appropriate picture which would have cost somewhere in the region of £25,000 in those days. When I told Christopher I thought I had found a picture, he said it was too expensive and he had decided to give her a book on Stubbs instead. On one occasion, I asked Estella if I could give her a watch; she said that would be the worst thing I could do to her.

The lady from Lavenham was an astonishing visit. This charming small town in Suffolk with a pretty church and lovely square was all built up on the profits from wool in the Middle Ages. I was asked to go and see this elderly lady who had a collection of Smythes. When I arrived, I was asked if I would like a drink, and I accepted in order to buy thinking time, little realising that she would get out a bottle from a chest and fill a large tumbler with neat Martini. This was the opposite of Nina Butterworth, an artist of horses who lived in Sloane Street and gave me a glass of gin with a tiny bit of tonic on top. Still, Ninetta was a woman who, when working in a stable in the Channel Islands under Nazi occupation, threw muck at the soldiers as they marched by. But to go back to Lavenham, as I sipped my Martini, this lady said she was an opera singer and wanted to get back on the stage. She knew that my cousin was Celia Johnson and therefore could arrange for her to make a come-back. There I was, sitting with an undrinkable glass of neat Martini, and listening to this singer sitting at a piano, wanting to buy all these Smythes. When she hit the keys of the piano her singing sounded more like the rasping croaks of a hoarse female corncrake, I was not sure whether to scream or burst out laughing. Luckily I didn't do either, just put the pictures in the car and drove away FAST from Lavenham. I still own one of those pictures of a horse and greyhound by E.R. Smythe.

Next door to No. 30, St James's Street was a small office and library of a famous New York gallery called Knoedler's. In that office was the most delightful French girl. I kept admiring her, but it was sometime before I met her and it wasn't

MYLENE DEMONGEOT
Stephen Ward
Author's Collection

until the gallery moved to Cadogan Place that I got to really know her. First we went to a restaurant called Andrea's, where a fellow diner annoyingly had a radio on. When the manager remonstrated with him saying 'We don't allow radios', the man replied 'President Kennedy has been shot.' She decided to buy a lovely early view of the Thames from me, and delivering it involved visiting her flat.

A particularly enjoyable meeting was with a girl introduced to me by a Yorkshire friend. At dinner she put her leg against mine; this certainly had the desired effect, and we met several times for a drink at the Carlton Towers. One day, I was having lunch at the gallery, when this girl rang up, insisting that we meet. I agreed to see her at 12pm for a drink. I asked her if she would like to go to the Olympia art fair, and we got in a taxi. When we arrived, we went up the stairs, but half-way up the stairs there was a simultaneous kissing. When we arrived in the actual fair, she removed her lipstick from my face, and we proceeded to walk round the stands, rather self-consciously. We agreed to meet the following week and had an excellent half-lobster at Drones, sitting at the next table to Bill Shand Kydd before he had that dreadful accident. When we left the restaurant, she insisted that we went to bed. Instead, disappointingly, we had to go the Chelsea Physic Garden, where I was a guide.

I was very lucky in having many beautiful girlfriends and enjoying them all. In fact, my only mistake was managing to lose two in fell swoop. At the end of 1963, I asked a girl to go to the Honorary Artillery Company Dance in January with me. When I got to New York, I sent a postcard to another girl, asking her if she would go to the dance at Armoury House with me. I then returned to London and, forgetting that I had already asked two girls, asked a third one along. When I found out I was taking three girls to the same dance, I had to enlist the support of two friends for a very amusing but slightly disastrous evening.

Living in the Albany, as I was then, was very fascinating, and there were many authors, artists and playwrights. The actor Terence Stamp lived opposite, and the socialite writer Fleur Cowles was nearby. In my block, there was a man from the Foreign Office, and Edward Heath was close by too.

I put all the girls and fascinating entertainment behind me on 3 July 1965 when I happily arranged to meet a beautiful blonde at the altar – the day that the wonderful Gay Lindsay became my wife and an integral part of my life.

Esther Rantzen was a well-known radio presenter, and I was delighted to be

BLACK STOCKINGS
Ken Howard, OBE, RA

In Oscar & Peter Johnson 'Ken Howard' exhibition

interviewed by her. There had been a burglary at Russborough, the Beits' house in Ireland, and I was asked what I thought about it. A girl called Rose Dugdale had been behind the stealing of the pictures from the house that famously has the longest façade in Europe. It was an IRA job, and without total conviction, I said the pictures would be recovered; to my amazement, so they were. I found myself in the recording studio behind a large octagonal microphone. I had to peep round the corner to look at Esther Rantzen's famous teeth, which later on she had corrected. One subject that cropped up was the question of restoration. At that time, people thought it would be a lot cheaper to have pictures cleaned in the country. Unfortunately, most of the so-called restorers were what my father called destroyers, usually artists who thought they could handle solvents and restoration. It was also an idea at the time that you could clean a picture with half a potato. I told Esther Rantzen that this made an awful mess, as there was enough acid in a potato to remove some of the old varnish, but you then had to get a professional restorer to repair the damage. In the old days, the man who painted and varnished the coach would do the pictures at the same time. This was fine, because it was at least a protective layer. A little knowledge is a very dangerous thing...

I enjoyed the interview, but it was even more interesting to live opposite the Beits. Lady 'Call me Clementine' Beit was a Mitford and had two lovely dogs and a Spanish butler. The butler looked after our keys, but when the alarm at No. 1, The Little Boltons went off, the police referred to the Beits as our key-holders. This meant the arrival of Lady Beit, when I was still in my pyjamas, to ask why I had given their name as key-holders. However, after a bit of explaining, the butler just kept the keys for us, as he did for most of the street at the time.

Similarly redoubtable was Myra, Lady Fox, who was renowned for being an incredible person. She would think of it as nothing to drive down from Croxton Park, her home in Cambridgeshire, to London for a drinks party before driving back. Similarly, she would fly off to America, India, Paris, or anywhere you care to mention. She was, without question, the most exuberant person of her (Edwardian) generation that I had ever met. She wore large hats, and everything was prefaced with 'My dear.' Once when Gay had managed to persuade me to take a holiday in a let cottage by a beach in Devon, I was surprised to hear the payphone ring and to hear Lady Fox on the other end: 'Peter, you must return to London at once.' I immediately imagined the logistical problems of getting back to London now that

GAY AND PETER IN ROSE FOYLE'S ROSE GARDEN

I was firmly ensconced in Devon. She said, 'My dear, I've got an Indian man who desperately wants advice on his paintings, and I know you are the person to look after him.' I said, 'Certainly, Myra,' and was on the train the next morning.

I had an extremely attractive secretary at the time who, when the Maharajah of Patiala (this 'Indian man') walked in the door, nearly fell off her chair. Although he was not tall, he was very handsome and sported a turquoise turban with a large jewel set in it. I did manage to find a restorer for him. He suggested I come out to India to look at the pictures there; unfortunately, I could not take him up on the suggestion, especially as the restorer got to meet Mrs Gandhi. After the restorer finished working on all the pictures in Patiala, he worked for many other maharajahs. (At that time, Indians could not send pictures to London, even for restoration, as they might be accused of illegally exporting capital.) Although I made a commission on the initial job, he did far better than I did out of the arrangement, but I am glad nonetheless as he was a very competent restorer. I am sure he coped very well with all the problems to pictures posed by the Indian climate.

The most beautiful client we had was Sarah Mason, whom I always considered to be the vision of Helen of Troy. Whether she would have launched a thousand ships is another matter. She had the most perfect face with high cheekbones, rather like Henrietta Tiarks, who later became the Duchess of Bedford. I sold several pictures for Sarah's trust. In order to do this, I had to go to a vault in a Glasgow bank. I only wish Sarah had come with me. She was married first to a fighter pilot, the Hon. Keith 'Jimmy' Mason, who was the son of a very distinguished client, Lord Blackford, who bought a lovely early view of Whitehall from me. Sarah Mason, behind the beautiful face, was tough, but I saw her walking round Hurlingham looking very sad. It was tragic when her son, who had given up drugs, later went out one night and fatally mixed drink and drugs.

The person I thought I was in love with was a girl who worked for me. At the time, my partner said 'Go on, marry her'. I remember my reply, which was 'She's too tall for me'. The fact was, Annabel Greene was too intelligent and too artistic. She married a charming chap called Charlie Gooch, and my father and I gave them a pair of Thomas Smythes as a wedding present. Some years later, I sold this pair of pictures for £2,500. My daughter was named Annabel after her. It was her picture by Louis-Léopold Boilly that I sold to the Musée Lambinet in Versailles.

CHAPTER FIVE

Wine and Dine

———— PJ ————

Ask not what you can do for your country. Ask what's for lunch
(Orson Welles)

W<small>E HAVE HAD MANY RECEPTIONS AND</small> parties at the gallery, but none will compare for amusement with the party for my namesakes in 10th April 1990. It arose because of a particular weekend which started at Worboys, our local garage at Gamlingay. Mr Worboys said to me, 'Are you all right, sir?' I replied I was fine. He said he had heard on the local news that I had flown into high-tension wires near Bedford and was in Addenbrooke's Hospital. On the Saturday, another Peter Johnson was in a motorbike scramble and came third, and yet another was playing football. The final straw was an article in a paper using the name as a pseudonym. My mother's approach was that I should use my second name, which is Alec, after my uncle who was killed in World War I as a young captain and was awarded the MC. I approached the matter differently and decided to have a party for my namesakes.

It started off with the half-dozen people I knew with the name Peter Johnson and grew and grew, until I found we had 30 Peter Johnsons and their wives. The press became interested, and the *Sunday Times* actually printed a copy of the invitation, while ITN wanted to interview some of the Peter Johnsons for the TV news. Christopher Rainbow asked me to get half a dozen to arrive early so he could interview them and have an item about the whole party idea on the 5.45pm News. It worked extremely well, even to the extent that Peter Johnson, a famous wildlife artist from Rhodesia opened the door and asking if it was the

Peter Johnson party. Everybody drank lots of champagne, and Sir Peter Johnson, who was in charge of the ruling body for international sailing, tried to make a speech to thank me for the party. He began by saying he would like to thank Peter Johnson, to which my mother said: 'Which one?!'

It was a remarkable cross-section of the community. My wife suggested that as we all had the same name, we should have badges showing what we did. Katrina Beckett, at the gallery, did some lovely illustrations. The brigadier had a tank, the butcher had a straw boater, etc.; it all added to the fun. Everybody enjoyed themselves, even though some thought there was some strange ulterior motive. After a lot of champagne, they exchanged cards, and one of them said to me that he had received a cheque that was meant for me. I said to him, 'What did you do with it?' He worked on the *Sunday Times* and wrote on antiques. The wives were even more mystified, as they potentially had 29 other husbands. Although it was an eccentric party, it caused a lot of amusement, and it was meant to be a yearly event. In fact, one guest came from New York, and he said he would have a similar party there. Party-planners who learnt of this party wanted to copy the idea for their clients, and it was certainly good publicity for the gallery.

It's amazing how many people had turned up from such a small beginning. It reminded me of back in the 1960s when I had invited people to a party at my flat in the Albany. I wrote out the invitations for this champagne cocktail party and went down the Rope Walk to post them. This was in the morning on my way to work in Knightsbridge. Imagine my surprise when I returned to find that they had not just taken the invitations but also the letter box. Richard Berens thought this was very funny and wrote a piece on William Hickey in the *Daily Express*, commenting 'I wonder if Peter's friends received their invitations.' He also wrote a piece about a baby in the Albany, because this breaking the terms of the lease.

On a visit to Sheffield, I found that I needed some information about a Yorkshire man, and I decided the easy way was to visit the offices of the *Sheffield Telegraph*. Nowadays, you would probably do the research on the Web. When I arrived at the newspaper, I gave my name, and I was asked to wait a minute. I explained that I'd only wanted to ask a question. A very smartly dressed man appeared, and I was ushered into an office. I explained again that I only wanted some information, and he asked me if I were Peter Johnson. I assured him that I

was, and he went off to get me a cup of coffee. I was completely dumbfounded with this red-carpet treatment. The person then asked me, 'Are you really the owner of Sheffield Wednesday?' I explained I lived in the south and was not a football fan. It turned out that this Peter Johnson was in the *Times* 'Rich List', and was an important local figure. With a name like PJ, there is no limit to what one might own or do.

An exciting sale was to the Musée Lambinet in Versailles, France. A great friend asked me to sell for her a picture that her grandfather had bought in Paris many years ago. The picture was by that unique artist Boilly, who painted in a delightful French manner in great detail. This picture was of the special box they had for the poor at the opera in the Paris of the *ancien régime*; it was the companion and pair to the picture in Musée Lambinet of the fashionable box, with all the rich and well-dressed. After a fairly lengthy transaction, the picture was bought by the museum. They invited the previous owner of the picture Annabel Gooch and her husband, Charlie, to a reception to celebrate the purchase. It was a hot, sunny day when we started to listen to the French Minister of Culture and various local dignitaries. The champagne was already poured out and getting warm, whilst the cake was getting stale, and there was no sign of the end of the speeches, which were all in French. So the four of us decided to *filer à l'anglaise* and have dinner at the Trianon Palace Versailles, the hotel where Clemenceau set out the terms of the peace treaty for the end of World War I.

It is funny the particular occasions that one remembers. The most splendid was the Queen Mother's 90th birthday. The British Sporting Art Trust was offered a coach and horses by Norwich Union, thanks to Lord Townshend, and the trustees all dressed up in 19th-century costumes. I wore an outfit straight out of Dickens. It was interesting to find that I was in the parade on the basis of four different charities I was involved with at the time, one being the South Kensington FSU (Family Service Unit) and another as a guide to Chelsea Physic Garden. But there I was in this wonderful parade on top of a coach. It was splendid. In fact, the support of people like the Queen Mother has made a lot of difference to my life. Sir Nicholas Assheton, the Queen Mother's Comptroller, always wrote to acknowledge catalogues I sent to the Queen Mother, and her funeral in Westminster Abbey was a sad but tremendous occasion. I was between two friends: Sir Anthony Evans and another Welshman,

so the music, being Welsh hymns, was perfect for them, and was especially chosen by the Queen Mother. I still enjoy looking at the service sheet and card. The 100th anniversary was also very grand, and this time they remembered to situate Her Majesty so that she wasn't looking into the sun, which happened at her 90th birthday.

I have always found that the pleasure of having a civilised lunch has been a significant factor in carrying out business. The relaxed atmosphere means that you can discuss the pictures and where they belong. I find it very worthwhile having lunch meetings with Edgar Both — an art dealer and friend — when we tended to celebrate before we had made the sale. Nevertheless, over the years there have been some important sales, such as the beautiful view of Chatsworth by Peter Tillemans which was sold by Robin Start to his friend, a prince.

It was at a New Year's Eve dinner that I managed to find a home for the Ackermann Meissen vase. Although I hadn't purchased it, I found it came into my care when I took over Ackermann's. The founder of the company, Rudolph Ackermann was a most interesting person who made a waterproof coat long before Macintosh. He also devised the water-colour paintbox. His connections covered a wide field, including raising £100,000 for the refugees from the Battle of Leipzig in 1813. The King of Saxony gave Rudolph Ackermann a large Meissen vase to show his appreciation of raising this large sum. I decided I needed to find the right home for it; on the spur of the moment, my wife and I decided to give a small dinner party. I rang up Robert and Angela Rhodes James, who lived down the road in Great Gransden, and Simon and Fionnuala Jervis who was the director of the Fitzwilliam Museum. Gay produced the most excellent lobster dinner, and I was able to provide some very good vintage champagne. The Elizabethan house looked lovely, and it was a most enjoyable evening, especially as Simon Jervis made a New Year's resolution, which was fulfilled in March when the vase was delivered to the Fitzwilliam. Much later on, I read about the man who had tripped down the stairs at the museum and broken a Meissen vase. I was very pleased to hear from Dr Duncan Robinson that it was not the vase I sold the museum. At least I can say that of all the New Year's resolutions one makes, at least this one came off.

I particularly enjoyed going down to Birch Grove to have lunch with Harold 'never had it so good' Macmillan, the former Prime Minister. I would be going

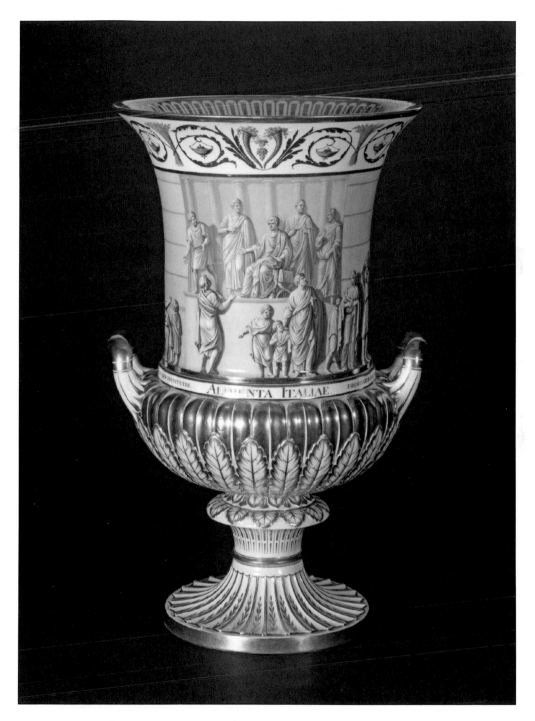

THE ACKERMANN VASE
Meissen
The Fitzwilliam Museum, Cambridge

Bought from the author by the Fitzwilliam

there to bring him pictures he had bought or was considering buying. The first time I went there, I was worried at lunch that the conversation seemed rather like that in a television interview, but luckily he relaxed and the conversation turned more general and to art in particular. I remember he particularly admired William Orpen. He talked about the 1961 purchase in Paris for £400,000 of two ugly Renoirs of dancing girls by the National Gallery. He said how he had asked the director whether he considered them vitally important for the nation. We then discussed at length the absurd situation that it was impossible for directors of public galleries to buy good pictures which were unfashionable before such paintings became more sought-after and hence more expensive.

When I next went down there, some five months later, bringing down the clock that I had got mended, the conversation ranged similarly widely across art and politics. At a lunch of ham, chicken, baked potato and salad, we drank another of the bottles that he had been given for his 85th birthday, this one a horrible bottle of Liebfraumilch from Herr Adenauer. He showed me a button on the leg of the table, and I thought he said that if he pressed it, his man would come; it was only from his subsequent comments that I realised that it was a panic button in the event of an attack. He had been warned by the police that he was a potential target, and given the recent assassination of Mountbatten, he was obviously rather perturbed. I had to admit to him that I had pressed this button, thinking it was just one to call his man. I was told that all 14 roads leading to the house would have been sealed off, and the police would surround the house in force. He tried to call the police to prevent them coming, but to no effect. After a quarter of an hour, a soldier arrived to check that the elder statesman was alright, and I apologised profusely to the officer and to my host, who tapped me on the shoulder and told me not to worry about it at all.

The third lunch I had at Birch Grove was seven months later, in April 1980. I remember that we initially discussed the problems facing the Acropolis in Athens. He said that the reason for the bad condition was a poor restoration in the 19th century, where they had used iron brackets to clamp together the marble – the iron since corroding the stone. He said he could not understand why they hadn't taken a cue from Classical civilisation, as builders then had always coated iron with lead when it was being used in this way. As we were going up the steep stairs to his flat which he had within his house, he told me what had happened

recently. When he had asked a carpenter who was altering the staircase what he was doing, without any hesitation, the workman replied, 'It's to get you out, sir.' Macmillan's only response was 'A very practical man, the carpenter.' We then talked about Chatsworth (it was the time of the touring exhibition 'Treasures from Chatsworth: The Devonshire Inheritance'). He said how Sir Anthony Blunt had been asked to write the foreword of the catalogue. When he was revealed to be a spy, the catalogue sold out and had to be reprinted – a very different situation to the one in the UK.

The fourth and final lunch was in the following month. We talked again about Chatsworth, discussing the very sensible arrangements made by his brother-in-law, the Duke of Devonshire. In order to minimise exposure to Capital Transfer Tax (now called Inheritance Tax), one could hand over the estate before death, provided you survived another seven years. The Capital Transfer Tax came to £8m, and giving works of art and Hardwick Hall and a certain amount of land, there was still £4m to pay. This, the duke borrowed, on the basis that the high inflation rate would make the works of art more valuable. He was proved right – the American government was insuring the works on the touring exhibition for £20m. While I was in the dining room opening a half-bottle of champagne for our lunch, I heard a loud bang, and thinking the worst, I rushed next door to find the ex-Prime Minister on his hands and knees explaining that he had lost a baked potato.

* * *

One telephone call from Hong Kong was an unexpected pleasure. On the flight to Hong Kong, John Manser had seen a copy of *Country Life*, and he rang up to buy the picture in our advertisement. The picture was a very beautiful view of Venice by E.W. Cooke with the colourful Venetian boats in the foreground. I knew he wouldn't be disappointed in the picture, but I told him that if when he returned to London he didn't like the picture, I would cancel the sale. It was a great pleasure to see the picture in his lovely house, and I was delighted when he reminded me about the story. It is this special relationship with picture collectors that make art dealing such fun, especially when the collector is also a very keen gardener. It seems extraordinary that, like the person who bought the picture of

Hunting at Belvoir Castle by E.B. Herberte, John Manser owns his village pub, where we were taken for a most excellent meal. I wish I had the money or inclination to buy our village pub, the Crown and Cushion; as I explained to our MP, Jonathan Djanogly, at a party on New Year's Day 2010, when I first came to Great Gransden in 1945, there were seven pubs, and although the population has increased, we are now down to one.

The lunches with my friend from Bermuda have been enjoyable with a mutual interest in politics and paintings. I am greatly indebted to him for the most pleasant lunches at the Rib Room in the Carlton Towers, at his own special table. John Epps is a Conservative and a supporter of the Queen; although he lives in Bermuda, he considers England as his home. He has bought a number of pictures, including one of Margaret and Denis Thatcher by Ruskin Spear. He also delights in a shipping picture which he has hung over the television to provide something else to look at when the programme gets boring.

The lunches at Buck's have also been most enjoyable, either at the Cad's table or at the individual tables, and in fact Buck's recently gave me a party to celebrate my 50 years as a member. Sir Michael Palliser announced that I was the oldest member, which was not quite true, as Sir Patrick Sheehy had just had his 80th birthday. Sir Patrick gave me a full account of his life, mostly with British American Tobacco. The dinner was excellent, and I was very pleased to see Robin Start, whom I had introduced to the club. I sat next to Michael Estorick, who runs the wonderful gallery of Futurist Art in Canonbury Square, London. To my amazement, he offered to lay on a book launch at his gallery for free. The delicious port at the dinner was kindly given by our chairman, although he wasn't even there to enjoy it himself, having just arrived in New York. It was a very good evening, and I was proud to be there on Thursday 9th September 2010. I suppose I should have made a speech. Like the Boy Scouts, I was prepared. I would have mentioned that in the room at the club where I was staying a lovely picture was found of a tiger by William Huggins, which I sold for the benefit of the club. Next, I would have mentioned the beautiful bronze by Herbert Haseltine of *Eastern Hero*. This had been stolen from Buck's twice. The first time by a chap who went into Asprey's to sell the bronze. Unfortunately for him, Algernon Asprey was a member, and so luckily the bronze came straight back. The second time, it was out of the club for rather longer, but happily the police

found it – in north London. The reason it could be stolen was that the bronze was not attached to the base. I rectified this, and this lovely object still sits in the middle of Cad's table.

There are some delightful members there, and they all greet you as if you were someone important. I certainly miss one member that I introduced to the club, who sadly died on a golf course in Spain. Geoffrey Davies was the best-read person I have ever met. There wasn't a book you mentioned that he had not read. Lord Dartmouth sat at the end of the Cad's table and laughed at my silly jokes and Sir Christopher Lee sat at the other end. Discussions were wide-ranging, but they all knew that I was an art dealer and asked me my opinion on pictures coming up in sales or exhibitions that were on at the time.

Not all lunches are so pleasant. I remember Rodney Gardner was Chairman of Yardley's. He had a lovely house in Suffolk and collected appropriate pictures, particularly small Constable sketches. His daughter was given several millions on her 21st birthday. Unfortunately, she was followed to Australia and married someone called Bell. With her money, he bought a house in Ascot. When we were invited to lunch, the first thing I did was ask her father if he would mind us going, as he and his daughter were now not speaking to each other. It was a strange lunch, with a Labour MP who was in the press at the time because he had moved in with a publican's daughter. Behind each chair was a waiter. After lunch, we were taken on a tour by Bell, who was now calling himself Gardner Bell. He showed us his bed which had belonged to Napoleon, then he sat behind a seriously large desk and handed out cards telling us that in future he wanted to be called Count Lavaggio, after his fascist father. Within a very short time, the money had gone, and the marriage broke up.

Nearest and Dearest

My mother said to me, 'If you become a soldier, you'll be a general; if you become a monk, you'll end up as the Pope.' Instead, I became a painter and wound up as Picasso
(Pablo Picasso)

IT WAS A HAPPY DAY WHEN my father and my mother's brother bicycled over to a village called Great Gransden. My father was told that Great Gransden was the end of the world, and Little Gransden a bit further. What he found was an Elizabethan manor house in need of much TLC. Apart from the roof, there were chicken coops in the sitting room, but thanks to my father's imagination, he realised it would make a lovely family home. He bought Rippington Manor in 1945, and it has been much praised by all who visit it, especially the head of architecture at Cambridge, Professor Marcial Echenique. The fact is that this house, built in 1565, has never been altered from its original H plan, except for an extension to the dining room. Originally it was lath and plaster, but 80 years later, it was brick-faced with lovely small Tudor bricks. Then the chimneys were added, made of sandstone from a local quarry at Sandy. One of the very first inhabitants was Sir Charles Caesar, who was Master of the Rolls under Elizabeth I, as was his son (naturally called Julius). I bought a charming portrait of Elizabeth I to hang in the sitting room, but as the children needed educating, the portrait was reluctantly sold. The history of this house with studded doors is that it was used for minor courts and had an important place in village life.

During the war, a scientist called Dr Welshman lived in the house; he bicycled to Sandy and took a train to Bletchley Park, where he worked on cracking the Enigma code, which saved many lives and shortened the war. The

odds against us being able to decode the messages were millions to one, and the Germans had no idea that we were deciphering the messages from German High Command to the U-boats. It is all part of the history and fabric of this beautiful house with a longer history than most. The fact is that the origins for the land are in the Domesday Book, described as a cell and three fish ponds. It was, of course, a monastery and a cell of Repton, which is now a school. The original name was Repington, and by derivation became Rippington. This small corner of England is still a joy — everyone who comes to visit the place notices the peace. One of the visitors came armed with a complete print-out about the house. I thought I might be in trouble when I started speaking about its history, but all was well as this new sheet married up with what I knew, and I was able to give everyone my ready-prepared guide. What is the impression of the house when you walk though the studded front door? If you are American, age; for everyone else, that feeling of peace. How does it all work? Thanks to the care that my wife has lavished on it, the house looks lovely. I like to think that we have contributed to this house by putting in a new kitchen and decorating the place appropriately. I have enjoyed putting in the pictures I love and also maps of Huntingdonshire, including the map that is now in the Clinton Museum. Sylvia Adler makes everything shine, especially the furniture, and Adrian Grant keeps the garden under control and makes sure that it looks its best when we have guests.

Nevill Holt was a tough school, but my best memory of it was 1947 when it was one of the worst winters on record. We were entirely cut off from the outside world, and this glorious 12th-century building looked a picture. Mr Philips was a severe man, who would beat the young boys like Simon Carter regularly. He told Simon that if he came up to his study once more that week, he would throw him out of the window. Simon took safety under Mr Philips's large desk, and the secretary had to be called in so that the headmaster could add to the record the number of beatings that Simon had received on his hand. Simon ended up as an art dealer too — his gallery in Suffolk specialised in local artists from the 19th century.

My only claim to fame at Nevill Holt was when I found myself in the ring with Turner, the boxing champion, who won his fights by charging with his head down until he contacted your body then hit you hard with his piston-like arms. Luckily for me, I ducked, and he went under the ropes and knocked himself out

on the fire-place in the old stable block in which we boxed. Nevill Holt is now owned and lived in by David Ross, co-founder of Carphone Warehouse. He asked me to find pictures that had originally been in the school, and I managed to find him a copy of Rembrandt's *The Man with the Golden Helmet*.

Having survived this rough start to my schooling, I went on to the much more relaxed atmosphere of Uppingham, where I was kept amused by my fellow pupil John Sutton, who played Fats Waller at full blast in the passage at Highfield, my house. I can still hear 'You've Been Reading My Mail' and 'My Very Good Friend the Milkman' ringing in my ears. Bill, who taught carpentry, asked me what I would like to make. As my home, Rippington Manor, was originally a monastery, I decided I would like to make a miniature refectory table. It was made of Slavonian oak, and I won 1st prize for it at Speech Day. This was one occasion when my father and mother used up precious petrol coupons to visit the school. I think they thought that this was a very expensive way to be educated, but I still think of carpentry was one of my favourite subjects. The other was the school cadet force. A master (Taylor), who had lost part of his stomach and one hand in the war, was in charge of the engineers, and we had enormous fun blowing up things. He put me in charge of plastic explosives and asked me if I had put enough under a tree stump. I told him I had done it according to the pamphlet, and he told me to put some more, after which the tree shot out of the ground. We would then go fishing by throwing some sticks of plastic explosive into the weir by the lake. Not something you can do these days...

Percy Johnson, known as Grandad Pop, was a delightful character who lived in a house he built in 1923 in Latham Road, Cambridge. The house is now owned by the university, and when Prince Philip visited the university, he stayed in Grandad Pop's house – how pleased Grandad Pop would have been. At the age of 85, he said to me the one thing that was wonderful about the art world was that you learn something new every day. He always carried a lighter in his waistcoat pocket in order to jump up and light people's cigarettes. He walked with very small steps, at very fast pace. He was very short, but he always seemed to get to places before I did. My favourite story about him was when he was visiting the Fitzwilliam, which he supported. He came down the steps and fell into Hobson's Conduit (which was then full of water). Instead of swearing, he sat there laughing. What an excellent approach to life. Similarly, on holding the

door open in the Cheapside gallery, the client put a shilling in his hand. My grandfather had it mounted on a small plinth, with the legend 'Honestly earned' and inscribed with the date, 17th September 1909.

He was a great one for giggles, and his caricatures of clients who had come into the gallery are characteristic of that humour. He believed that if you couldn't think of anything nice to say about someone, it was better to say nothing, an attitude I have always tried to emulate. He had a beautiful Thomas Gainsborough drawing in the hall at Latham Road. When he was short of money, my father sold it to a Mr Curly, who was a greengrocer from Glasgow. It was then sold by my father to Paul Mellon. Just another case of the merry-go-round of art which I have enjoyed all my life. When I took over Ackermann's, several people had said to me that I was the right person, but I remembered what my grandfather had said: 'Compliments are all very well, but I would sooner have a five-pound note!'

Having now the experience of three generations of art dealing, I remember well my grandfather's comments about the delights of the art world. He lived an amazing life, one which unfortunately I could not carry on, of catching the train at about 9 o'clock from Cambridge, commuting to the gallery and then returning to Cambridge in the evening. He was able to switch off completely from work and enjoy his garden, his bowls and his family. My father, on the other hand, never switched off from work – he was always dreaming up new adventures in the art world. Unfortunately, unlike his father, he never wrote any memoirs – they would have been fascinating. He gave me a very good start in the art world, allowing me considerable scope in the investigation of pictures and in the travelling to purchase them. And he, too, could take pleasure in the sillier side of life: I remember when he called me into his office at Leggatt Brothers in 30 St James Street. When he picked up the ringing telephone, the lights went out, only coming back on when he put the receiver down. I am sure that Charlie Chaplin or Jacques Tati would have enjoyed the scene of the perils of technology.

My grandfather's world was a quieter one: communications being less rapid, everything was more relaxed. Certainly, the farmer's view of the art dealer as sitting behind a desk with his feet up, smoking a cigar, would not fit the present-day dealer. The only occasion I remember having my feet up was when we had a visit from Bernard, Duke of Norfolk, some years ago on Christmas Eve. I found the

BOY WITH RED FLOWER
Thomas Gainsborough
Gainsborough's House, Sudbury

Bought in Scotland by the author for Gainsborough's House

duke framed between my toes when he came downstairs. His only comment was: 'There was no one upstairs – I could have pinched all your Christmas presents.'

My dear, eccentric Auntie Margie was a stalwart for upholding the traditions of an English cup of tea, such as warming the pot before putting in the tea leaves and making sure there were cakes and biscuits. I didn't understand why every time I went to see her I was slightly higher on the sofa than on the previous visit. The reason was that she stored all her old newspapers under the seat. I was very fond of this spinster aunt, even though I know my parents sometimes found her annoying – I do know that it must have been hard for her looking after my grandmother, who could sometimes be difficult.

On one occasion, Auntie Margie surprised me by insisting that we were direct descendants of Dr Johnson. This was very exciting for me, as I have always had a keen interest in words. It also made me buy a portrait of the famous doctor. I found it in a minor sale at Bonhams, and it was certainly alright when it was dirty, but when it was cleaned, it turned out to be a copy of the Reynolds portrait, and nothing like the wonderful portrait of him that I had sold on the instruction of Sir Gordon White, after Hanson (the company of which he was director) had taken over Courage and was selling off the latter's picture collection. The portrait I bought from Bonhams was of an old, unattractive man, and when Patrick Cormack, who was MP for Lichfield, suggested that we lend it to the Lichfield Museum, I was more than happy. We took the painting up to that city, where the Lady Mayoress was later to garner a lot of publicity for undressing in public, and for several years it hung in the museum. I received a letter from Lichfield saying that they would like to buy the picture. So I thought of a figure and wrote to them, but they said it was too much. Back it came to the gallery, and when a group of Americans came into the gallery and announced that they were from the Johnson Society of America, I thought, 'Here is a chance to find a home for the portrait.' Unfortunately, all they said was that they could see the likeness.

Auntie Margie was also inclined to make remarks which I found delightful, such as 'When do the cat's eyes light up?' She also rang me to tell me that dear Mr Collins, an antique dealer from Regent Street, Cambridge, had made an offer of £100 for a piece of my grandfather's furniture. I would immediately rush down to Cambridge in my Austin Healey and would give Auntie Margie a cheque for the lovely sofa-table or other piece of furniture. The Austin Healey certainly

wasn't the best car to carry furniture in. On another occasion, she showed me the medal that my father's brother won in World War I and the citation from his commanding officer that went with it. Unfortunately, when my aunt died, the MC medal that she had promised to leave to me was not to be found. I rang up Spink's, and they said they could produce a replica of the medal, but it wouldn't be the same thing. Maybe one day it will turn up.

Uncle Eric was a person that one could endeavour to live up to. His answering of the telephone was an insight into his character. It was always a great pleasure to hear him say 'Barwell.' And this meant two things: that even at a great age, he still maintained a stiff upper lip (although, with him, it was one tempered with kindness) and also you knew that you had dialled the right number. During the War, he was one of the Few who fought in the Battle of Britain. Unlike his brother, who flew Spitfires and who was sadly shot down over the Channel by friendly fire, he survived some heroic scenes. The fact was that he didn't like telling you about his exploits, such as saving the life of his navigator when they had to ditch in the Channel. This is all written up in books like Richard C. Smith's *The Hornchurch Eagles*, where there is a photo of Uncle Eric on the cover, which is particularly charming as his hat is what used to be called skewiff. Until his sight went, he used to go to read and write letters for airmen at Leonard Cheshire Homes. He also made sure he was totally up-to-date with his computer skills. The story you would hear from Eric Barwell was, as a young cadet when he first joined the RAF, he was on guard duty at Marshall's Aerodrome in Cambridge when he shouted at a house, 'Put that light out,' pulled the trigger, a bullet going straight into the house, and the light went out. He was always worried that he had killed someone, although he certainly did in combat. He met his wife, Ruth, in the RAF; she was a permanent invalid but a delightful artist. In the kitchen, we have three of her pictures: one of Avignon and one of Mont Saint-Michel, but the most delightful one is a drawing of herons. Ruth Barwell turned the herons into a ceramic which is in 'Pets Corner' in the sitting room. We held an exhibition of her work which was admired but sadly not a success, mainly because I put too high a price on her pictures.

Going away from Claridge's in an open Austin Healey after our lovely wedding service at St James's, Piccadilly is not a scene to be seen much today. Unfortunately Gay lost her voice, so it was difficult to hear her responses. A money spider climbed

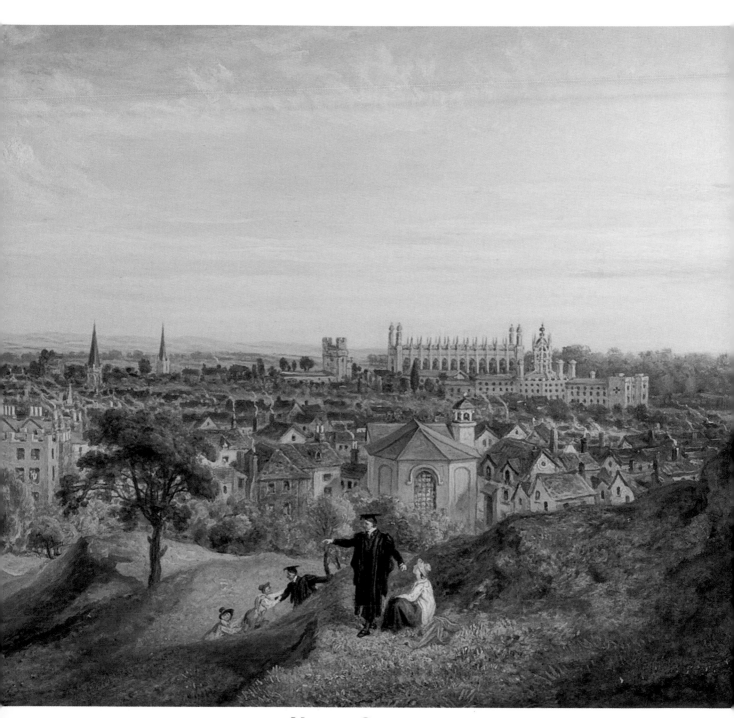

VIEW OF CAMBRIDGE
James Ward
Author's Collection

Owned by the author's grandfather

up her veil, which we were laughing about – her mother thought that Gay was crying. It was lucky that I hadn't managed to alienate my parents-in-law too much when, as soon as Gay and I had become engaged, I had whisked her off to Geneva, prompting a headline in the *Daily Express*: 'Parents told.' After the reception, my father-in-law, Douglas Lindsay, sent a bottle of champagne to our room in the hotel. Unfortunately, there was another Peter Johnson staying at Claridge's, and we received a note from him saying how much he had enjoyed the champagne. My best man was Sir Michael Craig-Cooper, who is now a regular in the papers performing his duties as Vice Lord Lieutenant of London.

Although this book is primarily about art dealing, I want to include a piece about my family. A year after my marriage in 1965 arrived a lovely redheaded daughter whom we called Juliet. She has just been awarded her second degree at Central St Martins and has shown that there is still an inventive streak in the family. Her first idea was a solar panel in the form of tiles, designed specifically for factories. She received an award for this and went to Bologna to collect it. Unfortunately, because she'd won this award, it made it impossible for her to patent it. Since then, she's made an armchair which turns into a children's slide – a great success with my grandson Zac. Annabel, who is four years younger than Juliet, is the real artist in the family. People who bought pictures in the exhibition I held for her in the gallery are particularly proud and fond of her work. At the moment, she has her own business which makes silver objects for families, and I am particularly proud of my pair of cuff-links that have Zac's drawings on them. I watched Annabel tirelessly producing and polishing these little works of art. My beautiful wife also started a business, which was very helpful in supporting the family. It was called Les Paniers and sold decorative accessories for the home. She went to fairs all round England, and thanks to her good taste, it did very well – you can see the lamps she sold Simon Howard at the Grade I-listed Castle Howard in Yorkshire.

One of the advantages of having a cousin on the stage is that you can go backstage at the interval or at the end of the play. I particularly remember going backstage at the Savoy when Celia Johnson was in *Lloyd George Knew My Father* by William Douglas Home. The play was about building a motorway through the park of the Boothroyd stately home. Lady Boothroyd (Celia) was going to lie down in front of the first bulldozer. She chooses the wood for her coffin and holds it up for the family to approve, rather like picking a material for the

curtains. General Sir William Boothroyd put on full dress uniform and ordered the butler (former batman) to sound the last post for her ladyship. Celia's artistic ability to play this part was wonderful, and to go backstage added to the enjoyment of the evening. This was particularly so when Celia was the Dame of Sark in the play of that name (also by William Douglas Home). The Dame was dropped as a child and always had a limp. When my mother and I went backstage, my mother asked Celia what she had done to her leg! The other advantage of having a famous cousin was that Celia opened two of our exhibitions most beautifully. She was very fond of plays and also Ibsen; although I went to the plays (I remember *The Cherry Orchard* and *Uncle Vanya*, I preferred more light, entertaining plays. Celia was best known for her part in David Lean's film *Brief Encounter* with Trevor Howard. Apparently, Trevor Howard asked David Lean, 'Why don't we just jump into bed?' The director replied, 'That is the whole point – you don't!' However Celia also had a good part in the war film *In Which We Serve* and a delightful part in *The Captain's Paradise*.

A really enjoyable occasion was the unveiling of a blue plaque to Celia. It was held at the house on Richmond Hill where she was born exactly a hundred years ago. I had a long talk with that delightful comedian Richard Briers. Lord Attenborough was meant to make a speech, but sadly he had had a fall and therefore Sir Tom Courtenay stepped in instead, speaking with charm and wit. The house is now Old Vicarage School, and the pupils sang to us, which added to the atmosphere. We then walked down the hill to a delightful Italian restaurant. It was a lovely party, and Celia's daughters, Lucy and Kate, were in great form. I was so pleased to be there, and I'm sure that Celia herself would have enjoyed the day! It was such a day that I thought it ought to be recorded in some way and I gave a Catalpa tree to Lucy and Kate to remind us of it.

As my cousin was a successful actress, I assumed that I had a similar talent lying dormant. At the time, there was a very active Young Conservative group in Chelsea. It had a Theatre Association which I joined, in the hope that this hidden talent would manifest itself. The play I particularly remember was called *Spring Meeting*, and I was an Irish reporter. The first night was particularly tricky, because my father insisted I meet some potential clients at the Carlton Club in my dinner jacket at 6.30. I was due on stage at 7.30 at the Chanticleer Theatre, Chelsea. I arrived a couple of minutes before I was due on stage. I put an old mac on over

my dinner jacket and rushed onto the stage where I had to kiss the leading lady, who was an exceptionally pretty girl called Jo Reynolds. The effect of kissing her was that I completely forgot my lines. I decided the only course of action was to go across the stage and kiss her again. There is absolutely no question that the only people who really enjoy amateur dramatics are the players. As my friend Sir Michael Craig-Cooper kindly pointed out, the other piece of entertainment was my leaning against the mantelpiece which then receded into the wall, causing some unintended laughs. It was all good clean fun, even if there wasn't anything artistic about the production.

Apart from my actress cousin, I have four other cousins who have made their way in the world. James Dyson needs no introduction, as his vacuum cleaners have become ubiquitous. His father, a school master in Norfolk, gave me my first set of cricket stumps. He now lives at Dodington Park in the Cotswolds. When he bought this large house, I was hoping that he might call on me to help me populate it with pictures, but it hasn't happened yet.

Alice is the daughter of Uncle John – John Barwell was an inventor who invented the extruder which was designed for rubber and tyres but is now used for plastic. Alice first started her professional life at Kew Records Office and then became second-in-charge of the British Library and was responsible for the highly successful move to Euston Road. I even like the Paolozzi sculpture in the forecourt; this very large work has a fascinating history. It is in red stone and is based on the drawing by William Blake. The drawing was of Newton measuring the world – his calculations were used by NASA for its moon mission. Blake intended the drawing to be satirical, as he did not like Newton. I had hoped that Alice would be the head of the Library, but instead she went to the States and became head of the 22 libraries at Yale, including the famous Beinecke Library. She is now returning to England to be Master of Somerville College.

As I have James Dyson as a cousin, and an uncle who invented an extruder, I thought there might be an element of inventiveness in me. First of all, I got very involved in producing a picture light, which would light paintings without emitting any ultraviolet rays, using fibre optics instead. Unfortunately at the time, you needed a big box to convert the light down a wire. It is a shame I didn't pursue this idea, as the National Portrait Gallery is now lit by fibre optics, and I was very pleased to see that Elizabeth Wills's collection of paintings by the

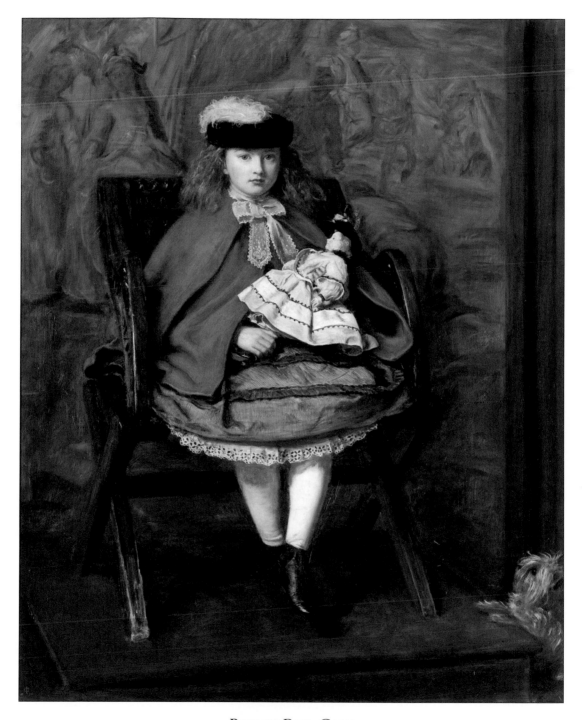

BOY IN RED CAPE
Sir John Everett Millais, PRA
Private Collection

Illustrated on cover of Country Life *and sold to a private collector*

Nasmyth family were lit by this method. But, of course, my other passion apart from art is gardening, and so came about the Joehoe. This is the weed-gathering hoe that I designed along with my cousin John Barwell (the nephew of the extruder inventor). It seemed to work well, and we were given a patent for it. Unfortunately, the cost of production made this special hoe too expensive to market. John and I had a splendid time visiting factories around Birmingham (which was where the Barwell family had made screws for horse-drawn carriages). It was sad that we never got the hoe off the ground, especially as Gay referred to it as 'marvellous'. Like always, this was a welcome diversion from art dealing when things were a bit quiet. I'm sure that the Chinese will find a method to produce the Joehoe at a competitive price.

The third cousin is a friend and client. She is an intriguing person who is writing a book on the Pakistani Army. Although Carey Schofield gives the impression of being shy, she is regularly taking trips to Pakistan to research her book. I am sure her writing will be a great improvement on my efforts. It is very pleasing to have such gifted cousins.

The fourth cousin, Joanna Booth, is Organiser of Entertainment at Sotheby's. She is absolutely charming and knows everyone. The invitations from Sotheby's are written in clear copper-plate pen, and it is a pleasure to put the invitation on your mantelpiece. The parties have continued, even though business has been more difficult. Joanna's father looked after my teeth, and when my mouth was full of implements would say, 'How is Auntie Margie?' Joanna has always greeted you as if you were someone special, and her writing has become used by smart people to add something extra to their invitations.

My niece has just won her second Prix de Saint-Georges, which makes me think that she is a true contender to represent Great Britain in the 2012 London Olympics in Dressage. It is a pleasure to watch her on her two lovely horses, Rhino and Rue. It is also very pleasing to hear my sister giving instructions to Annie Darling and to watch the concentration of the rider to improve her dressage. The test of equitation is much more difficult than my point-to-pointing.

*　*　*

Turning to paintings of families, one of the most unusual pictures we bought was

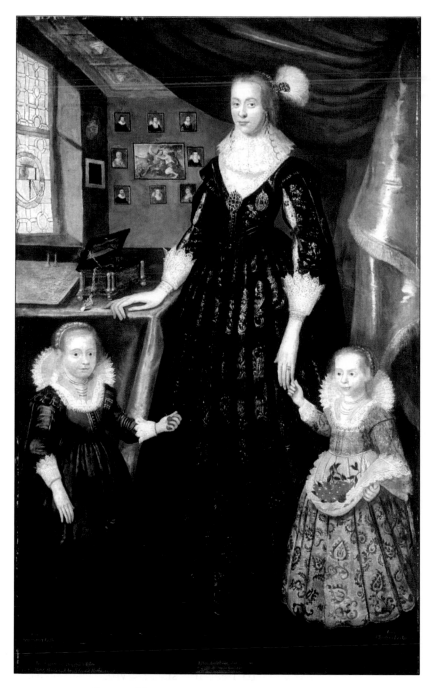

LADY ERSKINE AND HER CHILDREN
George Jamesone
Scottish National Portrait Gallery

Sold to SNPG by the author, following the 'Princely Magnificence' exhibition at the
Victoria & Albert Museum, London

a full-length portrait of Lady Erskine and her two children, by George Jamesone. It was extraordinary in several respects, first the detailing of all the clothes and the inclusion of Lady Erskine's jewel box with her jewellery overflowing from the box. This was obviously a demonstration of her wealth. We were asked if we would lend the picture to a V&A exhibition entitled 'Princely Magnificence: Court Jewels of the Renaissance 1500–1630'. The exhibition was quite exceptional – a pure joy – and in the middle of it was the lovely portrait. During the exhibition, we negotiated with the Scottish National Portrait Gallery. Dr Duncan Thomson was the director and was writing a book on the artist Jamesone. It was with great pride that when the exhibition ended, the picture departed to Edinburgh, the perfect home for the Erskine family. A happy and successful transaction.

The Aberdeen Art Gallery was the home for one of the best paintings by that very attractive artist Sir Henry Raeburn. The family who owned the portrait of this boy wanted to hand it over in lieu of the tax due on the peer's death and of his wife very shortly afterwards. Bonhams valued the picture at £60,000, but I believed this fine picture to be worth twice that figure; my valuation was accepted, and everyone was pleased when the picture went to Aberdeen. It was certainly a pleasure to help the family and for the painting to go to a lovely gallery, although one must not forget that unlike America, where museums can deaccession pictures, the Raeburn has been permanently removed from the art market. I have always been proud of finding the right public home for paintings, but I realise that this is the end of the road for those pictures, even if the public will continue to be able to enjoy these lovely works of art.

A very nice friend called Major Laurie Gardner invited me to stay at his wife's family home, Balliswil, Fribourg in Switzerland on my way to skiing at Gstaad. Laurie Gardner was a delightful person, who owned a lovely race horse. Over his bed was a large painting hanging on a piece of string, an *Adoration of the Shepherds*. Laurie agreed to bring the picture to London. I showed it to Professor Michael Jaffe, the leading expert on Rubens then and up until he made a mistake over the pictures bought by the National Gallery of Wales. He told me it was a Jordaens copy of a Rubens. I told the owners and very unfortunately gave the owner's name to Michael Jaffe. He told them that it was, as I suspected, indeed a Rubens, and it was bought by the National Gallery of Scotland in Edinburgh. Although I received lot of publicity about this, I didn't receive a commission or financial benefit.

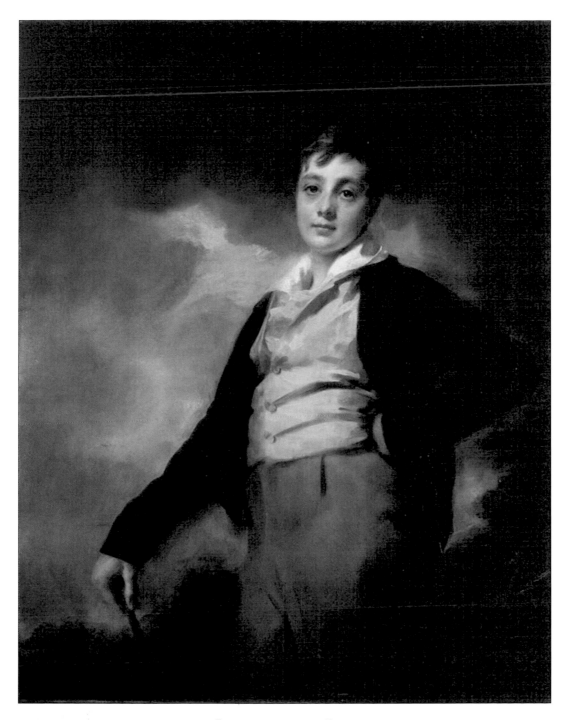

PORTRAIT OF A BOY
Sir Henry Raeburn
Aberdeen Art Gallery

Transferred to the Nation in lieu of tax, arranged by the author

remarkable animals. Instead, I explained that I was coming over a fence in a race when on the other side lay a horse and jockey on the ground. There was no way I could do anything to avoid this potential disaster, but in a fraction of a second, Spaniard moved his weight and, instead of hitting the horse and rider on the ground, we landed clear to the right and carried on with the race. Thanks to his action, he saved a very disastrous accident.

Horses I have ridden:

Joey: Welsh pony

Spanish Dew: dear hunter and point-to-pointer

Roscrea: marvellous Irish horse

Highly Inflammable: Light hunter and eventer

Valiant V: chestnut

Sunray: wonderful horse – looked like a Stubbs, won Melton Hunt cup

Plunder: hunter, point-to-pointer

Ad Astra: very good eventer

Oyster: light hunter

Fandango: given by the Danes to General Dewing at Newmarket because he was the first person into Denmark in the army liberating it from Nazi occupation.

Big Boy: big horse with big feet

Typhoo: lovely light hunter

Paddy: delightful, steady horse

Gransden Lady: ridden by my sister Jennifer at the 1st Badminton Horse Trials

Radar: Olympic horse, and mother of Sunray

Forever Amber: reversed into a briar hedge

Pandora: very sound school horse

Brave Highlander: Grand National veteran – ridden for charity

Mirander: Entirely traffic-proof and had all the gears, walk trot and canter in going round Hyde Park Corner and the park itself.

I had a lovely horse called Sunray, whom Gay thought was wild. To me, he looked like a Stubbs, and it was wonderful to be on his back. My father bred him from Radar who was an Olympic horse, and the sire was Bitter Sweet who was standing at the Meddler Stud, then owned by Bill Leach. My father sold him to me for £400 plus £50 for feed. Happily, he never owed me anything except a black

GREY HORSE AND GROOM
Frederick Whiting, RP, RSW
Author's Collection

eye! I came back from honeymoon in July 1965 and decided that it was high time that Sunray was backed, but that was against the advice of my sister and my mother. I saddled and bridled Sunray, but when I jumped on board, I realised my mistake and jumped off. The horse whipped round and caught me just above the right eye. There was lots of blood, and I was rushed to Addenbrooke's, where I had nine stitches in my eyebrow. When I returned to the gallery, I had a really big black eye, and naturally everyone thought it was my new bride who had given it to me. Sunray was a marvellous horse; his name, of course, was based on the fact that he was the son of Radar. I lent him to the Royal Horse Artillery. For a time, I rode round St John's Wood, past the studio of the Edwardian painter Sir James Gunn, but happily they decided to rebuild the barracks and so the horses, including Sunray, were moved to Combermere Barracks at Windsor.

This was an exciting and lovely time. I particularly enjoyed overtaking David Coaten in his red Ferrari. You ought to have seen the look on his face when a horse overtook the 'prancing horse'. On another occasion, I went to the park with Gay and Juliet, aged four. There were a lot of people flying remote-controlled aircraft. One came straight towards Sunray's head. He went into a type of gallop in reverse. Gay and Juliet were standing on a bridge. I shouted at them to get off the bridge and somehow managed to steer Sunray backwards over the bridge. On the financial side, I sold a half share in Sunray for £1,000. He then damaged himself on the wing of a fence which stopped him eating, and the insurance company paid up on the basis that he would probably die. Lawrence Rook, the famous Olympic rider of Starlight, suggested I contact the lady who operated the 'Devon box', a New Age healing device, and so I sent a piece of his tail and a description of the problem, and within four days he started eating. I then lent him to Lars Sederholm, chef d'équipe of the British Olympic team to teach young riders.

The most lovely point-to-point course was Water Newton, just off the A1, on the opposite side of the road to the small eponymous village, quite close to Stamford. Not only was it lovely to look at but also a joy to ride round, except on one occasion. Ted Harvey and I went to a deb dance given by Richard Howarth for his daughter Penny, in a lovely old abbey. Unfortunately, both Ted and I ended up with upset stomachs, thanks to bad prawns. This meant that we spent our time vying for the loo in the marquee on the point-to-point course. I certainly made the weight of 12 stone 7 that day easily, but I had to ride without

a stomach. Spanish Dew was marvellous, as he took me over the fences as a passenger, and I came third. Tom Wakefield, who had been helping me, said 'What is the matter with you?' When I explained, he said he wouldn't have let me ride in the race.

Slightly dangerous, but extremely exhilarating was my two and a half hours spent on the Grand National horse Brave Highland, in aid of the Bob Champion Cancer Trust. I raised about £1,800 and was on Cloud 9 for at least a fortnight, thanks to this wonderful ride and this lovely horse. There were many contributions, but I was particularly delighted by the £500 given by Richard Hoare and the donation from Jeremy Cotton on the basis of how long I would remain on board.

The 2012 Olympics seemed to me to be an expensive mistake, especially for the rate-payers in London, until my niece Annie Darling announced that she intended to compete. She has the most wonderful horse, called Rhino because he was born on the night of the Rhino Ball. Not only does he have the presence of a horse for dressage but looks a picture with Annie on top. I have contributed in a modest way, by introducing Tigger Hoare and John Sunley who have helped sponsor her. So 2012 is potentially a very special year.

* * *

Gay and I went to a Jubilee street party, and we were encouraged to go to a basement in Upper Phillimore Gardens where there was litter of lurcher puppies. The sweetest of all was a bronze bitch which we bought and called Zina, which was short for Bronzino, that beautiful Italian artist. Bronzino always included an elegant dog in his pictures, and certainly Zina grew into a similar dog. It was a wonderful stroke of luck. The dog was the most intelligent and beneficial animal. She always surprised us by her speed in catching a partridge on the wing, even if it was out of season, and jumping into a moving car when we were leaving a horse event. She also produced a litter of lovely puppies, thanks to the visit of the beautiful Lady Chichester with her lurcher, Zeraglio. The bond was consummated in the garden of No. 1, The Little Boltons, much to the amusement of our neighbours. We kept one of the puppies, which we were going to call Stubbs, but the Spanish *au pair* girl called him Bandido, and so the name

Bandit stuck, because of his markings. I commissioned Ken Howard to paint a water-colour of them — even though he said that he hadn't painted animals for a long time, he caught their character extremely well. In the large sitting room, we had two bean-bags — the comfortable one was always taken up by Bandit, but Zina developed the technique of rushing to the French windows and barking. This meant that Bandit had to see what she was barking about. Quick as a flash, Zina jumped on the comfortable bean-bag.

At the time, I was a very keen gardener, and we were able to open our gardens as part of the Yellow Book scheme, which was in aid of nurses. One problem I had was that Bandit decided to build a golf course in the lawn. I said he had to go, but Juliet loved the dog and said she wouldn't sit her exams if he went. So the lawn was repaired, and we had two lovely dogs who gave us a lot of pleasure. Bandit even started growling in the early hours one morning; when the postman rang our bell and said that the front door was open, I realised the dog had heard a burglar. We lost a picture which had already been pledged to Sir John Eden for Lady Eden's school and an oval mirror that had belonged to my grandfather and hung in his hall at Latham Road in Cambridge.

✳ ✳ ✳

'Master' the Duke of Beaufort was asked by my father to open our very special sporting exhibition, the works of John Wootton. The speech he made was charming but included the comment that the proceeds of the exhibition were going to Battersea Dogs Home. It wasn't until he repeated this and said the 'entire proceeds' that I interjected 'of the catalogue'. This prompted the tall Mrs Garnett to roar with laughter, and I can still picture the scene today.

The origins of things and events are interesting. The trip to Yorkshire with my father to visit Tom Laughton — the brother of Charles Laughton, the actor — was the starting-point for an exhibition of William Huggins of Liverpool. This supreme animal painter has since become a national treasure. It seems ridiculous today that before our first exhibition of his work, I went into my father's office and asked him if he thought anyone would buy a picture painted by someone with the name 'Huggins'. The trip north to Scarborough was uneventful, and we stayed at the Royal Hotel, which Tom Laughton owned and had provided the pictures

on the walls. My father and I received an invitation to have tea and see his pictures, mostly of chickens by William Huggins. It was a very pleasant tea, and we succeeded in buying all the paintings. The old Bentley of my father's was a joy to drive, and the gear box was like slicing cheese, with the gear level on the right of the driver. The rain was coming down in buckets, but in the lanes near Scarborough, I said to my father, 'I believe we have a puncture. Where is the spare wheel?' The answer, of course, was under all the Huggins pictures in the boot. Under direction from my father, with the car leaning precariously over a ravine, I managed to change the very large Bentley wheel.

We finally arrived at midnight at Great Gransden, where I carried into the house the Huggins *Chickens*, as they weren't insured if left in the car. My mother said, 'Chickens – you won't sell those chickens.' She had looked after chickens the whole of the war at Swavesey in Cambridgeshire. We all went to bed rather despondent. Interestingly, the very first picture to sell in our first show of this artist was *The Chickens*, and not the lions, which are now his popular paintings. But then again, the ones pictured were colourful special breeds, not standard ones. One was bought by Deborah, Duchess of Devonshire.

Born a hundred years after George Stubbs and also coming from the Liverpool area, he lived for some time at Christleton near Chester. The bible of sporting art (*British Sporting Artists: From Barlow to Herring* by Walter Shaw Sparrow) has a whole chapter on this wonderful artist, even quoting Huggins's self-penned epitaph: 'A just and compassionate man who would neither tread on a worm, nor cringe to an Emperor.' Huggins resented comparisons made of his work with that of Sir Edwin Landseer, stating that had Landseer passed through his hands, he would have made an artist of him. The first show was in May 1966; on the cover was a painting of a pair of leopards. The picture was originally sold for £850, but Prints for Pleasure made it into a print, and we received 6p for every one sold. This produced £2,500, but the picture was then sold for £2,500 and a few years later for £10,000. The owner was then David Telling, who turned down an offer of £80,000 for this exceptional painting.

John Rydon, who was the art critic of the *Daily Express*, rang me and said he had a lion for me. I told him that it was a private view, and I didn't want any of my very important clients eaten. He told me he would get me front page in the *Express* and that he had hired the lion especially. I told him I couldn't run the risk

FIELD OF POPPIES AT HASTINGS
Albert Goodwin, RWS
Private Collection

Purchased from a man who lived on a lake on Oxfordshire

of losing a client.

Huggins got a lot of publicity when I sold one of his pictures to Jackie Kennedy, but the real fun was when my friend and client John Law had decided that he would like to be involved in a deal in November 1966 over several paintings by Huggins. As with the later Albert Goodwin deal in 1970, it worked out to everyone's advantage. John kept the ones he wanted for his lovely house, and I sold the others and made a profit. In May 1970, we had the first major show ever held of Goodwin, that colourful water-colourist. Even though Martin Hardie had given him a big write-up in his three-volume work *Water-Colour Painting in Britain*, our exhibition helped put him back on the artistic map. He describes how Goodwin was an innovator in that he used water-colours with body colour, Indian ink and Chinese white. The effects are magical and have the strength or appearance of oil painting. I particularly like the way he draws his freehand washline around his water-colours.

The biggest picture in the exhibition was an oil painting of a view looking down the Thames at Westminster. This is now owned by Jeffrey Archer and hangs in his flat overlooking the Thames. One of the most exciting pictures was a large water-colour of a dazzling field of poppies near Hastings. This was one of a collection of water-colours bought from an eccentric man who built his own house on an island near Oxford. The day I went to see him the weather was exceptionally hot, and I was wondering if he would mind if I arrived without a tie. I was met by this chap in his bathing trunks and had to get in a boat to go to his house in the middle of a large lake that had previously been a sand pit. The reason he wished to sell his collection was in order to pay for a professional builder, as his wife-to-be would not live in his self-built house until it had been made stable. It was a lovely collection. At the time, he drove a hard bargain, but happily, with the aid of two potential collectors (Jimmy James and Peter Baker), we bought the collection. Some of them we sold, but the others we kept, and the poppies still belong to Peter. The recognition and acceptance of Albert Goodwin was pleasing to me, especially when Harold Macmillan bought some including the one he loved of Eton. In later years, I was rung up, and the person said, 'I am ringing you up as the King of Goodwins.' All I said was I might have been, but I had lost my crown.

The gallery was also the first to mount an exhibition of the Suffolk brothers

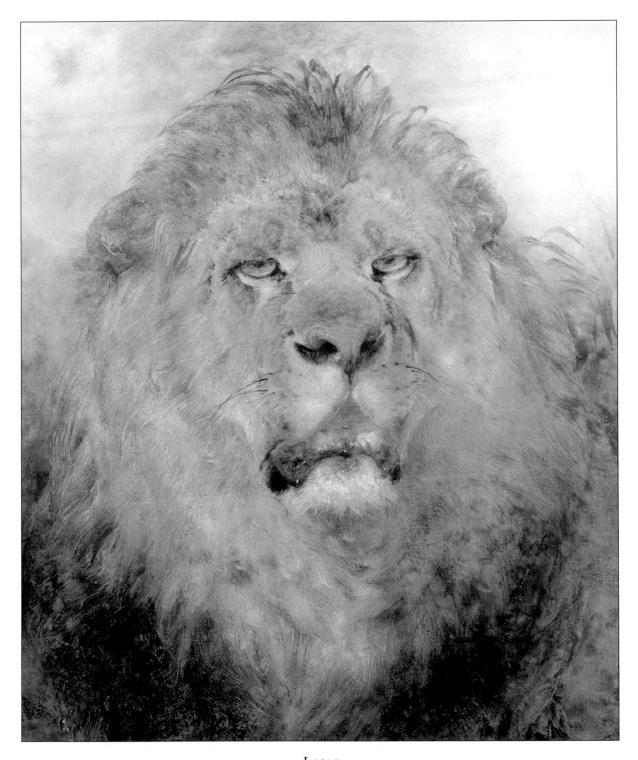

LION
William Huggins
Collection of Richard Hoare, OBE

E.R. and Thomas Smythe, but unlike Huggins and Goodwin, neither of these rural artists had been mentioned until we exhibited their work. On the opening day, a local turkey farmer came in and started buying the entire collection. I went into my father's office and stated that we were in danger of selling the whole exhibition before the actual opening that evening. My father suggested that every time Raymond Le Grys bought one, I reserve the next one. As it was, he bought half the show and gave me a cheque for £3,500. Although this was a lot of money at the time, today it would hardly buy one picture by either of the brothers. The dear Mr Le Grys always said to me afterwards that he wished he had bought *The Grey Pony*, which in fact was bought by my friend David Telling, who had the most lovely Regency house in Chew Magna, Somerset. On one visit, David said he wanted to build a swimming pool and asked me to sell another of the William Huggins paintings he had bought from me to pay for it. *Pumas* had originally cost him £450, and I asked him how much he needed; he said he thought £4,500 would cover it. I sold it to America, but when David became better off, he commissioned me to buy it back. I flew to New York and tried to persuade the new owner to part with the picture. Even though I had been instructed to go up to £85,000, the owner wouldn't part with it. The greatest picture by E.R. Smythe is that of the *Horse Fair at Woolpit*. These pictures now command prices in excess of £50,000.

It was very pleasing to have discovered such a wonderful local artist. The whole prospect was helped by considerable press coverage. The *East Anglian Daily Times* and Anglia Television made everyone aware of what they had hanging on their walls, or on their draining board in the case of one lady. Unfortunately, this use of the picture meant that it was in poor condition, but in view of the circumstances of this family, I gave them £30 for the picture and hoped that a restorer would at least make something of the remains.

* * *

It is difficult to believe that a Christmas card would solve a mystery. I went to a lovely house near Newbury where Peter Lowesley-Williams lived in style. In the hall was a lovely set of four paintings by E.R. Smythe of the Greene family hunting. The pictures were stolen, but some 12 years later, I received a Christmas

HORSE FAIR AT WOOLPIT
E.R. Smythe
Private Collection

Owned by a Suffolk collector of Smythes and photographed in situ by the author

card with one of the paintings on it. I rang up the restorer, and, sure enough, it was one of a set of four. The next day, the Newbury police rang me and said they had no record of the burglary. Unfortunately for the restorer, they were the pictures that were stolen. As my colleague pointed out, 'I don't expect you will get a Christmas card again from the restorer!' Apparently, the woman who sold the pictures to the restorer said she has received them as part of the divorce settlement. Certainly, it was an novel and intriguing way of finding lost pictures.

Lady Munnings was the wife of the great sporting artist Sir Alfred Munnings. On one occasion, my father and I were viewing a sale at Christie's when we bumped into Lady Munnings, who said to my father, 'What you need is Beechams.' My father said to me, 'Am I looking that bad?' In a further room at Christie's, we bumped into Lady Munnings again, and she said 'Yes, Oscar. What you want to buy are Beecham shares.' She kept her husband on a very tight purse string, only allowing him £5 a week out of the money he made from his paintings. On another occasion, we met Lady Munnings in Piccadilly, and she said, 'Oscar, I hear you are having an opening. Can I come?' My father's comment to me was, 'I hope she doesn't,' as she was a bit of a liability. In the event, Lady Munnings turned up at 8.30pm with Black Knight, her dog (then alive). She put the dog down in the gallery and asked it to sing. Within minutes, the gallery was clear of the remaining clients. The famous story of her was on a bus in Sloane Street with Black Knight (now stuffed). She put him on the seat beside her, and the bus conductor insisted she pay for him. An argument broke out, with Lady Munnings refusing to pay for her stuffed Black Knight. She was apparently very successful with her investments, which enabled Castle House (the Munnings's house in Essex) to be turned into a charming gallery for his paintings. There was a story that Lady Munnings decided that some of her husband's sketches were not good enough to survive. She therefore had a bonfire in the garden on which she planned to burn these pictures. Luckily, along came an enterprising art dealer who made a successful offer for the pictures, thus avoiding a disaster.

Not so fortunate as the Munnings sketches was a lovely shooting picture of partridges that I bought. It was obvious that someone had shot at the picture with a 12-bore shotgun; it was also obvious that the gun had a very poor pattern. I had it restored, and an American came in and fell for the picture. I felt I had to explain that it had been shot at, and to my amazement, he bought it. I later heard

how thrilled the American was with the picture, and how it made an excellent talking point.

* * *

Sir Gordon White was an interesting client, who regularly rang up from New York with a complex set of instructions which I would have to recall and carry out. Sara Sowerby took them down after the telephone call. He came into the gallery to see a marvellous big bird picture by Melchior d'Hondecoeter, and bought it for £130,000. He told me I had to find it the right frame. After much searching, I found a beautiful rococo-style frame, which had a feeling of Chippendale. I rang him in New York and asked him if he was sitting down. He asked me why, and I said I had found a frame for the beautiful bird picture; he asked how much it was, and I told him it was £10,000. After Gordon died, the picture came up at Christie's and was bought by the dealer Richard Green for three times the original price, and I like to think that the frame made a difference. On 18th December 2009, I was asked to be Honorary Art Adviser to the Royal Veterinary College. This is the perfect sinecure for me – a job which fits in with all that I've learnt in the last 50 years, and the people I've met. I am particularly happy over the horse connection. I first introduced a sculptor called Camilla LeMay to the college, which has already made her artist-in-residence. On 18th February 2010, a special meeting was held at the Camden campus to discuss the latest project – a life-size bronze statue of Sefton, the horse blown up outside Knightsbridge barracks in 1982 by the IRA. I wanted this project to go through especially as the college had a building called Sefton which it was about to demolish. I suggested the same scheme as had worked for the Churchill sculpture of selling bronze maquettes to fund the statue. As it happened, a benefactor of the college, Lord Ballyedmond, in recognition of the achievements of his friend Professor Peter Lees, very generously decided to fund the statue, and therefore the maquettes could be sold for the benefit of the college and its art collection.

It was very enjoyable to be back in the office of Quintin McKellar, the Principal of the college. I sat opposite Andrew Parker-Bowles, who was most enthusiastic about the idea, as he was at the barracks when it happened. Jonathan Forrest led the discussion, and Camilla LeMay gave an ideal short presentation.

I told the meeting how the money was raised for the sculpture of Sir Winston and Lady Churchill. Andrew Parker-Bowles suggested that he contact my old friend Ted Terry, who was Paul Mellon's lawyer, as, if they still had funds, these could be distributed to people who had been given money previously. (Paul Mellon had given funding to the Veterinary College for placing Adrian Jones's *Duncan's Horses* at the Hawkshead campus, and for Mill Reef, a building for autopsies). It was a delightful meeting, and made my week, especially when Andrew Parker-Bowles believed he might get the Princess Royal to unveil this exciting sculpture. It was a particular pleasure to see Quintin McKellar again. I am also involved in helping the college form an appropriate art collection, which has already been started by the donation of *Eclipse* by George Stubbs.

Architecture and Music

Light, space and silence
(Antony Gormley)

MY FIRST REAL BRUSH WITH ARCHITECTURE and architects was when my father and I set up the gallery. We had been partners in Leggatt Brothers, but the relationship had gone sour. Unfortunately, my grandfather (who had also been in partnership with them) had declined when Ernest Leggatt had suggested the firm be called Leggatt & Johnson, on the basis that it had always been known as Leggatt Brothers. As there was no way we could stop Hugh Leggatt from using his own name, the only solution was to set up a new gallery. Setting up a business aged 40 is one thing, but my father was 63 at the time. Luckily, my father's confidence in his and my ability was inspirational.

Finding the right building for an art gallery is a lengthy, painstaking process. The first place we looked at was a white elephant of a place in Cork Street, which ran the length of the block. It would have made a splendid gallery, but the rent was a facer and the rates would have subsequently been disastrous. Of course, we would have been right in the centre of all the galleries, between Christie's and Sotheby's, which is one of the advantages of the Buck's Club, to which both my father and I belong.

I remember meeting my father for a drink on a Monday evening in 1962. I was overjoyed because I had found what I considered exactly the place for the gallery. My father said, 'Do you know what? I think I've found what I think would make the perfect gallery.' When I said that I had too, I was worried that

this might lead to a difficult discussion, but believe it or not, we had actually chosen the same place independently. Not far from Cadogan Square was this very new building, the ground floor of which was a line of shops (just shells at the time). On closer observation, it was obvious that the corner site was the best, but it was already taken by one Peter Scaramanga. We therefore considered the adjacent site, which was significantly smaller and less appropriate. We went through the motions of wanting this one, but told the landlords that we much preferred the corner site. Luckily, Mr Scaramanga failed to complete, so we managed to get the one we really wanted.

Having found a good site, it was now time to get an architect on board. I was recommended to see Basil Spence, the architect of the Knightsbridge Barracks. He suggested that on my way to his office I should visit a gallery he had designed, called the Drain Gallery. It certainly lived up to its name – not appealing to me at all. When I arrived at his office, his secretary sat me down in front of his desk. When he finished his call five minutes later, he started to pace around the room. Luckily, his secretary saw my plight and said, 'Mr Johnson is waiting to see you.' He then showed me endless photographs of his projects, none of which chimed in with my ideas for an art gallery.

The next architect was a young, ambitious one, who drove me around in an old MG sports car at great speed and great danger to show me a site he had decided was perfect. I carefully explained that we already had the site and just wanted a designer, then I asked him for some ideas. His reply was: 'Oh, old man, you can't have ideas. If you employ me, I will go ahead and produce plans.' Not knowing what you were letting yourself in for seemed a ridiculous situation, but he insisted it was standard architectural behaviour.

Finally, I came across someone called Alan Hunt. A furniture designer by trade, he did some drawings of a scheme which is the basis of the gallery. His idea was for the front door to be like a bank's (thus giving the feel of solidity and respectability) and for the windows to be suited for flexible arrangement of pictures. With the plans now completed, we set about dividing the basement into office space and furnishing it. The workmen had literally left on the same day as the first exhibition – I remember my mother frantically hoovering the carpets in preparation. The first client was Lady Pulbrook, who bought a landscape that was displayed in the window. She ran the florist Pulbrook & Gould, which was

very near the gallery and which we used for all the exhibitions. When Juliet was born, a beautiful stork filled with flowers arrived. I was very happy to hear recently that she is still going strong at the age of 104.

* * *

Art dealing is full of surprises. Especially when an American rings up and says he wants a Doric temple for his island in Vermont. My only thought was: 'If I sell him a Doric temple, maybe he will buy a lot of pictures from me.' I happened to know of a temple in a garden in Sussex. The deal was that my wonderful secretary Sara Sowerby (descended from the great 19th-century writer on flora and fauna) would drive, I would talk, and the American would buy us a nice lunch. He was delighted with the Doric temple, and it was then 2pm, so I said we'd better find somewhere to eat. We found a delightful pub and asked the publican if we could have some food. He said, 'Help yourselves.' We had an excellent meal, and when the American went up to pay, he was told there was no charge. I then went up to the publican to double-check, and the answer was that he had taken over the pub that day and the previous owner had laid on this delicious meal to give away. The temple was carefully packed in wood and put on a ship called *Atlantic Container*, which had been in service during the Falklands War. Unfortunately, it broke down, and the temple had to be transferred to another ship. When it finally arrived, the buyers were delighted and sent me a Christmas card of their island with the Doric temple under snow, but, as you've probably guessed, they never bought a picture from me.

* * *

One of the most exciting days was the opening of the new entrance to the National Portrait Gallery by the Queen. I still have the tie, with tulips on it, that I wore that day. The Queen was absolutely charming and spoke to everyone, and I felt that I had, in some way, contributed to the major improvement to the gallery since it was I who had introduced Christopher Ondaatje to the director, Charles Saumarez Smith. Christopher provided £2.75m, which was the basic funding for the new entrance. It was such a jolly day that I can't remember whether the sun was shining.

The fact that the development incorporated part of the National Gallery with a part of the old Portrait Gallery being handed over to the National Gallery was a brilliant concept. The effect on the gallery was that you walked straight up the stairs into part of the gallery and then could take the escalator to the lovely Tudor gallery, for which Mrs Heinz had provided a lot of the money. At the top was a restaurant with a stunning view of London – Nelson's Column, Big Ben, etc.

＊　＊　＊

The opening of the new £60m development of the Ashmolean Museum in Oxford was another great event masterminded by Dr Christopher Brown, who wrote the foreword to this book. What it did was open up the whole gallery with a complete reorganisation of the collection. The use of lights and glass and vistas has made the place exceptional. It has become my third most enjoyable gallery in the world, after the Frick Collection in New York and the Wallace Collection in London. It was with great pleasure I introduced Mrs Scott to the Ashmolean; she is giving a major part of her collection to this lovely museum; the portrait of her famous great-uncle, Lord Duveen, is probably staying in the family, however. I found this picture in the art fair at Maastricht and was proud of the fact that it went to a member of this extraordinary family. More recently, I went with Mrs Scott and her daughter to see the play *Art*, which is about the argument between Bernard Berenson and Duveen. After the play, we went backstage and saw Peter Bowles, who played Duveen; Mrs Scott told him she thought he had portrayed her great-uncle beautifully.

Duveen was the most famous dealer of all time: the famous Gainsborough of *Blue Boy* was sold by him and hangs in the Huntington Library, San Marino, California, opposite *Pinkie*, the most beautiful Lawrence of a young girl. Although my contribution to the art world is in no way comparable to Duveen's, I have enjoyed introducing people who help, especially my really nice friend Tim Sanderson, who also went to Uppingham. I only hope that his generosity to the Ashmolean will also extend to the Fitzwilliam Museum at Cambridge. After several visits to Oxford, I was pleased to introduce him to Timothy Potts, the new director of the Fitzwilliam, and to Sir Richard Dearlove, the master of Pembroke College, Cambridge.

* * *

On 25th February 2000, while we were having a wonderful holiday in Mauritius, I bought a copy of the *Daily Telegraph* to find out what had happened in the tussle between Christie's and Sotheby's over collusion. I saw to my horror the photograph on the front page of Tangley, which had been burnt to the ground with all its contents, killing Michael Colvin – who was an MP – and his charming wife. Their house was immaculate, and I had visited it only a month before, but it had no fire alarms. I thought something had to be done about this, and, with the aid of Jamie Cayzer-Colvin, a trust was set up to warn people of the dangers of fire – a danger particularly present in historic houses filled with antique contents.

We held a series of seminars around the country, starting with Ickworth in Suffolk. This took place in November 2002, ironically on the day that the firemen went on strike. The first person to speak at the seminar was Jamie Cayzer-Colvin, who gave a wonderful but disturbing talk about what had happened to his family home. While he talked, a video showed the fire and the effects of that sad occasion. The next seminar was held at the National Trust-owned Uppark on 13th June 2003, where there had been a horrendous fire, but luckily the contents were removed, there was no loss of life and the house was beautifully restored. The third seminar, on 28th April 2004 was at the Elizabethan house Penshurst Place, thanks to Lord and Lady De Lisle. The fourth was at Castle Howard, which could not have been a better venue, given that this lovely house had suffered a major fire, and there were still parts that needed restoring.

Before the Penshurst Place seminar, the Colvin Fire Prevention Trust held a meeting on 13th November 2003 at Spencer House, the restored house of the Spencer family. Although the turn-out was good, a lesson was learned by us, because the talks were divided by lunch, after which half the audience disappeared, so missing my talk about the pictures. Probably just as well, but the day was expensive, and perhaps not as successful as the other events. This was made up for by a visit to the very grand Blenheim Palace on 26th May 2005. Again Jamie Cayzer-Colvin described what had happened on that dreadful night in February 2000. The message that we were trying to get over was that although you could lose some of your possessions in a burglary, a fire was all-consuming.

On several occasions, the fire brigade came out in force and showed off their equipment, but even more effective was the demonstration of how quickly things could get out of hand when a fire took hold.

The final seminar was held on 3rd November 2006 at the Tower of London. Both Hiscox and Gurr Johns were very keen to have a major event not only in London, but more specifically in the City. I, personally, was very concerned that this would not work. It was probably the most successful of all, judging from the enthusiastic letters we received.

After 10 years of trying to get our message across, it was decided that we should consider winding up the trust. My personal thanks go to Lord Luke, whose advice I sought regularly, and to Carey Schofield, a stalwart member of the team. Peter Buckley decided to make a very helpful donation. The idea was that the remaining funds should be transferred to the Heritage Cultural Garden for the Olympics, as Peter Buckley was, at the time of his death, chairman of the Royal Horticultural Society. In fact, the money was eventually divided equally between the British Sporting Art Trust and the War Memorials Trust.

Thanks must go to all the people who contributed to this series of seminars, and particularly to Jamie Cayzer-Colvin and his family, for the use of his name to promote this crucial issue. Thanks to Ian Evans, the government took notice and increased the number of adverts to encourage fire alarms in homes. The government expressed an interest in taking over the trust, but apparently this came to nothing. Thanks and praise must go to Sean Gay, who put in some Trojan work to set up and organise these seminars. Although he was paid by the trust, he always went that bit further. The seminars were sponsored by Hiscox and Gurr Johns, who both greatly contributed to the events, as well as providing the finance.

✳　✳　✳

One of the things I can recommend is learning to play the piano, even if you are in your 60s. Although I had watched Mrs Lloyd Webber teaching Juliet on an upright piano (bought mainly because it was a Pollard, and I liked to think there was some connection with the famous coaching artist of that name), I had never sat down at a piano before. But then I received a lovely flyer through the door at

The Little Boltons, saying, 'Wouldn't you like to learn the piano?' It was a slow and rather difficult development, but it really took off when I was lent a beautiful Broadwood grand piano. Angela Priestman suffered brilliantly with my efforts at playing, even more so with my forays into composition. Nevertheless I was able to enjoy myself with what I called my warm-up: Dvorak's *New World*, 'The Saints Come Marching In', 'Land of Hope and Glory', 'Greensleeves' (which was meant to have been composed by Henry VIII – particularly appropriate for a Tudor manor house) and Bach's Prelude No. 1 from the *Well-Tempered Clavier*. The Bach is a particularly simple piece, but very difficult to play well. It's rather like the Tiger Moth: very easy to fly, but difficult to fly well. I can't have tortured Angela Priestman too much, since she very kindly gave me her greenhouse when she moved house.

Unfortunately, Carole Williams, the owner of the Broadwood, wanted it back for her son to play. It's extraordinary that while I was wondering how I would possibly be able to find the money to buy a piano, Paul Bowskill, a friend and picture dealer, asked if I would like to have his piano. Even though it hadn't been played on for a number of years, it had a lovely mahogany case. Aside from the initial problem that the carrier didn't think it would fit in the hall, it made it in and is now being enjoyed by everyone. Although it doesn't play like the Broadwood I was lent before, it plays very well, thanks to Don Airey's piano tuner. In fact, it was made an offshoot of Broadwood, a company called Collard & Collard. A further development was that I bought a Broadwood square piano in Ledbury for £80. It cost £2,000 to restore, but I had it in the gallery and played it to celebrate the sale of a picture. I sold this piano to Carey Schofield, a cousin of mine, and I immediately missed it, as it was also good at showing off bronzes placed on top of it. Happily, this was replaced by another 1841 Broadwood square piano, which cost £800 but didn't need so much spending on it.

In our village, apart from artists, there is a great musician from the rock group Deep Purple. My introduction to him was the Midnight Mass on Christmas Eve. To my amazement, after the service was finished, the congregation was rewarded with a fanfare of music from the organ. All the cobwebs from the organ pipes were blasted out, and everyone remained seated to listen to this riot of sound, even though by then it was after midnight on Christmas Day. Don Airey is a wonderful person to have in the village, as he also

sings in the choir and has a sold-out concert every year in aid of the church and village. When he heard that I have a Broadwood grand piano in the hall, he agreed to come to Rippington to play a duet with me. Luckily, there is a photo of this event, otherwise I would not believe it.

* * *

Having piano lessons wasn't my first brush with the world of music. One of the smallest pictures that I have handled was an excellent *View of Salisbury* by John Constable. I was instructed by the charming client Sir Edwin Manton to buy the picture up to 300,000 guineas. This may not sound all that much today, but it was a considerable amount at that time – the price of a house in Belgrave Square. Although only six by eight inches, the bidding was very active; Patrick Lindsay was on the rostrum. The bidding reached £300,000 and was about to be knocked down, when I whistled, and Patrick said: 'With the whistler.' This was before the introduction of the premium and the bidding paddle. I was much amused by the congratulations from my colleagues and competitors.

* * *

There was a notice in the *Times* that Vladimir Ashkenazy was conducting and playing in the Waterloo Room at Windsor Castle (this was before the fire in 1992). I was very lucky to buy two tickets for this marvellous concert. The fact was that the combination of wonderful music and the full-length portraits of the generals, mostly by Sir Thomas Lawrence, made the evening sheer pleasure. All the pictures were saved in the fire except the vast equestrian picture of George III by William Beechey. It is happy news that Windsor Castle has been restored so beautifully, and the British Sporting Art Trust had a visit there to see this great restoration. While we were going round the castle in the evening, we were amused to hear that the Queen had seen lights on and was worried that there were intruders, but was told it was alright as it was only the British Sporting Art Trust.

* * *

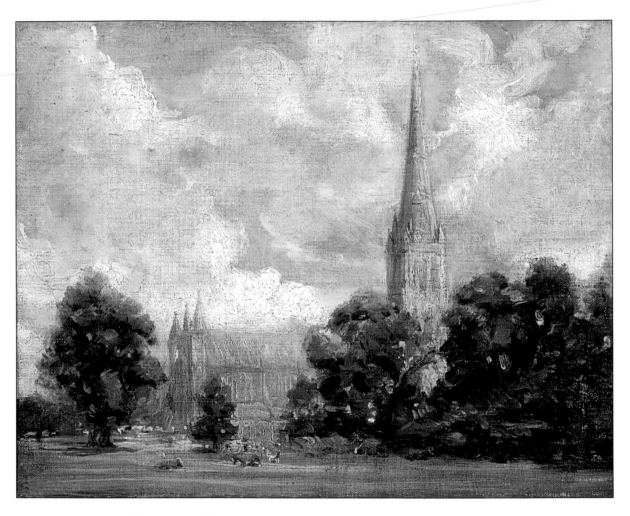

VIEW OF SALISBURY CATHEDRAL
John Constable, RA
Sir Edwin Manton

Purchased on behalf of Sir Edward Manton

It was great fun when there was an unexpected arrival in the gallery. When Kate Bush came into our exhibition 'Brush with Bush', the title of our Harry Bush exhibition, the atmosphere was heightened to the level of one of her extraordinary top Cs. She has a lot of charm and vivacity. Although she is only small, the image is powerful, and when she stands on tiptoe to kiss me, it certainly adds music to the show. The title of the exhibition was definitely over the top, nevertheless 'Brush with Bush' was a success, and it put another artist on the map. His views of Merton and Wimbledon were refreshing, even though they were views of suburbia, as mentioned in the *Daily Telegraph*. I do not know whether Harry Bush is related to Kate Bush, but she bought at least one of his pictures. The spectrum of clients is amazing, but I rather wish we had more actor clients like the art dealer Andras Kalman, who put L.S. Lowry on the map. But then, perhaps it is better not to have too many thespians, as apparently they are very variable payers.

Smell the Paint — Living Artists

———— 🔲 ————

Brains, madam
(J.M.W. Turner, on being asked with what he mixed his paints)

WE REPRESENTED A WONDERFUL WILDLIFE PAINTER called Douglas Anderson. Douglas was a very good portrait painter, and I was able to commission him to paint some very fine works. He lived in Tuscany, and he rang me to tell me he wanted a decent portrait, as he was feeling down in the dumps. I told him there was a chance of him painting the No.1: Princess Diana by then had become an icon — her photo on the cover consistently boosted the sales of newspapers and magazines. Every morning, I received a call from Tuscany to enquire whether he had got the commission. On finally learning the good news, he continued to ring me every morning, but now it was because he was in a panic about painting the beautiful princess.

The morning arose for the first sitting at Kensington Palace. Prince Charles was still there, and Douglas had to wait until he had finished his breakfast before setting up his easel. At the time, there were men taking down the scaffolding from Kensington Palace, and they were all looking in on the classic scene of an artist painting a princess. Princess Diana said to Douglas, 'Anyone would think you were painting me in the nude,' to which Douglas replied, 'Well, Ma'am, this morning I received a cable from America saying "Congratulations. I hope it is the nude."' Douglas was only allowed five sittings, so Katrina Beckett, a girl from the gallery with particularly beautiful shoulders had to act as a model. One

morning, she came to the gallery wearing the most fabulous necklace of diamonds and emeralds which wouldn't come off after her session of sitting that morning for Douglas Anderson. She took it all in her stride that part of her job at the gallery was to wear the clothes and necklaces of Princess Diana.

The portrait was a fine one, although it showed the sadness of what was happening in Diana's life. It was to be shown on television, and I found that my opponent over the portrait was Brian Sewell. The first thing Brian asked me was which my best side for the TV camera was. This was a ding-dong battle over the pluses and minuses of the splendid portrait, very much like a tennis match. The picture was hung in the entrance to the Royal Marsden Hospital, where it was damaged by someone. I rang up Douglas in Italy to see if he wanted to repair the picture, but he asked me to get restorers to do the work. I found this idea that someone wanted to damage the portrait very sad. Michael Grey, the manager of the Carlton Tower, asked if he could display the portrait in the entrance to the hotel where it caused quite a stir. Sadly, I never met the beautiful princess, other than at very smart charity evenings, although I did have a very vivid dream that she kissed me – no doubt brought on by hearing that a picture dealer was having an affair with her.

I remember very well discussing with Harold Macmillan the portrait that had been commissioned by the University of Oxford. I had gone down to Birch Grove in West Sussex to hang pictures a few times in 1979–80. The conversation started in October 1979, because we were discussing the various personalities who had been painted by James Gunn. He literally rushed out of the room to produce a sketch that Gunn had given to him, but undoubtedly the best picture of him was the one of him in the Chancellor's robes. I told him the story of a Canadian, whose partner suggested that books be painted in the background. When the sitter, Eddie Taylor, saw the portrait, his comment to James Gunn was: 'I have never read a book in my life.' James Gunn had to paint out all the books and put in a hunting scene instead. And then there was Budd McDougall, who insisted that James Gunn repaint the lines of the pin-stripe suit so that all the lines matched up.

I had recommended that he choose George Bruce, and Macmillan particularly admired a photo of Bruce's portrait of the Speaker, George Thomas. We then discussed alternative painters, such as Michael Noakes, Edward

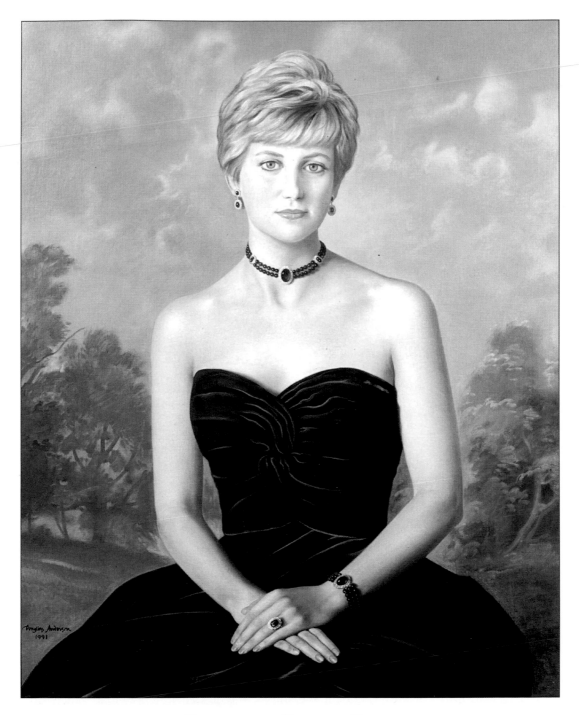

PORTRAIT OF PRINCESS DIANA
Douglas Anderson, RP
Royal Marsden Hospital, London

Commission organised by the author on behalf of the Royal Marsden Hospital

Halliday and Norman Hepple. Mr Macmillan then produced a catalogue of the Graham Sutherland exhibition, saying that he would very much like this artist to paint a portrait of him. I agreed it would be rather exciting – certainly more so than anything produced by Hepple or Halliday. He said that he was going to Oxford later that week and would bring the catalogue and the photo of the Speaker's portrait. I said that I would be very happy to contact either George Bruce or Graham Sutherland, depending on the final decision taken at Oxford.

When I next visited, on 14th April 1980, we discussed the portrait again. He said how he intended the portrait to be a head and shoulders one only, as he called the rest his 'decrepit parts'. I told him that I would be happy to talk to the artist, if it helped. I also told him how it was said that Winston Churchill would fold the canvas of official portraits so that the part depicting his legs would be hidden from view. Unfortunately for the ex-Prime Minister, Graham Sutherland had died, so the university had chosen Bryan Organ. Harold Macmillan is slightly amazed that Bryan is coming down in three days' time to take photographs from which he will make the portrait; I said that I thought he would make an excellent likeness.

It is always interesting how you meet living artists. In the case of Ken Howard, it was through my way of good client and friend Sir Gordon White. He contacted the director of the National Gallery, Neil McGregor, and asked what artist would he recommend to paint a picture of his house in Tite Street. The director recommended Ken Howard, and therefore Gordon contacted me and asked me to find out more about this artist, and enquired as to my views of his painting. Gordon liked Ken's work and bought a number of Ken's paintings from our exhibitions.

The exhibitions were a great success and Lord Hanson (Gordon White's partner) bought some. In all, we had three major exhibitions and a number of Christmas exhibitions, and they were great fun. Unfortunately, the bottom line was that we didn't make money on the shows – whether we spent too much on advertising, the catalogue or the champagne opening, I don't know. Nevertheless, it was marvellous putting this excellent artist on the map, and I have a number of his pictures in my collection – not only a lovely nude pulling on or off her stockings (illustrated) but some stunning views of Sennen Cove in Cornwall and some lovely views of Venice. The artist Tom Coates wanted to buy the best one

of these views, but it didn't work out, so I had it at home for years, selling it five years ago. To be involved with an artist like Ken Howard is sometimes very enjoyable (I designed his garden), sometimes a chore (I once got a call from Cornwall asking me to go up the road to his studio in Bolton Gardens to find his passport) but always interesting.

We held several exhibitions of paintings by Ken Howard, but the one I remember best was when he asked me to organise not only a private view but a separate party for his artist friends and models. On the staircase, I put a painting of a girl in the nude with her legs apart, which made an interesting view as you went down the stairs. At this party stood the model of this particular picture, and the whole time, she kept pointing up at this picture and saying, 'That's me.' The next day, Sir Clive Bossom came in and said he wanted to buy the picture. I said to him, 'What about his wife, Barbara – would she like it? The next day, the picture arrived back.

Thanks to the introduction by Christopher Ondaatje, I was able to meet the delightful Daphne Todd. I went down to see her work. Although she is a portrait painter, she had painted some landscapes and wanted me to have an exhibition of these paintings in London. I certainly considered the idea very carefully, but the problem persists that if you turn the gallery over to a contemporary artist, you have to take down your stock. Even though it is only for two or three weeks, it causes an interruption of your core business. Daphne has painted a number of portraits of Christopher, and I feel sorry that I didn't take his introduction further. Christopher also arranged for me to meet John Wonnacott, who is an excellent painter and would have made a useful addition to the contemporary artists we handle. At the time, he was committed to another gallery and was also artist-in-residence at the National Gallery.

Peter Curling was a Newmarket artist, who emigrated to Ireland and is now painting the horses there. He and his wife pop into the gallery, and he usually tells me about some picture he's thinking of buying. I'm happy that he's done so well with his colourful racing scenes that he is able to afford to buy serious traditional and Modern British paintings. His character is anything but serious – he treats life as something to be savoured and is full of joie de vivre – something which comes across in his painting.

It's always a pleasure to sell a picture by an artist you really appreciate. Such

is the case with Alison Wilson, and when our neighbour, Eleanor Sclater, fell for a picture of coloured horses in the river at Appleby, where there is a gypsy meeting of coloured horses every year, I was particularly pleased. I commissioned Alison to paint a picture of Ruth's Boy, a black Irish horse. Gay chose the background of what she called penises, which were Scots pines, and I held the horse who put his head on my shoulder and fell fast asleep. Alison's string of horses hangs outside the kitchen, and is much admired. This week, at Alison's request, I attended the Society of Equestrian Artists at the Mall Gallery. As usual, Sir Mark Prescott made a lively and entertaining speech. Contrary to my expectations, it was a good exhibition, much better than previous years. This was perhaps because not so many had been painted from a photograph – a technique which always shows up.

Perhaps my greatest success had been with Douglas Anderson, who was introduced to me by Derek Strauss. I have already mentioned the commission I got him of Princess Diana for the Royal Marsden Hospital, but there were many others such as the chairman of a brewery and Tony Murray Smith, MFH. What struck me as the most beautiful element of Douglas's paintings was the way he painted animals. Like Landseer, he started drawing from a very early age. When he was at Eton, he was known to be drawing rather than concentrating on lessons, but this paid off in terms of the number of successful wildlife exhibitions. He also mentioned that he was better than famous Swedish wildlife artist Bruno Liljefors, who mainly painted foxes. I'm inclined to agree with Douglas. When he was up at Lossiemouth in Moray (the 'largest and busiest fast-jet base in the Royal Air Force'), he had a fox cub which knocked on the window every morning for his breakfast.

I've always been interested in the principle of drawing and painting, but it was only when I was on holiday that I got down to trying it myself. I was rewarded in one way, in that my mother, to whom I gave the pictures, hung them in her bedroom. I don't know whether she really liked them or whether this was to show her love for me. I then signed up to a painting course at the Royal Academy. The course was run by Francis Bowyer, a most enlightened artist. Not only did he give you an incredible amount of encouragement, but he always had a book of drawings to demonstrate how the great masters approached problems. I found myself in a lovely part of the Academy schools where there were lots of

busts and models in clay. There was also a very good student who painted and drew most perfectly. I find it very difficult to produce work, in that I have weight of art history on my shoulders – I know that I'll never be Titian. I was extremely impressed by the other students' work, especially that of Leslie Haynes and Claire Knox.

I have already written about Don Airey, the musician who lives in the village, but we are also blessed with an artist. He has just returned from Antarctica where he has been painting the wildlife. His paintings are full of air and light and, of course, movement with the animals and birds. I first met Bruce Pearson when I set up the committee to compete for an icon for East Anglia, rather like the *Angel of the North* by Antony Gormley. I decided that as East Anglia was renowned for its windmills – which were recorded by wonderful artists such as John Crome, John Constable and John Sell Cotman – their importance should be recognised. The second artist to become involved was the sculptor Laurence Broderick. He was well-known for his *Bull* at the Bullring in Birmingham. He made some drawings of a conceptual windmill. His studio is in the next village, Waresley, and his drawing was turned into a beautiful working model in stainless steel. The presentation of all this was by Trevor Bounford, who is a graphic designer, and gave our entry into the competition a powerful image. Engineered by Mark McIntyre, the beautiful model windmill's two sets of sails went round and were illuminated, which made the whole concept feel achievable and desirable.

We were all convinced that our entry would win, and when it was on view in Cambridge, Anglia Television gave us a big boost. The winner was Sir Michael Marshall's firm, the Marshall Group, which had came up with the reed bridge over the A14 – a charming idea but not very practical. There was a lot of tea and cake consumed in the discussions, and the idea would not go away, even after the initial rejection. When I was asked at random at a lunch in Boodle's whether I knew anything about windmills, it was a real bolt from the blue – I thought that we had another real chance of realising this project.

Patrick Barker is an impressive sculptor, who makes his figures come alive. I decided to commission him to do a figure of a conductor, who would stand at the end of the garden at No. 1, Little Boltons. It was a piece of conceptual gardening, in the form of the figure conducting an orchestra of plants and flowers. I approved of the sketches that Patrick Barker produced. The great day

arrived for the delivery of the sculpture, and Patrick and a friend in the back drove down the M4 with this nude white stone figure stretched out, causing consternation on the motorway. I had a shock in that it was a female conductor, rather than a male. Luckily there was a famous female conductor at the time called Jane Glover. The figure worked well, and it was fun to design her orchestra. The best part was the Regale lilies who were the trumpeters. Patrick Barker certainly deserves the success he's had, and I was very pleased to see an article on Lord Carrington's garden in *Country Life* with some of Patrick's rolling figures.

I have lost touch with this nice, talented artist, and have therefore been in touch with Phillip Blacker – I had already sold two of his marvellous studies of *Northern Dancer*. This was the famous horse that produced Mill Reef, the Derby winner. After a lot of discussion, Phillip suggested that the ideal figure for the end of my avenue would be Lady Godiva. This appealed to me for two reasons: first, she was the mother of Hereward the Wake – an East Anglian historical figure – and second, my mortgage was with Godiva (part of Coventry Building Society). So far, the figure is only in the form of a plaster maquette.

George Bruce was a very successful chairman of the Royal Society of Portrait Painters. This is entirely appropriate, given that he is descended from Robert the Bruce. What I like is that he has a wicked sense of humour, but one that does not give offence to anyone. He also holds delightful drinks parties at his house and studio behind Pembroke Square in Kensington. Whenever I visit there, he is painting some grand portrait of an archbishop or some other worthy – I have always claimed that he is the reincarnation of Sir Thomas Lawrence. On one occasion, he rang me up to say that he was having trouble with his paints. I put him in touch with David Bull, our best restorer, and he advised George Bruce to grind his own paints, as artists did at before and at the time of Turner. I like how George's painting combines great freedom and great care. His picture with a signpost in a landscape gives me a lot of pleasure. As there is no name of village of town on the sign, it allows one's imagination think where it might be. I like to think that it is one of the signs which were turned around in case of a German invasion.

Richard Foster is the brother of Neil, who like me was on the committee of the East Anglian Historic Houses Association. Although Neil is the architect, it is interesting to see how often Richard's paintings include architecture. Even

Richard's splendid painting of India depicting an Indian palace on a lake was particularly attractive due to the architectural detail shown. I would have liked to buy the painting, but I was beaten to it by an Indian lady. I love his pictures of interiors with families, rather in the style of a modern Arthur Devis painting. The particular picture I like is of the Corsini family, who live in a palace on the Arno in Florence. One can actually feel the pleasure that Richard got from painting this picture. I'm sure he was very well looked after by them.

On two occasions, we were lucky enough to buy the studio of artists. It was an interesting decision to go along and actively decide to spend the money and time on a pursuit that was not entirely based on making money – trying to raise the reputation of lesser-known or forgotten artists. The first was a sale of works by A.C. Cooke (not to be confused with E.W. Cooke). Arthur Claude Cooke was a charming rural painter who recorded lots of scenes, both domestic and farming. Oscar & Peter Johnson held a very successful exhibition with a lovely landscape entitled *England's Green and Pleasant Land*. I sold this to Australia, but unfortunately it ended up at Wellington, New Zealand – 3,000 miles from its Australian namesake, where it should have gone. The other studio sale was an artist called Harry Bush. I went rather overboard with the title, when I called the exhibition 'A Brush with Bush'. Terence Mullaly wrote an article in the *Daily Telegraph* calling Bush a suburban artist, which he was; most of his pictures are of Wimbledon and Merton. The most impressive picture was of a house being built in Merton. This was sold by Christie's in aid of a charity for 10,000 guineas.

A very good friend of my father was a very rich Canadian called Colonel Phillips. He asked my father to go down to Augustus John's studio in Hampshire to collect his wife. On the drive down to Fordingbridge, my father stopped at the pub in order to get some Dutch courage before he faced the great artist. When he explained to Augustus John that the Canadian wanted his wife back, Augustus John said, 'Take her away – I am fed up with her.' The story is told that every child he met he called them 'My boy' or 'My girl', just in case they really were his.

When I was in New York, I would always stay at the St Regis. It was a marvellous old-fashioned hotel, and even more importantly, the hotel bought from Leggatt Brothers three very fine portraits which were hung in the Oak Room. When I came down to breakfast, there were the portraits to greet me and make me feel at home. On one occasion, staying at the hotel was Salvador Dalí,

the great Surrealist artist. He asked me to his party on the top floor. There were lots of girls in all sorts of dress or undress. I can't remember much about the party, but Dalí succeeded in setting fire to the hotel. Although there was a certain amount of damage, I don't think anyone was injured.

Lucian Freud came into the gallery and said to the secretary, 'I am Lucian Freud. I believe you have some pictures by me.' It was the first time I had met this important modern artist. He was dressed in a smart blue striped suit. The problem was that he had had some drawings stolen from him, and also artists have a habit of deciding that they did not paint a particular picture if they now consider it wasn't good enough. I showed him the 12 drawings that we had, and he was happy to confirm that they were his and that none of them had been stolen from him. In fact, he nearly bought one of his house in Suffolk.

History

The main difference for the history of the world if I had been shot rather than Kennedy is that Onassis probably wouldn't have married Mrs Khrushchev (Nikita Khrushchev)

ONE OF OUR MOST DISTINGUISHED CLIENTS was ex-Prime Minister Harold Macmillan. He was a regular visitor to the gallery in Lowndes Street. He rang me up to tell me that he had a clock stolen from his dining room. Luckily, I remembered what the clock looked like. I searched all over London from Ronald Lee to Asprey's and Harrods, eventually finding the right one in Hollander's, on the Fulham Road. It was a lovely bracket clock with a beautiful flower piece engraved on the back plate. I rang Harold Macmillan, who agreed to come and see it. Aged 80, he first bought four pictures including a lovely view of Eton by Albert Goodwin. I showed him the clock, which he decided to buy. I was very relieved, as it had sitting on my desk, and the chimes every quarter of an hour had fast become annoying. He went out of the door to catch his bus in Sloane Street, and I was about to go downstairs, when the door opened again and the elderly statesman came back in and said, 'I never really thanked you for finding the clock!' I was very happy, as I had just sold four pictures and a clock to an ex-Prime Minister. Later, he rang up to say that the clock had developed a slipped disc. Our manager, Leonard Domleo (who had been manager to Horace Buttery, the Queen's picture restorer), went down to Birch Grove to collect the clock. Harold Macmillan asked him to lunch with him. Leonard spent the rest of his life talking about eating pheasant with the ex-PM.

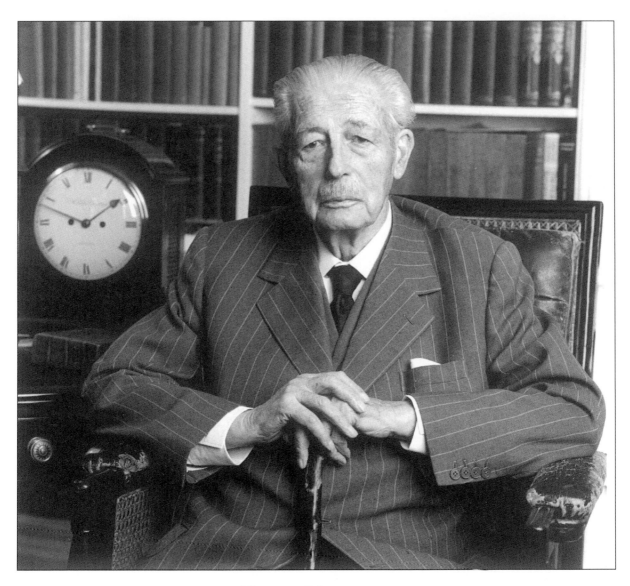

HAROLD MACMILLAN
Unknown photographer

Clock sold to the ex-Prime Minister by the author

Churchill Statue Fund

This is to certify that this is Number 3 in a Limited Edition of fifteen bronze casts of Oscar Nemon's Maquette for his double statue of Sir Winston and Lady Churchill, specially produced by the Fund to finance the presentation of the heroic size statue unveiled by H·M Queen Elizabeth the Queen Mother at Chartwell on 13th November 1990.

Winston S Churchill MP *Lady Soames DBE*

Dame Jennifer Jenkins DBE

Patrick Cormack FSA MP *Peter A B Johnson*

TRUSTEES OF THE CHURCHILL STATUE FUND

CHURCHILL STATUE FUND CERTIFICATE OF AUTHENTICITY
Author's Collection

SIR WINSTON AND LADY CHURCHILL
Oscar Nemon
Chartwell, Kent (National Trust)

Money raised by the sale of maquettes paid for the casting and placing of the life-size statue

One of the most glorious days of my life was the unveiling of the sculpture of Sir Winston and Lady Churchill at Chartwell, Kent. As my father's name was Oscar, the sculptor Oscar Nemon adopted the gallery. He asked me, on one of his many visits, to find a suitable home for his monumental sculptures of Sir Winston and Lady Churchill. The initial idea was that it should be in Hyde Park. Drawings were made and stones for the plinth were considered, but the Fine Arts Commission said that there were already too many sculptures there. The next suggestion was outside the Cabinet War Rooms – there was a suitable space, and it would be an appropriate spot, being so close to Downing Street and Whitehall. Again, the answer was no, but the Fine Arts Commission suggested contacting the National Trust with the idea of putting the sculptures at Chartwell. On the suggestion of Sir Patrick Cormack, MP, and with the agreement of Falcon Nemon Stuart (Oscar Nemon's son), 15 maquettes were made of the bronze, to be sold to raise the money to cast the large bronze for Chartwell.

The first thing to do was to set up a charity, the Churchill Statue Fund, to sell the maquettes. I thought that it was a brilliant idea, but doubted it would work. In fact, it was a great success, and we sold them for £5,000 each to raise the amount for the bronze for Chartwell. So successful was it that we could afford to give one to Mrs Thatcher and another to Lady Soames. When I went to deliver it to Sloane Court West, a voice from above, that could only be the daughter of the great Sir Winston Churchill, called out, 'The lift has broken down, but there is a glass of champagne waiting for you.' After several flights of stairs, carrying the 8lb maquette, I certainly needed that glass. Jonathan Aitken bought one on the suggestion of Sir Patrick Cormack. Unfortunately, when things got tough, Jonathan Aitken sold it for very good profit. Michael Heseltine bought one, which I hope he still has at home.

Once the money was raised, we could then make a cast, but first the plaster of the original had to be repaired – this was done by a Polish sculptor friend of Oscar. The foundry Morris Singer in Basingstoke agreed to cast the bronze, which was a very exciting part of the whole plan. This firm did most of the work for Barbara Hepworth and many other famous artists, like Henry Moore, Jacob Epstein and Eduardo Paolozzi. The foundations had to be prepared with a suitable plinth. It even had Patrick Cormack's and my name in Roman letters on the base.

The day arrived for the bronze to be taken to Chartwell on the back of a truck. The weather couldn't have been worse. I followed behind the truck, but at Westerham, Churchill's head appeared from under the tarpaulin as if to say, 'I am here!' The truck nearly got stuck in the mud before it arrived at the perfect site down by the pond that Winston loved so much and where he used to feed the fish. The Queen Mother agreed to unveil the statue, and on 13th November 1990 on a beautiful day, we assembled there. The Queen Mother was absolutely charming, and when she pulled the cord, there appeared this most excellent bronze. I kept thinking of all the events that led to this great occasion, including the placing of a time capsule under the statue. Sir Patrick said to me, 'Have you put the capsule under the bronze?' I therefore had to put my hand underneath when the bronze (which weighs a couple of tons) was only four inches from the plinth. If the crane had slipped, there would have been a one-handed art dealer.

The ceremony went beautifully; afterwards, I went round Chartwell to check that everything was in order to find someone shutting all the windows in that lovely room with the oval window at the end. I explained that there were 120 people coming to have drinks in the room on that very hot day. The lady who was shutting the windows turned round and said, 'Do you know who you are talking to?' And if looks could kill! It was Pamela Harriman, Churchill's daughter-in-law. The lunch was lovely. The Queen Mother sat opposite Lord Tonypandy. She took a rose from the flower decoration and presented it to him. I sat next to the young Minnie Churchill, who giggled the whole time. At the end of the day, there stands a lovely tribute to the great man and his wife in the home he loved so much. I bought some silver leaf pear trees to add some reflected light to the sculpture. A most satisfying and enjoyable project. A number of photos have appeared in the press and included one of the Churchill children climbing over the bronze, which was part of Oscar Nemon's original concept.

It was with considerable excitement that I was offered a portrait of Winston Churchill aged four. It was obvious that the proper home of this portrait by P. Ayron Ward was Blenheim, where Churchill, a descendant of John Churchill, the 1st Duke of Marlborough, was born. The present duke came to see the picture and asked for a large photograph of the charming portrait. Never did I imagine that he would have the photograph framed and displayed in the memorial room to Churchill at Blenheim. Happily, the Cabinet War Rooms decided that it would

WINSTON CHURCHILL, AGED FOUR
P. Ayron Ward
Bulldog Trust
(On loan to the Cabinet War Rooms, London)

be a great addition to their new development of the rooms as a museum. Thanks to the generosity and long-sightedness of a great friend, the picture was bought by his trust, appropriately called the Bulldog Trust. This was the first major purchase on a basis of being a facilitator to help museums enhance their collections. Although it would have been good for this delightful long-haired four-year-old to have hung at Blenheim, there are now many people admiring it at the Cabinet War Rooms.

I have always been a great admirer of Churchill. That he was the Prime Minister who led us through a terrible war more than qualifies him for greatness, but that he was also able to write, build walls and paint pictures puts him in a different league. In the year 2000, I decided to acknowledge my belief in the great man by holding an exhibition of as many portraits of him as I could find. We have held many exhibitions over the years, starting with 'Pictures and Drawings from Yorkshire Houses' in 1963, when we were Oscar & Peter Johnson Ltd, at Lowndes Lodge Gallery. Altogether, there were 61 exhibitions up until 1993 when we became Arthur Ackermann and Peter Johnson Ltd, but 'Images of Sir Winston Churchill' was the most extraordinary. I was very pleased with the catalogue, which had seven portraits on the cover. The end papers showed a painting of Sir Winston lying in state in Westminster Hall, by Alfred Egerton Cooper, which I had previously sold to the Palace of Westminster, thanks to Sir Patrick Cormack, MP. I had also sold a wonderful head of Churchill in marble, by Oscar Nemon, to Westminster. I suppose it was sales like these which had given me the impetus to organise the exhibition 'Images of Sir Winston Churchill'. Lady Soames very kindly opened the exhibition with the panache one would have expected from her father — she was a real chip off the old block.

I borrowed from the National Portrait Gallery the preparatory drawing by Graham Sutherland for the portrait which the House of Commons presented to Churchill. He did not like the portrait, and it is said that Lady Churchill burnt it. Someone had warned me that Lady Soames would not appreciate the drawing, but when I showed her round the exhibition before she made her speech, she admired it. Churchill's comment about the portrait was that it was a good example of modern art. Personally, I think he did not like it for two reasons. First, the background was yellow, a colour associated with cowards, which he certainly was not; second, that it had rather clumsy banana-shaped fingers on his

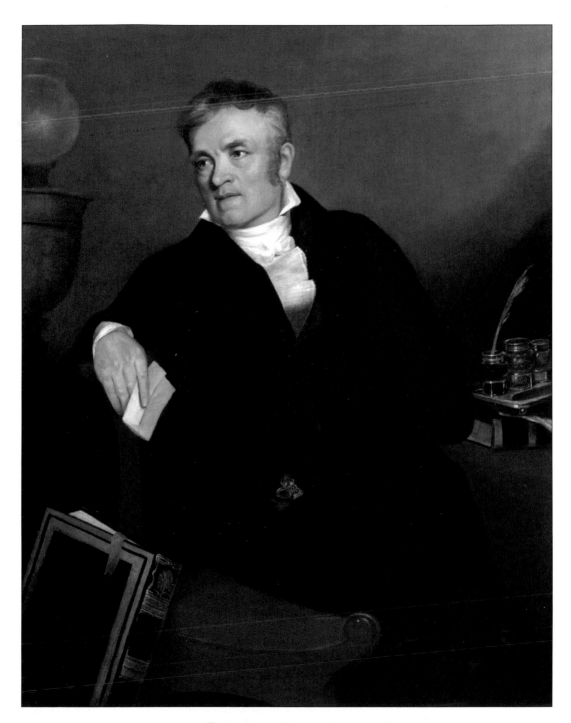

RUDOLPH ACKERMANN
François-Nicolas Mouchet
National Portrait Gallery, London

Sold to the NPG after the acquisition of Ackermann's by the author

hands, and I understand he was rather proud of his hands. The exhibition was a great success, and the paintings by Churchill were much admired. I only wish they had been for sale. In 2007, a painting of Chartwell, given by Sir Winston to General Marshall (of the Marshall Plan) fetched £1 million.

A dealer friend, Anthony Willson, saw the show before we opened and said, 'Lovely exhibition, not very commercial.' How wrong he proved to be: even though it got off to a slow start, we sold all the portraits. The sales and connections from it proved very beneficial. Apart from anything else, the exhibition was enormous fun. My favourite portrait of Churchill is still the one by Adrian Hill of him in a railway carriage with a lighted cigar (not a thing you can do these days), with his spotted bow-tie, reading some government papers. This picture came up in a sale in west London in a mixed lot. I was delighted to purchase it and only wish I had kept it for my home, with its Enigma code connection. On the back of the sale catalogue is the famous photograph of Churchill hunting with the Old Surrey & Burstow Hunt at Chartwell in 1949, when he was told not to ride by his doctor, showing once again the spirit of the man.

My associations with Pembroke College, Cambridge give me much pleasure. My first connection was with Sir Roger Tomkys, who was Master when I found a beautiful small picture of William Pitt, our youngest Prime Minister. It was with great excitement I took this small package to show Sir Roger. Somehow he guessed what was in the package. The happy outcome was that one of Pembroke's fellows paid for the picture of William Pitt, who was one of the college's most famous students. The college has a lovely chapel designed by Christopher Wren — one of his very first commissions. It came about because Bishop Wren (the Bishop of Ely), while he was in the Tower, decided if he ever got out he would give his college a chapel designed by his nephew. Not only is it a beautiful building, but installed by the altar is a wonderful 16th-century Italian religious painting. I'm happily continuing my connection with the college with the present Master, Sir Richard Dearlove, who although he was Head of MI6 is very knowledgeable about art.

The portrait of Arthur Balfour by John Singer Sargent was one of the toughest and most complicated deals. First of all, I was approached by a member of the Carlton Club committee to see whether I would be prepared to sell the large important picture on behalf of the club. Even at the start, I knew that the

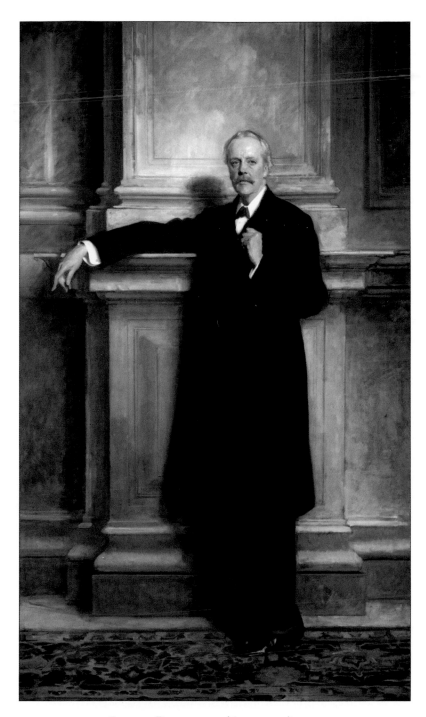

LORD BALFOUR (ARTHUR) PM
John Singer Sargent
National Portrait Gallery, London

Sale arranged by the author

chances of obtaining an export licence were nil. This picture is of an English Prime Minister by a very important American artist. Sotheby's had put a figure of £600,000 on the picture, but I knew it should be possible to sell it for a million. The main problem was the secretary of the club, who seemed to have his own agenda. The first gallery to be interested was in America, and negotiations continued. Then the Israel Museum in Jerusalem became interested. The secretary sent me fax after fax – he seemed to think he could carry out my role. The tide of things became so difficult that I had to contact the chairman of the Carlton Club, Lord Walker. Luckily, he approved of all my efforts. I was then contacted by Philip Mould, who had a client interested in purchasing the picture, but he stated that he wouldn't stand in the way of the National Portrait Gallery purchasing the portrait. I knew that was the correct home, and after many more faxes which, thanks to David Eldridge, were kept under some sort of control, a sale to the NPG was agreed, subject to them raising the funds. With a final donation from Sir Christopher Ondaatje, whom I originally introduced to the National Portrait Gallery, it managed to acquire this wonderful picture.

As I live in Huntingdonshire, I have been collecting maps of this county which was the home of Samuel Pepys, Capability Brown and, of course, Oliver Cromwell. One of the most elaborate maps showed a shield, under which was the name 'William Clinton'. My colleague suggested that it might mean that Bill Clinton, the then US President, might come from the home of Cromwell, Huntingdon, rather than Ireland, which he claimed. I therefore wrote to John Major, who was not only my MP but also Prime Minister. He sent a research student from the Foreign Office, who pointed out that Bill Clinton had taken his stepfather's name. His real surname, like John Major's, was Ball. Nevertheless, John Major bought the map from me and gave it to Bill Clinton on his next visit to America. I like to think, perhaps rather whimsically, this was when the relationship between these two leaders improved. This sale was in a true tradition, since my father found a piece of furniture with many secret drawers for Harold Macmillan to take to Khrushchev when he visited him in Moscow wearing the famous fur hat.

Prince Rupert has always been known as a flamboyant character, but he was much more than just that. Cromwell said that he would have lost the Civil War, had Prince Rupert had total charge of the Cavalier army. Certainly, if Charles I

had taken his nephew's advice and marched from Oxford to London in the early days of the Civil War, things would have been very different, and Charles I might not have lost his head. I bought a large, very handsome portrait of Prince Rupert which I showed to General Sir Frank Kitson, who wrote two excellent books about the Prince. His *Portrait of a Soldier* is particularly good. It tells lovely stories of the prince when he was still young and was in a type of open prison in a castle. The daughter of the owner of the castle fell in love with him (of course – standard fairy-tale scenario). When he took his dog, called Boy, for a walk, it went down a fox-hole. Prince Rupert went after him, followed by his equerry. Luckily a passer-by saw a leg and pulled. From the fox-hole first of all came the equerry, followed by Prince Rupert, who had hold of his dog which was still holding onto the fox.

Prince Rupert was also an engineer and is meant to have invented steel engraving. There are some lovely examples of his work in the British Museum. I was very proud of that portrait, and I would have loved to have kept it. My friend Jeremy Cotton had a share in the picture, and after it was cleaned, we sold it to St John's College, of which Prince Rupert was an honorary member. It was to be hung in the Rupert Room, but the college decided to give it a grander place in the college hall, where it looks very good. I delivered the 50 x 40 inch picture myself on a very rainy day. I received no help from the porters and only a Post-it note as a receipt. I would like to think that things would be different at Cambridge, especially Pembroke College.

I have just attended a meeting of the Cromwell Museum Management Committee. I was able to point out to the committee that I have been going to these meetings at Huntingdon since 1968, when I took over from my father. According to the minutes, I am an 'interested party', but, thanks to the chairman who acknowledged my contribution, I was able to mention some of the pictures for which I have been responsible in all those years. The first was a fine portrait of General Fairfax which came up in a sale at Christie's. I could not persuade the curator or the committee at the time that it was an important picture for the museum. Luckily, it was brought in, and I was able to buy it for them at the cost of the frame. The picture is illustrated in Lady Antonia Fraser's book on Oliver Cromwell. At many meetings, I tried to persuade the mainly farmer members of the committee at the time how important it was to have a portrait of Charles I,

so that there were the two protagonists in the Civil War. I came across a fine portrait of Charles I belonging to Lord Foot, who was prepared to sell it to the Cromwell Museum.

The picture was in my gallery on one of the occasions when Harold Macmillan called in. He admired the picture and inspected it closely and noticed things about the portrait which I had not seen, such as the shape of his eyes and costume details. I can picture it now, with the old Prime Minister, with his half-shut eyes peering at the painting at the bottom of the stairs in the gallery. The picture was bought by the museum and restored by our restorer. I drove the picture down to Huntingdon with our two lurchers. When I opened the back door of the Rover, out shot Zina, at top speed. I nearly turned around and drove straight back to London, but having inspected the picture I could not find a single mark from the lurcher's rush out of the car.

The most important picture for the museum was the painting of the Battle of Marston Moor by James Ward. On a lovely sunny day, the whole committee and chairman, Lord de Ramsay, stood waiting for the delivery van to show up, with mutterings of 'Why couldn't we have a contemporary picture of the battle?' If it ever existed, it would cost millions. I realised what had happened. Huntingdon had just got a new ring road, and it was difficult to find your way in the centre, to the museum building (which was where Pepys and Cromwell went to school). I drove out and spotted the van on its third circuit of the town, and the committee agreed to buy the picture by James Ward, an artist I have always loved.

Another art dealer friend produced a picture by a Scottish artist called Irving of an old tar whose nickname was *Old Croul*. I wrote to the National Portrait Gallery, and they suggested I contact the Scottish National Portrait Gallery. Although I had been in touch with them, they had not bought a picture from me since Duncan Thomson bought the picture of Lady Erskine and her children. Old Croul, a press-ganged sailor, had an unusual history in that he fought with Nelson and, like Nelson, lost an arm. He also fought the Americans at the Battle of the Chesapeake in 1781 and had an obituary in both the New York and London *Times*. I was so delighted to hear, in January 2009, that the museum's comittee decided unanimously to buy the picture.

The painting by George Morland of *African Hospitality* was a seriously

difficult case. The picture consisted of Africans helping white people from a shipwreck off the coast of Africa. It was a most unusual subject and absolutely beautifully painted. One of the questions about Morland is whether he painted better when drunk or sober. As he wrote to his brother-in-law, telling him what he drank for breakfast, it seems as if he might have been drunk most of the time. The picture of *African Hospitality* was exceptional, especially in the high contrast between the whites of the clothes of the shipwrecked with the black skin tones of their rescuers. Although a dealer said he had a museum who would like to buy the picture, when he didn't get in touch for a long time, I assumed it had fallen through and sold it myself to another buyer. Unfortunately, he got back in touch and was threatening to sue. Rather than have a lengthy and expensive case, I decided to settle it before the dispute got out of hand.

The portraits of Henry VIII and Catherine of Aragon were included in a sale at Ledbury, and I was the happy purchaser. Firstly, they had very elaborate frames although they needed restoring. Secondly, they had gold detailing which made the portraits particularly attractive. Most importantly of all, they were exactly what I needed for my dining room. Catherine of Aragon was particularly appropriate, as she spent her last seven years at Kimbolton Castle, which is about seven miles from my home. It is now a school, where I was a governor for seven years.

On a Saturday morning, a charming Italian lady called Mrs Benedetti came in and saw the pair of lovely portraits sitting on the floor of my office. She immediately bought them and asked me to take them over to her flat across the road from the gallery. I hung them there for her on the most exotic yellow wallpaper, and although I say it myself, they looked wonderful. She gave me a cheque, but I couldn't decide whether I was pleased with the profit, or sad that they would not hang in my dining room. I need not have worried, because on Monday morning, I received a call from Mrs Benedetti's interior decorator, who said the portraits were beautiful, but not for his client. With a certain amount of delight, I tore up the cheque and took the pictures home, where they added to the room – both because they were exceptional portraits, but also because they make the room look wider. I should not be pleased with the decorator, but I am delighted, especially when I had a valuation done for insurance (they were valued substantially higher than the figure I sold them for in the first place). This is not the first time something like this has happened. It means one should never lose

CATHERINE OF ARAGON
Unknown artist
Author's Collection

Purchased in Ledbury by the author

HENRY VIII
Unknown artist
Author's Collection

Purchased in Ledbury by the author

hope that everything turns out naturally, whether one likes it or not at the time.

There are occasions in an art dealer's life that give him a particular lift. This time was telephoning Lord Cadogan to tell him about the portrait of Sir Thomas More, similar to the picture in the Frick Collection, New York. As he owned the estate which originally belonged to More, he came into the gallery and bought the painting. I then bought a portrait of Henry VIII, who took over a part of the original estate after beheading More. Charles Cadogan agreed to buy this lovely portrait. He added that he now needed to find a portrait of Princess Elizabeth, who worshipped at Chelsea Old Church. I began to give up hope of finding such a portrait until I went to the Fair at Olympia, and there was a fine portrait of Queen Elizabeth. Happily, Charles agreed to buy that as well. Having rebuilt – beautifully – Petyt House next to Chelsea Old Church, Charles Cadogan asked me to hang the three portraits there. The idea was to put Elizabeth between More and Henry, but as Henry VIII had the most glorious tabernacle frame, he took pole position. The three pictures were put at the end of the lovely hall, and I had a feeling of achievement to see them *in situ*, especially when I met the architect John Simpson and was able to admire his handiwork with my addition to it. I was then asked by Jürgen Schumacher (a banker who is in charge of the guides at the Chelsea Old Church) to talk about the portrait of Sir Thomas More in the church, without any warning or notes. Lord Cadogan introduced me to Prince Charles, who was charming and attentive, even though he had arrived late back from a trip to Belgium.

I often find myself on awe of some of the great figures in history. It was particularly made clear to me on my two trips to Rotterdam to see the Erasmus exhibition. Why do we want to know what this famous man looked like who lived 450 years ago? He remains a figure to measure against other historical figures. Even though Shakespeare is more often spoken, there are a large number of sayings in everyday use that come from Erasmus – for example, 'cupboard love', 'In the country of the blind, the one-eyed man is king', 'Prevention is better than cure' and 'Women, can't live with them, can't live without them.'

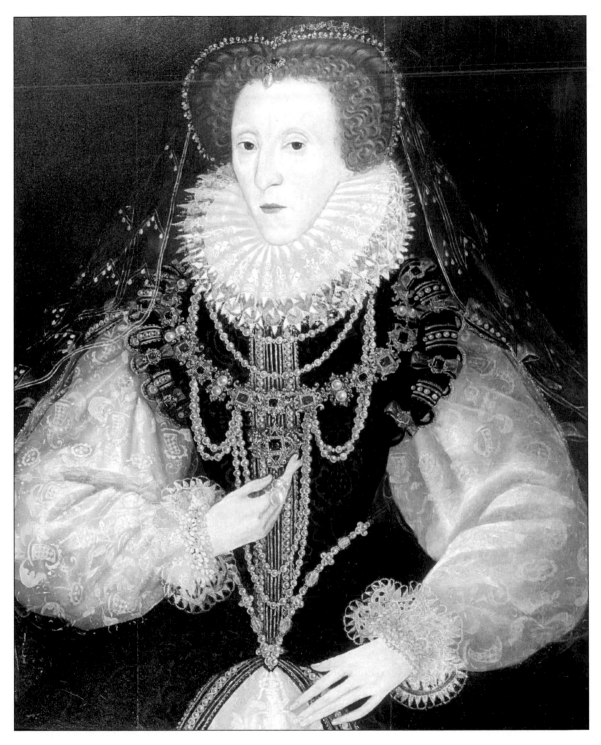

QUEEN ELIZABETH I
Unknown artist
Private Collection

Gardens and Trees

———— 𝗣𝗝 ————

All gardening is landscape painting
(Alexander Pope)

Oんい OF THE THINGS I MOST enjoy is planting things in the garden, especially trees. It started on a fairly small scale with a rare oak for the Millennium. Quercus macrocarpa has the most extraordinary leaves: although their shape is typical, they are about five times larger. It has grown faster than any oak I have known. My love of trees was started by the Norwich School. These artists are the only ones I know who paint trees so that you can identify the species. James Stark is particularly good at this; his willows by a river are beautifully rendered, and, like John Crome's, his oak stands proud, rather like the latter's famous *The Poringland Oak* in Tate Britain.

It is with great pleasure that I became a member of the International Dendrology Society, thanks to Lady Colman, a friend and client, who proposed me, and Lord Heseltine who seconded me. On the proposal form, I listed some of the trees I have planted. Having written them down on the form, I then decided to check the spelling. The proposal looked rather less smart when the names such as Liriodendron had to be corrected. This tree I planted in the walled garden, and it looks beautiful because of its perfect shape. The leaves have a wonderful colour and in the wind they reflect the light marvellously. The only worry is that it might grow too big. My favourite tree is the Catalpa bignonioides, commonly called the Indian Bean. This gets a Triple A rating, as

first of all it has lovely orchid-like white flowers with speckled centres, which are very sweet-smelling. The next joy is that the leaves are large and an attractive light green. Lastly, it has the extraordinary hanging beans which give it its common name, although it comes from North America, particularly Georgia.

The selling of a Parker 51 out of my collection of pens would have been sad, except that with the proceeds I bought an intriguing tree, Wollemia nobilis, which was discovered in a canyon in New South Wales in 1994. Looking rather like R2D2 in the film *Star Wars*, it is a tree that existed 200 million years ago and had dinosaurs as company, which is why it is nicknamed 'Pinosaur'. I do not know whether they were around in East Anglia, but it is a most interesting tree. Everybody asks me how large it will grow, but nobody knows, since it has only been in cultivation for 16 years. When I look out of the bathroom window and see the tree at the end of the tennis court, it gives one the feeling of how young the human race is in comparison with the age of this very unusual tree. I am waiting to see whether it does all the strange things that are described in the IDS booklet. I tried to photograph it with my three-year-old grandson for this book, but he didn't like the idea. At the moment, the Pinosaur is winning on height.

Beside this unusual tree is the Ginkgo biloba, which is also a prehistoric tree. It has the most strange fan-like leaves, which presumable give it the common name of Maidenhair tree. It was found in temple gardens in Chekiang province in China in 1758, and a visitor to my garden was most impressed with the way it was growing in East Anglian clay soil. Nearby is the loveliest tree, the Paulownia (or Foxglove tree), which is growing very well near the back drive. So far, it hasn't cut us off the telephone, but it is close to doing so. Although it is nearly seven years old, it hasn't flowered, but to make up for that, it has large light green leaves the size of a big pancake.

The lovely pond at the bottom of the walled garden at Rippington Manor, which was one of the ponds recorded in Domesday Book in 1086, had over the years collected nine feet of silt. The problem was that the bottom of this mini lake was puddled blue clay, and if that was damaged, we wouldn't have a pond. I arranged a meeting with an expert who had been a lion-tamer earlier in his life. It was an interesting meeting, as the man was bedecked in gold, with a bracelet and necklace. The lions must have had an unusual time, because his forearms were the size of most people's legs. When I got talking about removing the silt

from the pond, I suggested that the monks probably hid their treasure in the pond, and if he found it, we could go 50/50 on the value. He explained that he'd taken on a job in Sussex, on the basis that he would be paid by the findings of the treasure. As nothing was found on that occasion, he was not prepared to take on another job on those terms. He quoted £5,000 for doing the whole operation, which involved bringing up his team and equipment from Sussex, but I decided that this was too expensive at the time.

When I was doing the deal over Ackermann's, I devised a code with my solicitor David Eldridge which was based on the botanical name and the common name of plants and trees so I could communicate securely with him while I was having to use a communal fax machine while on holiday in Skiathos. David Eldridge's call sign was 'Pink Trout lily' (Dianthus Erythronium, or DE). My favourite code word was Betula pendula Youngii or weeping silver birch, which meant 'Go ahead with the purchase.' This was the tree that I joined to another weeping silver birch to form a frame for a sculpture of a girl reading a book by the Victorian sculptor Patrick MacDowell in the garden at No.1, The Little Boltons. Patricia Gill thought it was a wonderful idea and asked if her company, Designer Gill, could copy it.

One of the pictures I inherited from the Ackermann purchase was a ghastly flower picture where the flowers clashed, and I didn't even like the frame. Two Japanese gentlemen came in and immediately got very excited about the picture. As I couldn't think of anything nice to say about the painting, I said nothing. To my amazement, they bought the picture. Perhaps this is a lesson to us all. I was so relieved when this picture went off to Tokyo. I wonder if it is still there and being enjoyed!

I didn't realise what fun it was to write a book until Ernle Money and I were commissioned to write a book on the Nasmyth family of painters. It was ground-breaking, in that the births and deaths of the various members of the family were at that time unknown. The research for the book involved enjoyable trips to the Grassmarket in Edinburgh, where most of the Nasmyths were buried. We were lucky because we found most of the gravestones, and the dates on them were still legible. It was amazing that Alexander Nasmyth, who was the father of the family, was not only an artist but an inventor and engineer, very much like Rudolph Ackermann. Alexander was also an architect and designed most of New Town, Edinburgh, and particularly St Bernard's Well. The best-known member of the family was Patrick

Nasmyth, who painted lovely landscapes in a traditional fashion, rather like the Dutch but with beautiful English colouring. He was the eldest son, but then came Jane and Charlotte who also painted lovely landscapes, followed by Margaret and Barbara, who both painted landscapes and were taught by their father.

Lastly was the charming James Nasmyth who invented the steam hammer, a model of which is in the Science Museum in London. For added recognition of his painting, he put a little illustration of the hammer on the back of his pictures. He also wrote a book on the moon which is illustrated by his photographs of the models he made after he observed it through the telescope in his garden. These are so effective they look like modern photographs of the moon. He also demonstrated his steam hammer by putting his half-hunter watch under the hammer and lowering the hammer down onto the glass without breaking it. Unfortunately, he had the habit of showing his book of ideas (which included detailed drawings) to customers. When he visited France for the first time, he was rather surprised to see his invention already in operation there. He promptly patented the device afterwards, but the horse had already bolted. The book was particular fun because we held our discussions in the bar at the House of Commons, as Ernle Money was then the MP for Ipswich. Lotty Shepley-Cuthbert was meant to write it all down, but most of the time was spent laughing. It therefore took seven years to complete the book. It certainly didn't turn out the way I expected it to, but nevertheless I bought the remainder from Frank Lewis, the publisher. I could not think why I did that, but every week, we would sell a copy at the list price. I don't know what it would cost today. I particularly remember when we bought *View of Dochfour House, Loch Ness* by Alexander Nasmyth, a most beautiful landscape of Scotland. When it was dirty, it even looked as if the Loch Ness monster was in the picture! The painting was large and impressive; the more it was in the gallery, the happier I was. The first sale was to Scotland, although I thought it should have been bought by Lord Burton who lived at Dochfour, but the timing was wrong, as he had a court case on his hands. Naturally, I offered the picture to the National Gallery in Edinburgh, as a picture by an important Scottish artist of a famous subject, but I was happy when it was bought by the very good client Sir Gordon White, who later instructed me to sell the picture. It was equally pleasing when my landlord who had admired the picture for some time bought it. A van was arranged with

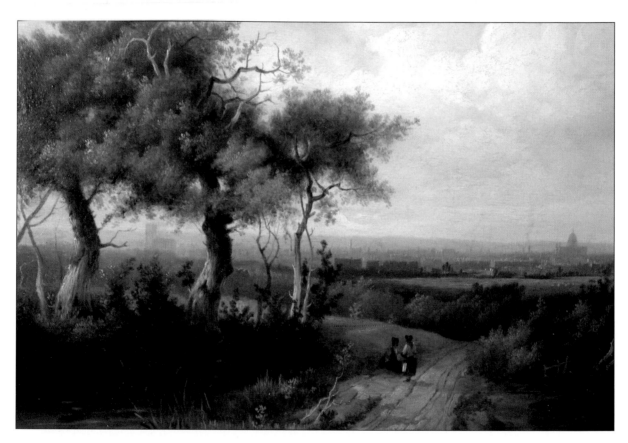

VIEW OF NORWOOD LOOKING TOWARDS ST PAUL'S AND WESTMINSTER ABBEY
Charlotte Nasmyth
Johnson Fine Art

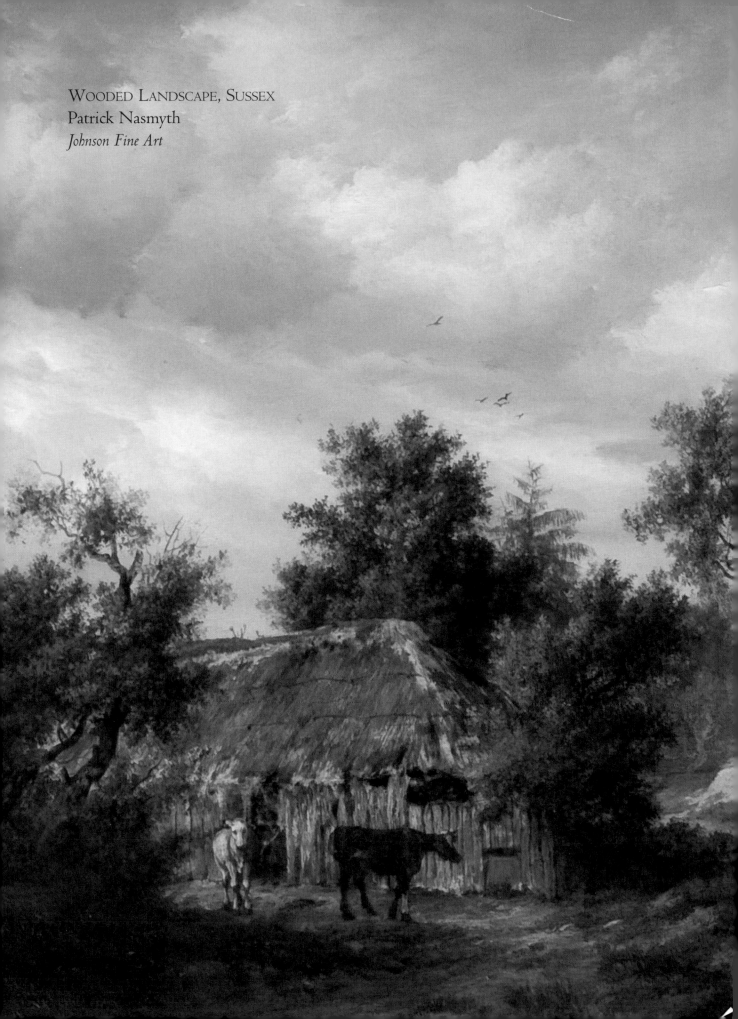

WOODED LANDSCAPE, SUSSEX
Patrick Nasmyth
Johnson Fine Art

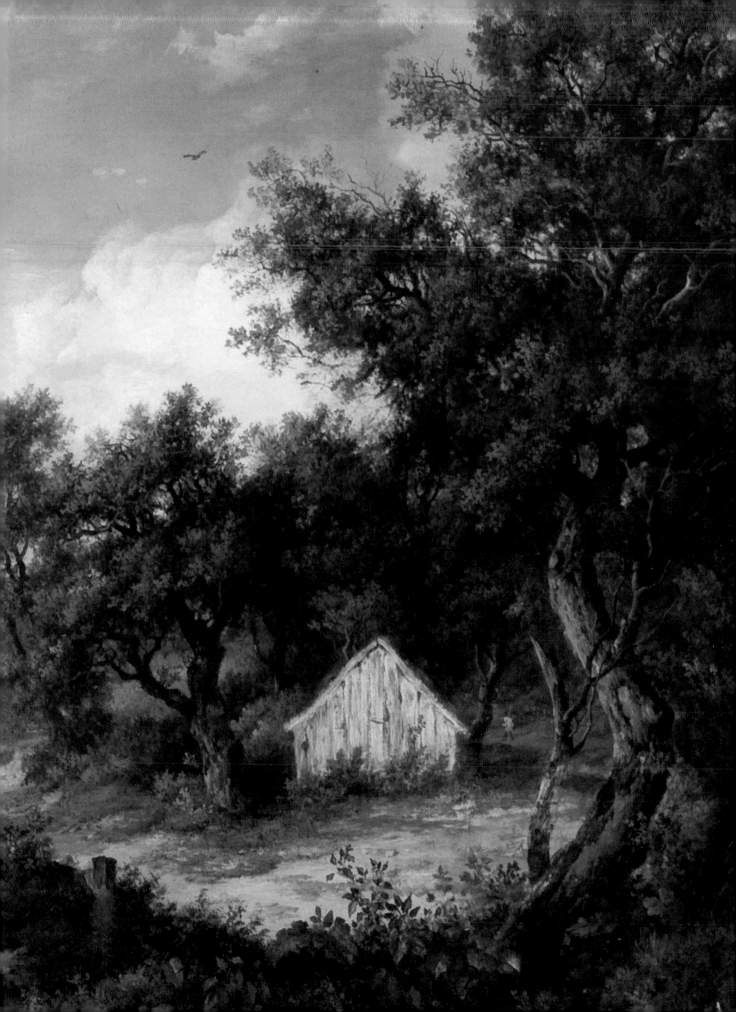

a chap to hang the picture, and it went up in Lord Cadogan's home, and a very jolly lunch was given to my wife and me before we returned to London.

A major event in my life is the sale of a J.M.W. Turner. It was one of the usual types of day until the arrival of a dear friend and client, Lady Colman. In the back of her estate car was one of the most beautiful Turners of Lake Constance. The blind attached to the frame, which protected the picture from ultraviolet rays fading the colours, was damaged – she had brought it in for me to arrange to get it fixed. I said to her, 'Do you know the value of that Turner?' She suggested two to three thousand; I told her it was worth over £100,000, and Sir Michael and she decided to sell it. The York City Art Gallery agreed to buy and paid £60,000 net of any tax, with the aid of National Art Collection Fund, as it was then called. The picture has been much exhibited, but I was very concerned when I read in the paper that a Turner had been stolen from York City Art Gallery. Luckily, not Lake Constance. Unfortunately, the only Turner which came close to being in my own collection – a view of Edinburgh – was given by my father to the Graves Art Gallery in Sheffield as a thank you for looking after his family in that great city during the war when he was a captain in the Royal Artillery.

I will never forget a visit to a Mrs Turner at Middle Wallop, Hampshire. My father and I set off for tea with Mrs Turner. I cannot remember what the tea was like, because my eye caught sight of the most glorious still life by van der Ast. It was magical in every way: the flowers were superbly painted, and so were the shells and insects. You can imagine the excitement some years later when my friend Nicholas Cunliffe-Lister, now Lord Swinton, asked me to sell the picture on the basis of handing it over in lieu of paying Estate Duty, as it was then called, which was at the highest rate, probably 80 per cent. Dr Christopher Brown, then a curator at the National Gallery, expressed a very keen interest in having this lovely picture at the NG. I asked Nicholas to request that his picture went to the National Gallery, and we informed the Art Advisory Panel that not only the National Gallery wanted the picture, but that the owner had made a specific request that the picture go to Trafalgar Square, where this lovely picture would be seen by millions of people. At the time, there was a belief that all the best pictures were going to the capital, and because people felt obliged to adhere to the notion of political correctness, the painting travelled north to Temple Newsam, where it sits in a corner of a room and seen by only a few people each year.

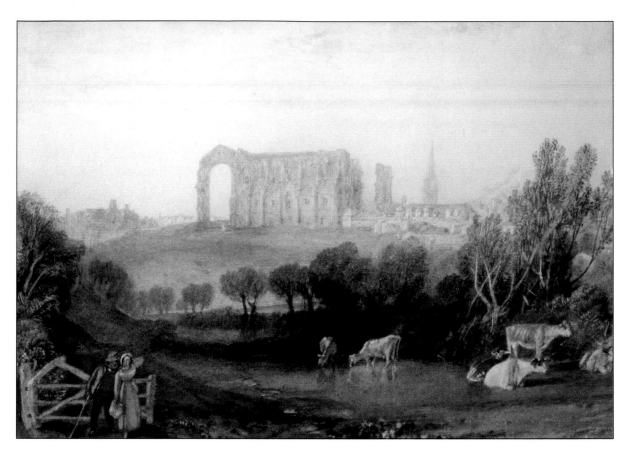

MALMESBURY ABBEY
J.M.W. Turner, RA
Private Collection

The importance of the three C's (colour, composition and condition) in determining the quality of a picture are well illustrated by a picture I handled of flowers by Maurice Vlaminck. The artist mainly painted rather dark and stormy landscapes, but on this occasion, he painted a very colourful and charming picture in an unusual composition for him. My father sold the picture to a New York dealer, who was a great character with a gravelly voice. Before the picture was shipped, my father noticed that the petals on the flowers were dropping off. Vlaminck had painted the picture with great pieces of impasto. Luckily, the picture had glass on it, and the petals were caught in the bottom of the frame. When my father rang the dealer and explained what had happened, the dealer asked, 'Could the petals be stuck back?' My father said he thought it was possible, and a restorer stuck the pieces of paint back again, and the picture went back to New York. Needless to say, this is not an ideal situation, and illustrates the importance of condition.

The three C's could be said to be vital to garden design too. One of the loveliest places we lived was at No. I, The Little Boltons. It had wonderful proportions and a handsome, big garden which we opened to the public and was in the famous Yellow Book, which was to raise money for the nurses charity. We had two lurchers at the time who also enjoyed these garden openings. Bandit particularly, as he always found children who would give up their sandwiches, which then had to be replaced by us. It is difficult to believe that we had four or five hundred people who came to see the garden, and my mother was always baffled that we could charge the visitors £1, whereas she, with her large garden, only charged 50p. Some very interesting people from the art world always came, and it was a jolly occasion combining, as always, business with pleasure.

Boris Johnson (no relation) said at Bergen that he wanted the London Olympics to have a cultural element. I knew I could organise an exhibition for the Olympics, but that didn't seem appropriate, so I produced a brochure, and a team of people to put forward a special garden for the Olympics. It was based on the wonderful art of Capability Brown, Humphry Repton and, more recently, Gertrude Jekyll, not forgetting William Kent and Sir John Vanbrugh. Whether the plan ever gets off the ground is another matter, but the committee was formed and meetings were held in my office, where the British Sporting Art Trust started. I sincerely hope that the Heritage Cultural Garden for the Olympics achieves something.

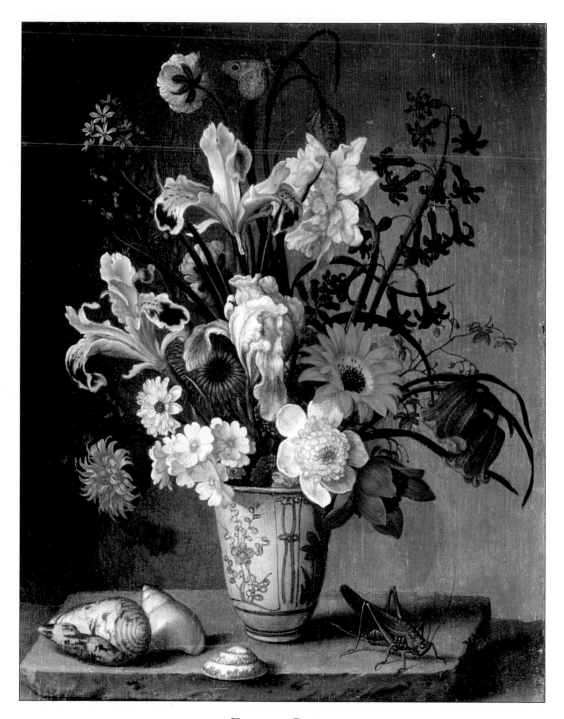

FLOWER PIECE
Balthasar van der Ast
Temple Newsam, West Yorkshire

The author arranged for this picture to be handed over to the Nation in lieu of tax

CHAPTER TWELVE

Buy One, Sell One

———— 卫 ————

Everyone lives by selling something
(Robert Louis Stevenson)

PERHAPS IT WOULD BE FUN TO outline an art dealer's typical week in the 1980s. It starts with the Monday morning viewing of sale, first at Christie's South Kensington. Arrival at the gallery at about 9.20. I open my post, which always contains something of a surprise, perhaps a letter giving me instructions to sell a painting or asking to buy a picture, or an estimate to go ahead with the restoration of a picture, plus the accompanying bills. I deal with the important letters and then look round the gallery to see what needs to be done. We try to change the window every other day, and the gallery is rehung once a week. Then comes the day when we organise an exhibition. Any pictures not part of it are taken down and sent to the store for the duration, and the gallery is rehung and smartened up.

I like to think that every day I have one thing of major importance. This I concentrate on and deal with to the best of my ability. Sometimes, it's a success; sometimes, success is not so forthcoming. I write appointments in my large London diary, including lectures to attend. I enjoy going to them whenever possible, because I always feel they can present a new perspective of a particular image or subject.

I have devised a new method of having lunch. Rather than having an expensive and fattening three-star lunch, I find that it is pleasant and rewarding to have a gallery lunch. My secretary goes out and purchases smoked salmon and

161

a bottle of wine, and I invite somebody to join me. This means that a free exchange of thoughts take place about art dealing and the world at one... I then endeavour in the afternoon to proceed to view sales and finish the general work in the gallery, in the hope that Tuesday will bring even more benefit to myself and the gallery staff.

Tuesdays are usually a day that I enjoy particularly, as it seems to be of day of advent, i.e. potential for operations happening – sales, purchases and such like. If I don't concentrate on a sale, then I will concentrate on a purchase. Having purchased – with the aid of a friend's money – a set of the most beautiful water-colours of Windsor by William Daniell, I was extremely lucky to subsequently purchase a complete set of the engravings done by William Daniell and framed in beautiful maple wood frames. I would dearly love to have a study with those hanging round it. I was even considering removing the silhouettes that hang in my study in order to hang these splendid engravings. But the actual purchase of those engravings involved determination more than anything else. First of all, to carefully prime my secretary on how I expected her to bid, then arrive myself just before the sale, in case of any complication. As it was, we purchased them for £750, and, in fact, a dealer friend was considering them at £6,500, although I was hoping they would all go for an even higher sum to the Windsor Hotel in New Orleans.

I am glad to say that whenever one goes out the door, a client would appear. It then becomes very difficult to make the decision whether to go view/buy at sales. To some extent, that problem has been overcome by my current situation, as clients now make appointments, and although some of them don't keep to the time of the appointment, it does make for a more simplified and regulated timetable of gallery life.

Tuesday lunch is always an enjoyment. I usually try to find somebody special, or perhaps someone who owes us money, in the hope that the lunch might just persuade them to pay; but there is always a laugh to be had. Tuesday proceeds with more viewing. We may have a picture in, offered to us by a runner who says that he will accept one figure and hopefully will come down. (A runner is a man who borrows a picture from Gallery A, usually one which has been in stock for a long time, and tries to sell it it Gallery B, making a modest profit). We put it under the ultraviolet light, which shows up any restorations, then may

consider calling in a restorer to examine it more closely. I do find it very satisfying and enjoyable discussing a picture in detail as to how it will clean (or how we hope it will clean) with the restorer.

The person who certainly had the greatest ability in this field was David Bull, who restored pictures in a specially constructed octagonal house at Wimbledon. Unfortunately, he was charmed away by the appeal of the J. Paul Getty Museum in Los Angeles, and this was a great loss to the restoring world in London. He went from the J. Paul Getty Museum to the Norton Simon Museum in Pasadena and then to the National Gallery of Art in Washington, subsequently setting up his own restoration business. I am hoping that eventually he will return to London, like so many restorers who have sought their riches in the United States.

Tuesday over, it is then time to go to the opening of an exhibition or to have dinner and drinks with some friends and then dinner with others, again discussing, even if it is in a roundabout way, art and the art world. The number of people who wish to join the art world has always been considerable. A person from a very well-known Scottish family, whose sister worked at Sotheby's, agreed to come work for us and on practically no pay, on the basis that he would learn more about art dealing. Unfortunately, in one week, he succeeded in doing more damage and costing us more money than if we had employed him full time for the whole year. He smashed the gallery car, which had already been sold in part exchange for another one, and he hung up pictures with the hooks turned in the wrong way. We were all tearing our hair as to what he would do next. Finally, I called him into my office and said, 'Look, this can't go on; you'll have to go.' 'What about my money?' he replied. 'My dear chap,' I said, 'you have cost us so much this week, I hardly think that we should pay you anything.' In the end, I agreed to pay him a nominal amount, on the basis that it was cheaper than having him smash anything else before he left. I did take a reference out on this chap from the chairman of Christie's South Kensington, who informed me that he was a good worker but hadn't got very much above the eyebrows. What he failed to mention was that the man had moved a trolley-load of coins — large, cumbersome trolleys, they were — holding a sizeable collection of rare coins, and he had ran it down a slope into a wall, thereby mixing them all up. If I had heard this, I would have had serious reservations about him joining us.

Wednesdays are always also an interesting day, because I try to attend one of

the sales, usually held at Sotheby's, if it's an important English sale. This way, I can find out what pictures are making — invaluable research for pricing my own. Sometimes, I purchase a portrait just because it's going so cheaply; sometimes, I find an English landscape which I can't resist. On one occasion, I purchased a Patrick Nasmyth, standing at the back of Sotheby's, and was bidding against the person standing next to me. He turned round to me and said, 'Oh, do you want that picture?' I said yes, to which he replied, 'You have it.' I bought it for £1,500 and had it collected and brought back to the gallery.

I then received a telephone call from Sotheby's saying it had sold the wrong picture. Luckily, I had already sent it off to the restorer to have a 'window' cleaned in it to see how it would clean overall. I then received a letter from Sotheby's, stating that as it wasn't entitled to sell the picture, we weren't entitled to buy it. I put the matters into the hands of the very able solicitor David Eldridge, who, after a number of phone calls and letters, established that Sotheby's would pay us a sum for the loss of the picture. By then, the picture was already under offer to a client for £5,500, which I felt to be about its correct market value. In the end, Sotheby's agreed to pay us £2,000, and the picture was returned. Although I made some profit, I would have made much more if I had sold it to one of my clients. The complicated problem is the finance of those purchases. You can't be certain that when you purchase a picture on Monday you will sell it on Friday — sometimes, you might have a picture for five years. The difficulty is that you become attached to the one you have had for five years, and you don't really get to know the one you have had for three days. Somebody asked me how you actually make money in the art world. I think it is basically the collection of stock, the purchase and writing down of old stock, and the hopeful anticipation of a sale at a later date.

Thursday also is an interesting day. I arrive at the office at nine o'clock, open my post as usual and find that the telephone starts ringing at about half past nine and doesn't stop. If it were possible to talk on more than one phone at a time, I would endeavour to do so. The accountant comes in to ask me to sign cheques and gives me details of various things that we owe. The question obviously is: can we match the cashflow in with the cashflow out. This is sometimes extremely difficult, as money seems to flow out rather rapidly, and sometimes takes a long time to flow in. I then continue possibly to have another view at the sale of

MRS BEAL BONNELL
George Romney
Fitzwilliam Museum, Cambridge

Sold by the author to the Fitzwilliam

Christie's to see whether there is a water-colour coming up on the following Tuesday. I write some letters, and I usually allow myself on Thursday a few minutes to write one or two not necessarily business letters. Early in 1982, I wrote a letter to *Country Life*, asking for information about Joseph Duveen, who was one of the most eminent and certainly the most controversial art dealers in the earlier part of the 20th century. Hardly a week went by when a letter was not received from somebody in various parts of the country and also from America giving details about Duveen. I even had a telephone call from his daughter in America asking us to go to what turned out to be the most extraordinary dinner party I think I will ever remember.

The people were astonishing: they all had to persuade you that they were doing something spectacular with their lives. The daughter of Duveen, the Hon. Mrs Dolly Burns, was very flamboyant, dressed in glamorous and exotic fashion, talking every second, with a husband who wasn't allowed to. The whole scene was amazing. The house in Mayfair was charmingly decorated with delightful pictures, and the food was exceptional. The conversation was complicated, and at the end of the dinner party, one of the guests was on the radio, having spoken in the House of Lords that morning. The butler brought in the radio so that we could listen. Mrs Burns wouldn't allow us to sit over our port, as she was very anxious that the ladies shouldn't get bored upstairs.

Thursday is usually a day when I organise a special lunch, taking somebody out to a restaurant, giving them a special meal, even possibly taking them to Buck's Club in Clifford Street, which is extremely entertaining. The food is not as good as it used to be, but the company is still fascinating — all sorts of interesting people who all enjoy the very homely and pleasant surroundings of Buck's.

Thursday afternoon is usually very hectic. There always seems to be many telephone calls and visits by various people. On the whole, Thursday is an excellent day, and in fact we don't have time to stop for tea, and usually I'm fairly exhausted by the time 5.30–6pm comes around, but there is still drinks with somebody and dinner afterwards and, on the odd occasion, a dance or a nightclub.

Friday is the day when I like to get things straight and ready for the weekend, and deal with the remaining correspondence; somebody even said that they were

delighted with me because I replied by return. I'm afraid that reputation has slipped, as I now receive so many letters that it is impossible to complete all the letters by return of post. In any case, the post no longer returns them on the following day. My method of communication is often by postcard. Luckily, the gallery has produced a number of postcards of pictures we have had in the past, including one of the most fascinating, of a William Huggins still-life of various flowers and pots. This picture is one of the few pictures that are very hard to date by eye: it could have been painted last year, it could have been painted in the 1920s, it could have been painted early in the 19th century. In fact, it was painted in 1880. The picture was bought by the Queen's equerry, Lord Plunket, from our Huggins exhibition for something like £350. It was repurchased by me for £1,800 and sold at a profit also. The picture had a rare quality of modern art. It is the forerunner of the Renoir still-life. It has a quality which every work of art should have – timelessness.

Friday is also the day when Christie's hold their big sales, such as the sale of *Titus* by Rembrandt (which I remember so well). This sale was particularly sad from my point of view, as in 1963, I was offered this picture by the person who later became head of the National Museum of Wales; Peter Cannon-Brookes came in and said, 'Did I think I could sell a painting by Rembrandt of *Titus?*' I said that I was convinced that I could find a home for it. My father seemed less enthusiastic, but between us we managed to persuade one of our clients, Lord Thomson, to become very excited in it, and he agreed, subject to the dealer Harry Sutch agreeing that he should have it in his collection. Harry Sutch was a very complicated individual, and when we discussed it with him, he said, 'My friend should never buy a picture like that.'

It was sometime later that the picture came up at Christie's after a long battle over who should own it, which was fought out by the Cook family. Sir Francis Cook had married several times, and each of the wives was trying to claim the picture. In any case, it was sold at a memorable sale for the then-record price for a Rembrandt £880,000. I remember the scene at Christie's when David Somerset thought that he had purchased the picture, until somebody, an American, stood up – it might as well have been with a gun, it was so dramatic – and told the auctioneer, Peter Chance, that he was still bidding. This was against what everyone learnt to have been his arrangement with Christie's that

when he was seated he was still in the bidding, but was to be out when he stood up. He then sat down again, and although Peter Chance asked several times what his intentions were, the chap didn't say anything. The scene was extremely dynamic, full of potential fight: Peter Chance shouting out, 'I have my solicitor behind me, and I could put the picture up again', which he duly did, to many dealers' consternation that potentially this formed a dangerous precedent. The American, who was representing the Norton Simon Museum eventually won the second auction, David Somerset of the Marlborough Gallery having won the first, overruled, one.

Purchasing pictures can be a very complicated business. I particularly remember buying a picture, of the unattractive scene of a woman dying in bed. I was convinced it was by Hogarth, and was sure that it had been engraved before. I bought it and returned to the gallery to receive a telephone call from Patrick Lindsay at Christie's to say that there was some confusion over the purchase. I held my hand over the telephone receiver and immediately despatched someone to go collect it, while agreeing with Patrick that the person who thought he had bought the picture should get in touch with me. It turned out to be Martin Butlin of the Tate Gallery, who had been seated directly behind me in the sale. He thought he had bought the picture (this was in the days before the paddles identifying the buyer), only to discover that I had done so when he returned from lunch to collect it. One lives and learns from one's mistakes – I should have lent it permanently to the Tate, but instead I sold it for a modest profit. But perhaps it paved the way to other pictures the Tate have bought off me, knowing that I wouldn't be unfair.

I didn't get any consolatory compensation from another difficult client. We had a very lovely picture of Etaples on the northern coast of France by Eugène Boudin. It was exceptionally pretty, with a lovely blue sky – a real joy to look at. I offered the picture to a diamond merchant who agreed to buy the painting. Before the sale was completed, I had a call from Lord Plunket to say that the Queen would like to buy the picture. I explained that the picture was under offer, but I would see what I could do. In one of my mistakes, I told the diamond merchant that the Queen wanted to buy the Boudin. I was hoping that this would mean that he would do the honourable thing and let Her Majesty have it. Not a bit of it: he became even more determined to buy the painting. I would have

loved to have had the picture in the Royal Collection. If only I had said that the picture had a problem... But as I've said, you can't have any regrets in this business.

<p style="text-align:center">* * *</p>

It is now 50 years since I joined the art world. The whole scene has changed since 1958, but it is still a fascinating business. One of the continuing problems is capital, and I have only survived on making debts. With the prospect of having two new hips and my search for a person to take over the business, I was lucky to find an old friend, Robert Jeffcock, who had started a gallery in Mount Street in 1972 but due to IRA threats at that time closed it and went into the oil and gas business. He is kind enough to say that all he learnt about the art business at that time was through my advice and comments. It is particularly charming that he does tell people I introduce to him that I have helped him in that way. It turned out that a member of his family had bought pictures from Ackermann's. I was therefore happy to find that he wanted to take over the business. The gallery at No. 27, Lowndes Street has been done up, and the whole operation has taken a newer, 21st-century look.

Meanwhile, I have started a new dealing business called Johnson Fine Art, dealing in the pictures my father and my grandfather loved. An old school friend has agreed to help me by buying some of the old stock. I had just been to Jeremy Cotton's 75th birthday party in Devon, even though he still looks much younger than me, thanks to his dark hair and riding every day. Although Sarah, the surgeon, gave me a new lease of life with my new Titanium hips, I am not sure whether I should be back on a horse, especially as Mark Chamberlain said it was easy getting on but more difficult getting off. Certainly I would be in trouble if I was kicked on the leg, like Jeremy was the day before his birthday party. Apart from the selling of the usual Oscar & Peter Johnson pictures, I am at the moment involved in selling a beautiful Stubbs of a grey Arab, a Hoppner portrait of Pitt the Younger, and a van Gogh drawing, as well as planning a bronze of Sefton for the Royal Veterinary College. In addition, I have an advisory job for the Government and am working on the material for the second volume of memoirs...

Exhibitions

Exhibitions held by Oscar & Peter Johnson and Ackermann & Johnson

Pictures and Drawings from Yorkshire Houses	4th April 1963
Twelve Masterpieces	12th December 1963
John Wootton	13th December 1963
Collection of the Late Robert W. Reford	6th August 1964
The Smythes of Ipswich	4th December 1964
Painters of the Norwich School	21st May 1965
English Little Masters	10th December 1965
Ward, Morland and their Circle	27th May 1966
William Huggins of Liverpool	9th December 1966
Painters of a Seafaring Nation	10th November 1967
The Influence of Crome	15th November 1968
Sport and the Horse	11th July 1969
Albert Goodwin	29th May 1970
Quintessence of Civilisation	4th November 1971
Henry & E.K. Redmore: Sea Paintings	2nd April 1972
Henry Bright. The Smythes of Ipswich	23rd June 1972
Continental Views by English Artists	7th June 1974
The Country House & English Landscape	15th July 1977
The Smythes of Ipswich	17th March 1978
Albert Goodwin, RWS (1845–1932)	14th December 1979
Christmas Exhibition: English Watercolours	12th December 1980
Arthur Claude Cooke	7th November 1981
The Art of English Watercolour	19th May 1982
To the Manor Born	6th November 1982

Douglas Anderson, RP: Exhibition of Wildlife Paintings	4th December 1982
James McBey: A Centenary Exhibition of Watercolours	7th June 1983
James Stark and the Norwich School	5th November 1983
James Webb and the Influence of Turner	9th June 1984
The Menagerie of William Huggins	27th October 1984
Harry Bush: A Brush with Bush	18th June 1985
The Power of Animal Bronzes	15th November 1985
Terence Short: Many the Faces of Birds	15th November 1985
Major Masterpieces	14th December 1985
Scenes by the Smythes	6th June 1986
The World of Wildlife	12th December 1986
1900 Belle Epoque Painting, at Home and Abroad	25th April 1987
Ken Howard: Studio Scenes and Landscape Subjects	12th June 1987
A Kaleidoscope of Collecting	10th June 1988
Ken Howard: An Amalgam of Light	26th May 1989
E.W. Cooke, RA and His Contemporaries	24th November 1989
The Pleasures of Observation	25th May 1991
Annual Exhibition of Sporting Paintings and Watercolours	30th November 1991
Ken Howard, RA: Drawn by the Light	30th May 1992
The Art of Sporting Landscape	6th November 1992
The Horse in Art	9th December 1994
Land, Sea and Sail	13th December 1996
The English Landscape	17th April 1998
Images of Sir Winston Churchill	2nd June 2000
Douglas Anderson, RP: Seasons of Wildlife	9th December 2000
Sport in Art	7th July 2001
William Huggins: Animal Kingdom	26th October 2002
The Art of Sporting Landscape	19th November 2004

Index